Spirit of Place

The Art of the Traveling Photographer

Bob Krist

AMPHOTO BOOKS

An imprint of Watson-Guptill Publications
New York

For my wife, Peggy, and my sons, Matthew, Brian, and Jonathan, with all my love

Bob Krist is a freelance photographer who works regularly on assignment for such magazines as *National Geographic Traveler*, *Smithsonian*, *Islands*, *Endless Vacation*, and *Travel/Holiday*. His photographs from these worldwide assignments have won awards in the Pictures of the Year, *Communication Arts*, and World Press Photo competitions. During his work, Krist has been stranded on a glacier in Iceland, nearly run down by charging bulls in southern India, and knighted with a cutlass during a Trinidad voodoo ceremony. He was named "Travel Photographer of the Year '94" by the Society of American Travel Writers, and his work was featured on the cover and in a 10-page portfolio in a recent issue of *Communication Arts*. For seven years, Krist served as contributing editor and photography columnist at *Travel & Leisure*. He is currently a contributing editor at both *National Geographic Traveler* and *Popular Photography* magazines, where he writes photography columns. He also writes and shoots how-to and feature articles for several other national publications, including *National Wildlife*, *International Wildlife*, *Outdoor and Nature Photography*, *Caribbean Travel & Life*, *GEO,* and *Outside*.

Along with his magazine work, Krist has photographed the coffee-table books *Caribbean* and *West Point: The US Military Academy*. He is also the author of *Secrets of Lighting on Location* (Amphoto Books, 1996). Krist appears periodically as photography correspondent on "CBS This Morning," and has been the keynote speaker at the national convention of the Society of American Travel Writers and at regional meetings of the American Society of Media Photographers. Krist also teaches travel-photography workshops at the Maine, Santa Fe, and Tuscany Photo Workshops, as well as at the Disney Institute. He lives in New Hope, Pennsylvania, and his Website address is www.bobkrist.com.

Copyright © 2000 by Bob Krist

First published 2000 in New York by Amphoto Books, an imprint of Watson-Guptill Publications, a division of VNU Business Media, Inc.

770 Broadway, New York, NY 10003

www.amphotobooks.com

Library of Congress Cataloging-in-Publication Data

Krist, Bob.

 Spirit of place: the art of the traveling photographer/Bob Krist.

 p. cm.

 ISBN 0-8174-5894-8

 1. Travel photography. I. Title.

 TR790.K75 2000

 778.9'91--dc21 00-23009

Manufactured in Hong Kong

4 5 6 7 8 9 / 08 07 06 05

Edited by Liz Harvey
Designed by Jay Anning, Thumb Print
Graphic production by Hector Campbell

Acknowledgments

I'd like to thank Robin Simmen for commissioning this book and Liz Harvey for bringing it to fruition. You couldn't ask for two brighter guiding lights.

Over the years, numerous photo editors and art directors have given me the opportunity to photograph some incredible places. For giving me a break early in my freelance career (and not giving up on me later!), I will be forever indebted to Bill Black and Adrian Taylor, then of *Travel & Leisure*, and Bob Gilka, then director of photography for *National Geographic*. Without the leaps of faith on the part of these gentlemen, I'd still be shooting Little League games in Jersey City.

The late Gene Daniels, of *Boys' Life* magazine, was the first picture editor of a national publication who ever gave me an assignment, and we worked together for many years. My thanks also go to Tom Kennedy and Kent Kobersteen of *National Geographic*, and to Dan Westergren, Carol Enquist, and Linda Meyerriecks of *National Geographic Traveler*. Albert Chiang and Joan Tapper of *Islands* magazine have been key supporters for a very long time and for that I am grateful. David Dunbar, senior editor at *National Geographic Adventure* magazine, is an invaluable sounding board and advisor.

I'd also like to thank Connie Ricca, Tom Heine, and Doug McSchooler of *Endless Vacation* magazine; John Nuhn of *National Wildlife* magazine; Richard Rabinowitz and Monica Cipnic of *Popular Photography*; and Steve Connatser; Martha Zenfell; Hilary Genin; Lisa Passmore; Bob Ciano; Hazel Hammond; and Peter Burian. For their continued support, my thanks go to Anne Marie Bakker, Jerry Grossman, Bill Giordano, Richard LoPinto, Bill Pekala, Mike Corrado, and Lindsay Silverman of Nikon, as well as John Cole of Cole and Company.

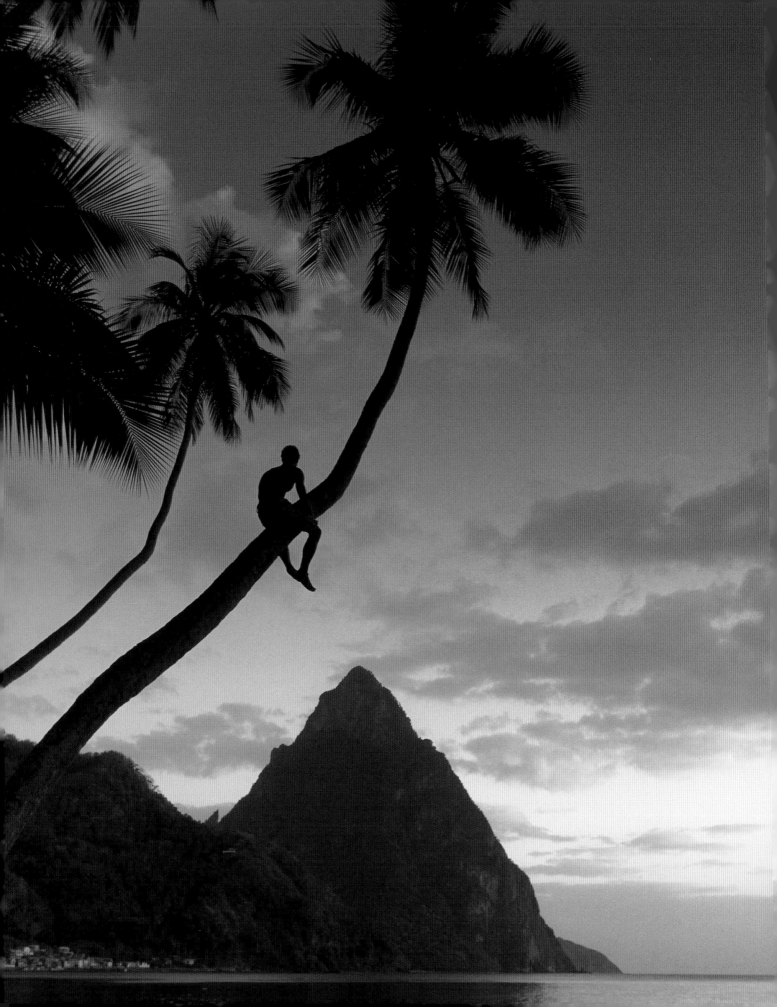

Contents

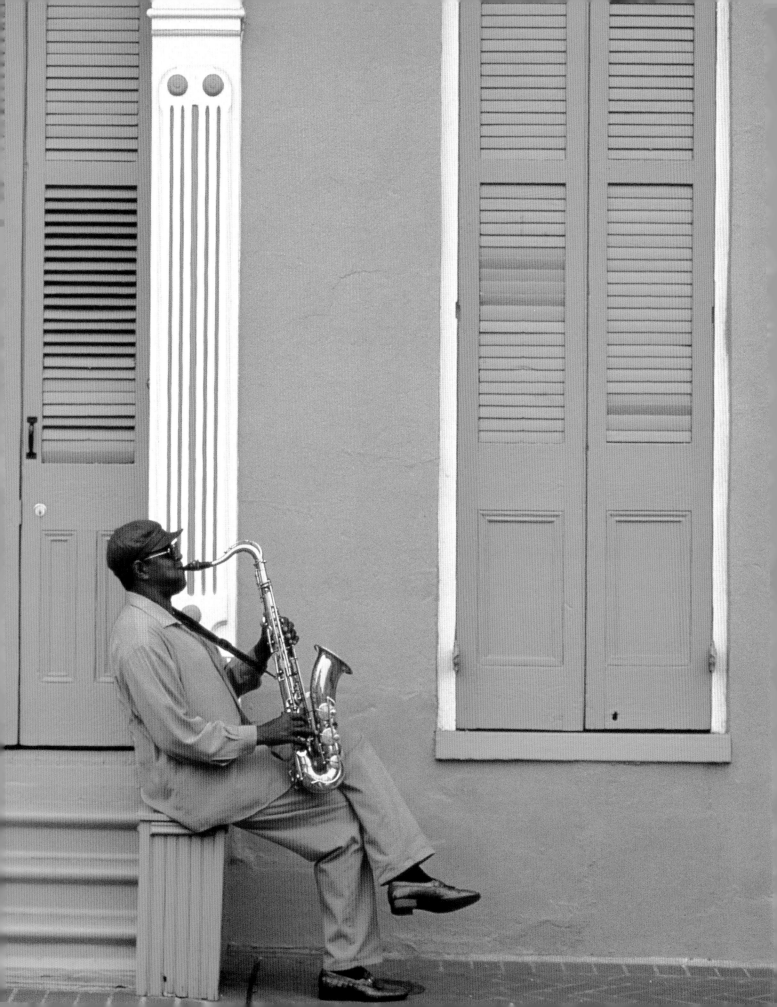

Introduction

"Though we travel the world over to find the beautiful, we must carry it with us or we find it not."

<div align="right">RALPH WALDO EMERSON</div>

EVERY PROFESSION has its FAQs, or frequently asked questions. Doctors are pumped for medical advice, lawyers are questioned on legal matters, and Wall Streeters are probed for hot stock tips. Travel photographers are no different. The question we're continually asked is, "What is your favorite place?"

This is an impossible question to answer. How can you rate the magical temple life of Bali against the riot of color and swirling masses of people in India? How can you give a better "mark" to the majestic beauty of the American Southwest than to the bucolic harmony of the landscape in Tuscany? And which is more beautiful, the incredible blues of the water in the Caribbean or the South Pacific?

I used to struggle with this "favorite place" question and never really could come up with a coherent reply, until I realized that I was approaching it all wrong. There is an answer to this question, and for anyone who is well and truly afflicted with wanderlust, it is obvious. My favorite place is always the *next* place—the place I haven't yet been.

Travel and photography have always been intertwined passions for me because still imagery first fueled my wanderlust. As a kid, I was a great fan of the Sherlock Holmes stories. Even though they are fiction, when those stories described Dr. Watson's military adventures in India or Holmes traveling through Tibet disguised as the Norwegian explorer Sigerson, I reached for the *National Geographic* to check out what those places looked like. (The *Geographic* was the baby boomers' version of the Internet, only with much better writing, editing, and photography!)

The pictures on those pages were galvanizing, much more than the moving images of television travelogues. I studied them until my eyes nearly burned holes in the pages. I wanted to be there with the photographers, to see what they were seeing and to experience what they were experiencing.

I caught New Orleans musician Rasheed Ahkbar in a relaxed moment while he was playing some tunes in the French Quarter. I liked what the open shade did to the blend of pastel colors.

Nikon F100, Nikon 80–200mm AF zoom lens,
Fujichrome Provia exposed for 1/125 sec. at f/2.8

Discovering Spirit of Place

I never really understood why those pictures grabbed me so profoundly until years later, when Susan Sontag, in her book *On Photography*, shed some light. "Photographs may be more memorable than moving images," Sontag explains, "because they are a neat slice of time, not a flow."

But these were not just random slices of time. They were moments, snatched from the chaotic stream, where everything came together in a harmonious fashion and made you really feel what it was like to be there. The talent of these photographers was to crystallize their travel experiences into visual epiphanies, or the moments of realization you have when you suddenly understand something previously unfathomed. Writer Lawrence Durrell called this quality the "spirit of place" in his essay "Landscape and Character."

Another word for that quality, the spirit of place, might be "beauty," but not necessarily in the conventional sense of the word. As Bill Jay observes in his book-length interview with Magnum photographer David Hurn, called *On Being a Photographer*, ". . . for many people, the word beauty is associated with the predictable . . . cliché images of sunsets, small furry animals . . . postcard views and so on. For me, most great photographs displaying beauty reveal a sensation of strangeness, not predictability. . . . They are the opposite of clichés; they have a quality beyond the visually obvious. But even if it is difficult to define, beauty still lurks behind the scenes. . . ."

If you're reading this, you are probably struck with the same desire I was when I studied the *Geographic*. You want to make beautiful photographs of the places you travel to. But the question is, "How?" Is there a method or procedure to help you achieve your goal? That's the aim of this book: to share with you a method that I've used to try to do the same thing.

The first step is to try to define the elements of a travel photograph that capture the spirit of place. Besides the ineffable quality of beauty, it seems to me that four defining characteristics are always present: interesting composition, great light, a sense of moment, and, depending on the medium—color or black-and-white—good color or a range of gray tones.

This doesn't sound like a particularly difficult combination to put together on film. But as David Hurn says in that same interview, "That is the driving, obsessional force behind photography, the fact that although the elements are simple to state they are extremely difficult to integrate. Aiming for your goal is worthwhile as long as you realize it is a constant effort, rarely to be achieved."

Don't I know it! I've spent the better part of my career trying to make pictures of people and places that exhibit all four of these characteristics, and I can't say that I've succeeded every time. Nevertheless, I keep trying, honing my reflexes, my timing, and my ability to see in the ever-present hope that it will all come together in the viewfinder.

The added wrinkle that makes travel photography so challenging is that it isn't just about making pictures. It requires you to immerse yourself in a foreign culture, to spend long stretches of time all alone, without your usual support network of family, friends, assistants, and colleagues. In order to be successful you must be able to function with a high level of "strangeness," overcoming language and cultural barriers to create insightful photographs of a place where you might not even be able to read a street sign or order a cup of coffee without a great deal of difficulty.

I've seen many accomplished photographers go off on a "soft" travel-photography assignment only to return nearly empty-handed because the rigors and uncertainties of travel logistics got the better of them. One friend, a superb location portrait photographer, went off to Russia for a tour-company brochure. This was his first big overseas travel assignment, and he swore that he wouldn't come back with the usual cliché photographs, that he would go beyond them.

Predictably, nothing went right. The weather was bad, the arrangements kept falling apart, and my friend was completely frustrated. "I couldn't even make a good cliché shot, let alone go beyond one," he confessed. "It was incredibly draining." He discovered something that I've known for years: professional travel photography, like most things in life, is nowhere near as easy as it looks!

Of course, if you peruse some of the travel publications out there today, you couldn't be blamed for thinking otherwise. Many of them look as though they've been put together with amateur snapshots—soft, little, or no focus; dull or washed-out light; feet and hands thrust into the foreground of otherwise decent pictures; full-page pictures of a wineglass, the inside of a beach umbrella, or some other inane detail; and the requisite pouting model lolling about in tousled bedsheets, looking ever so bored.

These amazing, deep green tea terraces capture the essence of peninsular Malaysia. I made this shot in the Cameron Highlands on a rainy day while on assignment for Travel Holiday *magazine.*

Nikon 8008s, Nikon 80–200mm AF zoom lens, Fujichrome Velvia exposed for 1/125 sec. at *f*/2.8

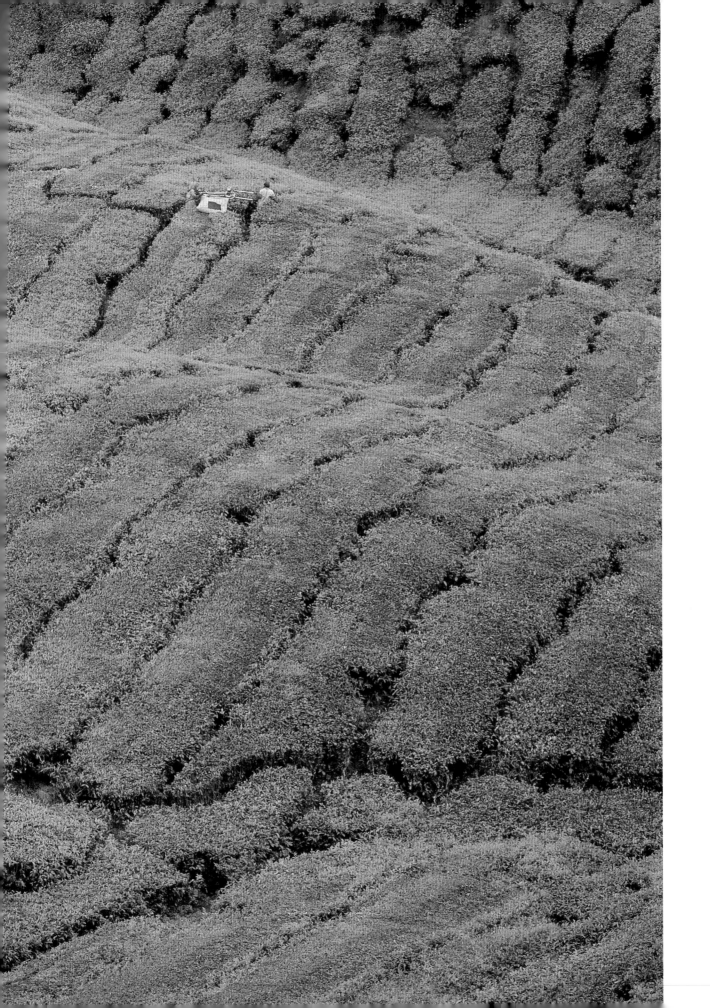

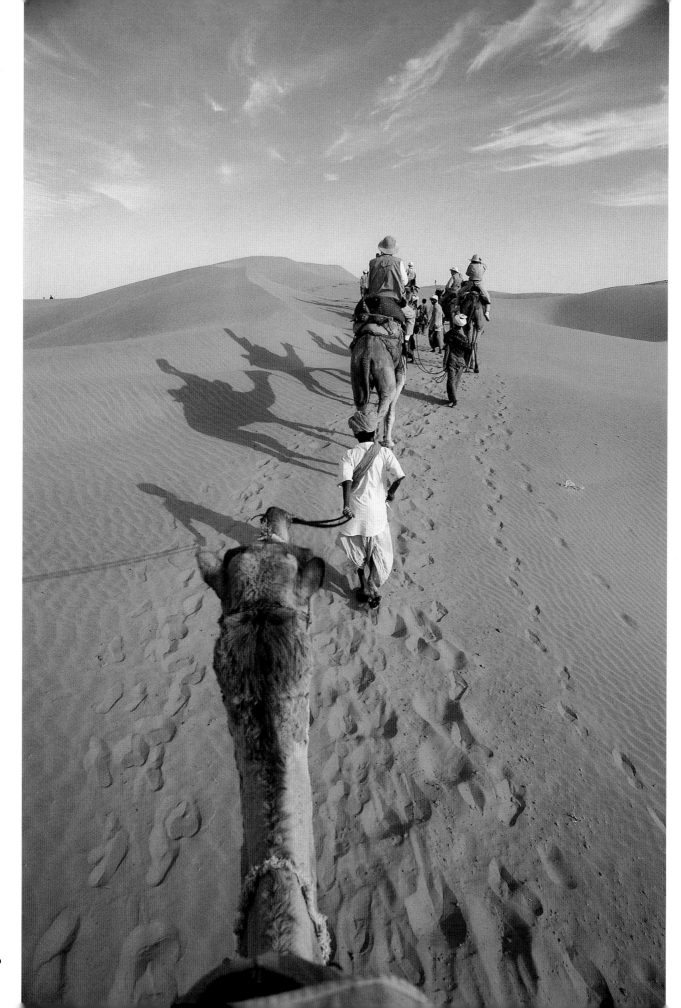

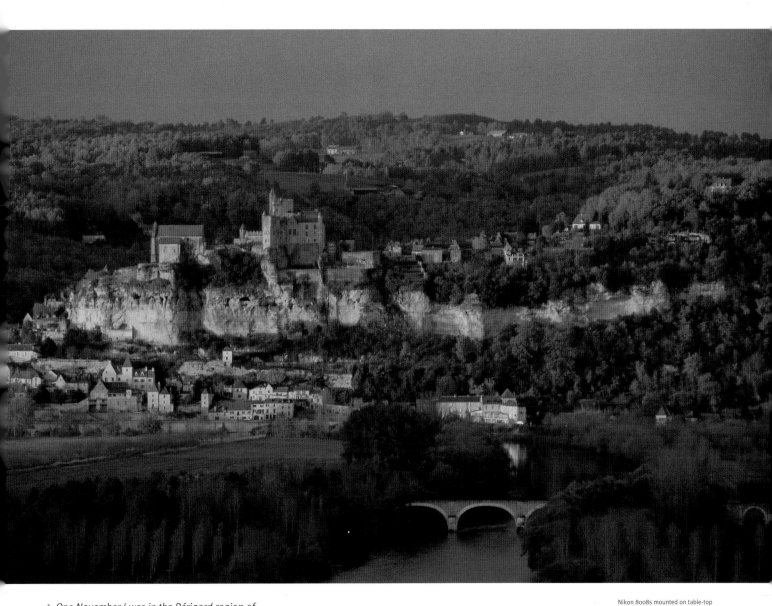

▲ One November I was in the Périgord region of France shooting a story about truffles for Polo magazine. The weather was dicey, but the landscapes were beautiful. Here the sun popped out for a few minutes at the end of an otherwise rainy day, and I used a long lens to concentrate on the castle town of Beynac from a nearby hillside.

Nikon 8008s mounted on table-top tripod, Nikon 80–200mm AF zoom lens, Ektachrome 200 exposed for 1/30 sec. at f/2.8

◀ For a story about Rajasthan for Travel & Leisure magazine, I took a short camel safari across the Thar Desert. I wanted a photograph that captured the feel of the experience and shot this image from the rider's point of view.

Nikon 8008s, Nikon 20–35mm AF zoom lens, Fujichrome Velvia exposed for 1/125 sec. at f5.6

These layouts have much less to do with the place they're purported to show and far more to do with the aesthetics of Manhattan-based editors and art directors, a surprising number of whom rarely venture west of the Hudson River or east of the Hamptons. These slick, "cutting edge" photographs depict travel as fashion and interiors rather than as a cultural encounter.

One such publication recently featured a horrendously overexposed shot of the beautiful island of Bora Bora on its cover. The sky was featureless and white, the foliage and water barely discernible, a real washout. The pictures inside were more of the same: people-less landscapes that can only be described as "cold" at best.

On the contributors' page, the fashion photographer who shot the pictures boasted that he had "never been to the tropics" (as if we couldn't tell that already!), that he was "the only one on the island dressed all in black," and that everyone stared at him. Here he was in one of the world's most gorgeous spots and welcoming cultures, and when asked to make a comment about the experience, all he could talk about was what he was wearing.

Unfortunately, this emphasis on "Me" is rampant in photography today. It is the reason that much of what is passed off as travel photography is not about the place at all. It is about the photographers and their alleged "personal vision." I can't help but agree with Bill Jay when he says, "Most photographers would do the world a favor by diminishing, not augmenting, the role of self, and as much as possible, emphasizing subject alone."

If a photographer's vision is particularly unique or informed, I want to see it. But if it isn't, just show me what the place and the people look like in well-executed, storytelling pictures. Far too many photographers out there are laboring under the false assumption that their personal vision is worth sharing. In too many cases, this assumption is used to cover up a lack of craft.

David Hurn sums up this situation beautifully: "If the images are not rooted in 'the thing itself,' to use Edward Weston's term, then the photographer has not learned anything about the real world. He/she can only justify the images by reference to self: 'This is how I felt.' . . . there can never be any objective benchmarks against which to measure the success or failure of these images. If a person says: 'This is how I feel,' you cannot respond: 'No, you do not feel that way.'. . . the results are often banal, superficial images created and defended in the name of 'personal vision'."

Am I saying that there is no room for "personal vision" in most travel photography? Certainly not. When I see a story on a familiar place done by a photographer like Bob Sacha, Jim Richardson, James Stanfield, Ian Lloyd, or Macduff Everton, I am literally blown away at what these photographers saw that I didn't. Yet no matter how unique their vision, one thing shines through: the spirit of place. In each and every case with photographers of this caliber, the people and the place are clearly the center-ring attraction. There are no gratuitous technical affectations, no gimmicky techniques that overshadow the essence of the location, no schtick that calls out, "Look at me. I'm so sensitive and talented that you don't even know why I'm good!"

In essence, travel photographers are like skillful character actors. A large part of their job is to make the star look good without calling undue attention to their own efforts. But what about your "personal vision"? Well, you don't worry about it because, let's face it, the very act of framing a photograph in a camera's viewfinder is an exercise in personal vision. If you make photographs, you are in fact expressing a "personal" vision.

Rather than worrying about whether your vision is personal, you should make sure that it is sensitive, informed, and well crafted. As a traveler—not a tourist!—you owe that to the culture you're visiting, to the people who will look at your photographs, and, finally, to yourself. The fashion photographer in Bora Bora behaved like an arrogant tourist, not a curious traveler, and his pictures reflected that mind-set.

Everyone would be wise to realize that traveling with a camera is no longer quite as simple a proposition as it once was. Tourism has become a major industry, and like many a major industry it threatens to destroy the very resource that it lives by. In many ways, we travel photographers have contributed to this juggernaut and all its trappings. We are no longer adventurous messengers bringing back images of the strange and wondrous world to a largely naive audience. Like it or not, the world has grown up, gotten smaller, and become more jaded.

On the other hand, with the alarmingly high percentage of American high-school and college students unable to locate Mexico and Canada on a map, there is an argument to be made that much still needs to be done, in the words of the National Geographic Society credo, "for the increase and diffusion of geographic knowledge." One of the best ways to do this is for people to share the excitement of travel through their evocative imagery.

My friend Jim Richardson, a *National Geographic* photojournalist, likes to make the distinction between being a "traveler" and a "sightseer." According to Jim, a traveler seeks engagements with the local people and culture, while a sightseer just clicks off sights in the guidebook, a "been there, done that" mentality. A sightseeing photographer stands apart from the culture and "steals" pictures from a distance, while a travel photographer becomes involved with his or her surroundings and the people, and the resulting pictures become more intimate. While you might have started reading this book as a "sightseeing" photographer, it is my profound hope that by the time you finish it, you'll be a travel photographer in the very best sense of the word.

How to Use This Book

In my early days as a newspaper photographer, Al Paglione, a veteran staff photographer from a much bigger, better paper, took me under his wing and showed me the ropes. He taught me how to function on the rough-and-tumble streets of Jersey City, Hoboken, Bayonne, and Newark—the "garden" spots of deepest New Jersey that made up the core of our newspapers' circulation area.

On my days off, I rode with him and watched the way he handled the cops, criminals, politicians, street people, nuns, junkies, kids, and animals he came across during the course of his assignments. I got an invaluable photographic and life education that no school could ever duplicate. One of my mentor's favorite expressions was that there was really nothing to getting good news photographs; it was just a matter of "$f/8$ and be there."

I didn't know at the time that "$f/8$ and be there" is a common saw among newspaper photographers. I was just bowled over by the simple profundity of the statement. And I still am, because the same can be said of great travel photographs: It's all just a matter of "$f/8$ and be there."

Most photographers tend to obsess about the "$f/8$" portion of that equation. That is to say, we concentrate on the technique-and-equipment part of photography. As my family and colleagues will attest, no one is more enamored with the gadgetry of photography than I am. Despite my "gearhead" tendencies, I still recognize that the really important part of travel photography is not the "$f/8$" part, or the gear-and-technique part. It's learning how to "be there"; how to put yourself in the right place at the right time to photograph those magic moments that capture the spirit of place.

This book addresses both parts of the "$f/8$ and be there" conundrum. Plenty of how-to books deal extensively with the "$f/8$" aspects of photography—the straight technique. This is not one of them. Rather, it is a personal approach to travel photography and, therefore, is not intended to be a photography textbook. Nevertheless, I deal with some basics of the craft: composition, light, lens choice, equipment, etc. If you have a good grounding in these matters, you can skim these sections. Interspersed with these basic pointers is the really choice advice on, well, on how to "be there," whether that place is Bhutan or Bayonne, New Jersey.

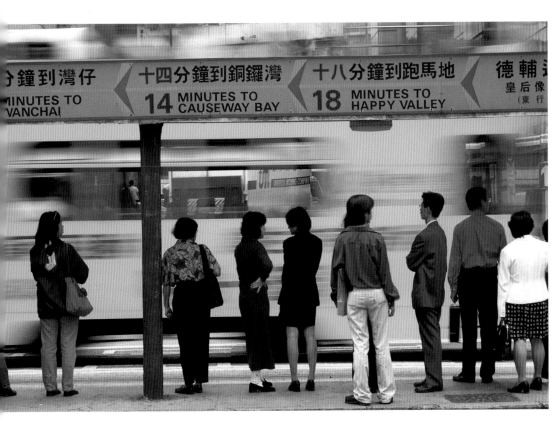

Hong Kong moves at a frenetic pace. To capture the sense of this movement, I chose a slow shutter speed. I wanted to blur the trams as they whizzed by the momentarily stationary pedestrians.

Nikon F100 mounted on tripod, Nikon 80-200mm AF zoom lens, Fujichrome Provia exposed for 1/8 sec. at $f/11$

13

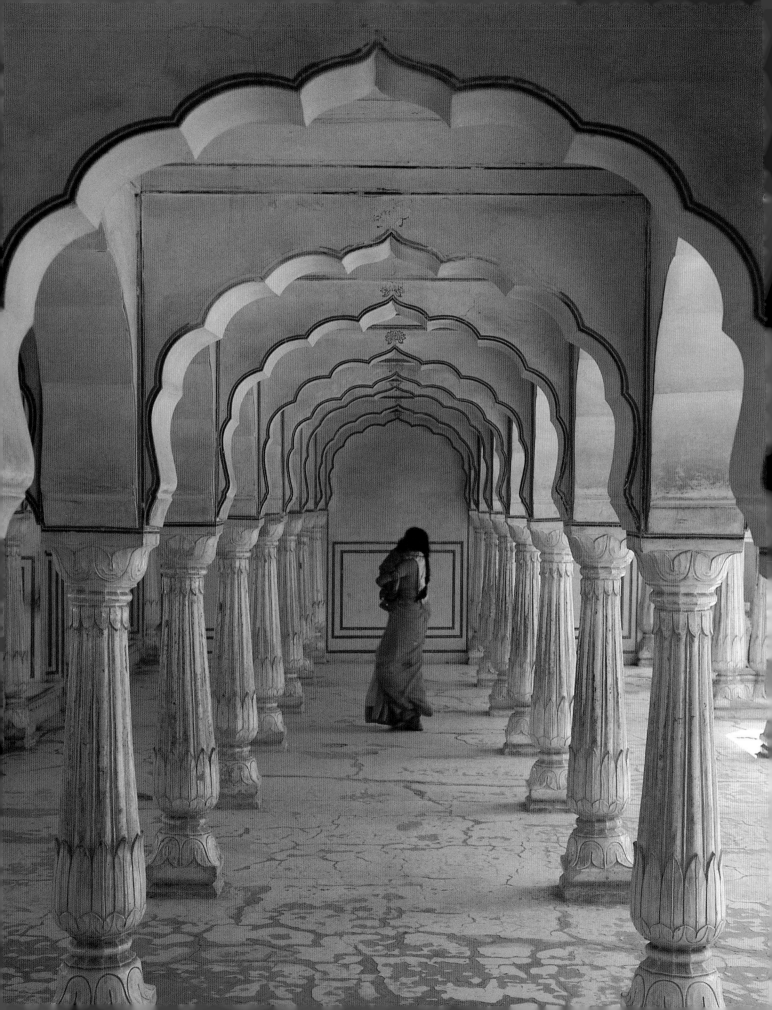

Windows on the World

"It is a pity indeed to travel and not get this essential sense of landscape values. You do not need a sixth sense for it . . . you will hear the whispered message, for all landscapes ask the same question in the same whisper. 'I am watching you—are you watching yourself in me?'"

LAWRENCE DURRELL

LONG BEFORE construction began on the information superhighway, travelers eagerly shared their experiences with the folks back home, using the media of the day—first journals and letters, then drawings, paintings, and lithographs. Photography, though, quickly proved to be the soulmate of travel, a technology that flung windows on the world wide open. For the first time, evocative—and sometimes provocative—images reproduced the travelers' experience with extraordinary emotion and immediacy.

Then as now, however, the desire to show all can be a powerful deterrent to good photography. The most compelling pictures eliminate extraneous information in order to tell a story in simple, graphic images. Rather than as a painter trying to fill a huge canvas, think of yourself as a sculptor shaping a formless mass until a work of art emerges.

Admittedly, trying to find your photographic David in a chunk of raw visual material is difficult. One reason is that the camera is objective: it sees only what is in the viewfinder. Photographers, however, are subjective: we see what we want to see in the viewfinder and ignore distracting foregrounds, jarring backgrounds, and other unsightly details. This "psychological cropping" explains why pictures often don't seem as good as we remember they did when we took them.

But by combining the intelligent application of a few basic principles of composition with a knowledge of the properties of camera lenses, you'll be surprised at how soon you'll be capturing the beauty and excitement of the world through the window of your own viewfinder.

The repeating pattern of archways made an interesting frame in this chamber of the Amber Fort in Rajasthan, India. I was shooting a story about a train trip across the region for Travel/Holiday *magazine and simply had to wait until someone interesting, in this case, a mother and child, walked through the composition.*

Nikon 8008s, Angenieux 28–70mm AF zoom lens, Fujichrome 100 exposed for 1/60 sec. at f/4

A Gift to Be Simple

Clutter spoils more pictures than any other compositional flaw. To avoid this problem, ask yourself two questions before you press the shutter: "Why am I taking this picture?" and "What do I want to show?" If you find yourself listing four, five, or more elements you want to highlight in a composition, you're probably trying to do too much in one picture. Until you become more experienced, give each picture only one center of interest. Scan the edges of the frame to ensure that no unwanted elements lurk there. To eliminate unnecessary details, crop your composition more and more tightly until something seems to be *missing*. Remember the advice of photojournalist Robert Capa: "If you don't like your pictures, move closer."

Amateur photographers often zero in on a single center of interest, then negate it with a chaotic background. Unless you're rooted to one spot, such as in a theater or some other crowded venue, you always have a choice of backgrounds. Sometimes moving just a few feet to the left or right, or up or down, dramatically improves the presentation of your primary subject matter.

In portraits, a background can make or break a photograph. If the background doesn't unobtrusively showcase a subject and provide additional information, then it merely distracts. Backgrounds are so important for "street shooting" that I'll often find them *first* and then wait for something to happen or for someone to walk into the frame.

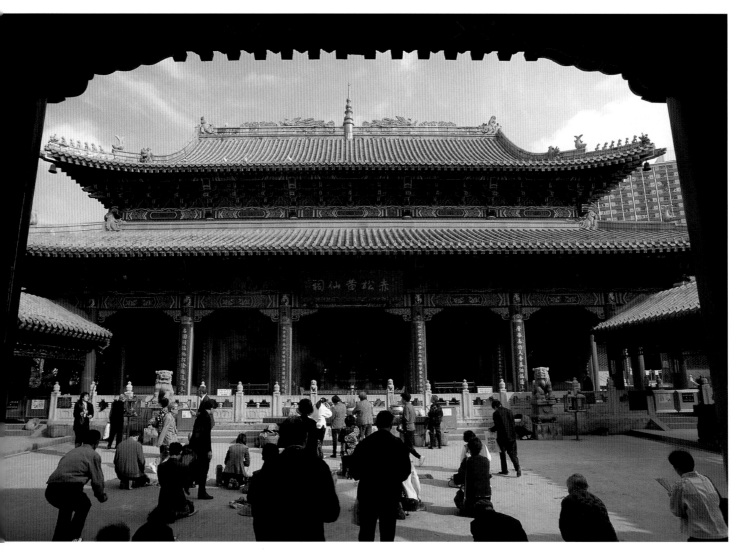

The entrance gate to China's Wong Tai Sin Temple in Hong Kong proved to be an excellent framing device; it gave this image a sense of depth and three dimensions. I made this shot while on assignment for the Hong Kong Convention and Visitors Bureau.

Nikon 8008s, Nikon 20–35mm AF zoom lens, Fujichrome Velvia exposed for 1/125 sec. at *f*/8

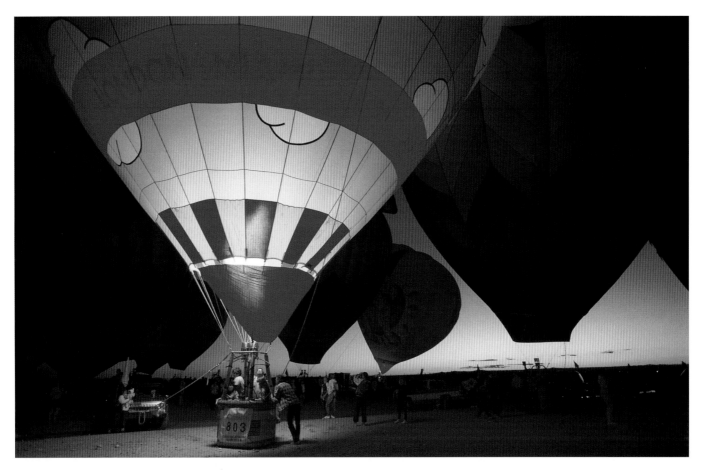

The famous annual balloon festival held in Albuquerque, New Mexico, is full of picturesque scenes. At night the balloonists do "light ups," during which entire groups of balloons have their gas supplies turned up full. When this participant fired his balloon's gas tank, he created an eerie glow in the twilight.

Nikon 8oo8s mounted on tripod, Nikon 20–35mm AF zoom lens, Kodachrome 200 exposed for 1/8 sec. at f/4

Composition 101

Keeping it simple is the first step toward taking better travel photographs. Following a few other elementary compositional guidelines will enable you to produce even more compelling images. Many rules of composition were developed by early pictorialist photographers, who borrowed Renaissance-painting concepts about the balance of the parts in relationship to the whole, to help them maximize the potential of their new art form. Remember, these "rules" are guidelines, not commandments. When you gain enough experience, you'll discover that you can sometimes break them for startling effect.

THE GOLDEN RULE
The first rule: Keep your center of interest out of the center of the frame. Don't fall prey to bull's-eye vision, through which the subject is stuck in the middle of the viewfinder just because focusing

devices—microprism, split-image, and autofocus brackets—are there. The pictorialists determined that the most pleasing compositions resulted when the picture area was divided into one-third to two-third sections vertically, horizontally, or both. If you divide your viewfinder into thirds horizontally and vertically, the four points where those lines intersect are the strongest areas in which to place your center of interest. This *Rule of Thirds* works for environmental portraiture, as well as for landscapes.

A corollary to the Rule of Thirds: Keep the horizon out of the center of the frame. The balance created by dividing the frame into two equal parts creates a visual stasis, and the resulting lack of tension makes for dull pictures. When the horizon line is in the lower third of the frame, the sky is emphasized, giving the picture a feeling of space. When the horizon line is in the upper third of the frame, the foreground is emphasized.

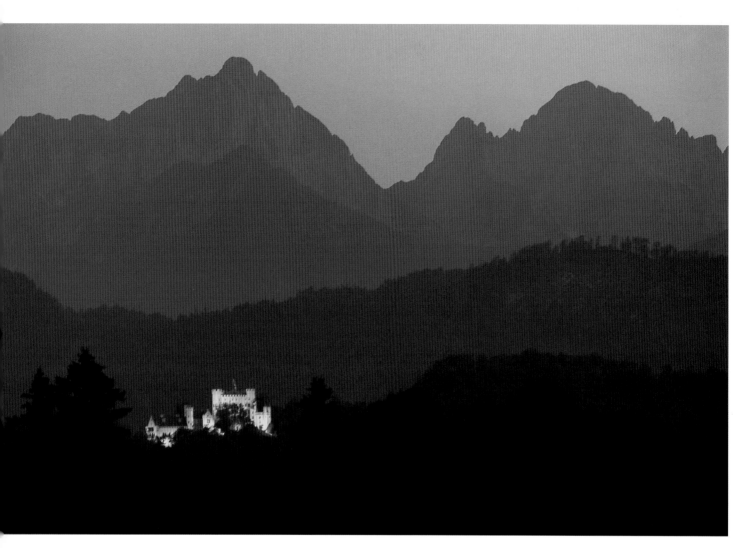

Several compositional elements are at work in this shot of Hohenschwangau Castle in Bavaria, which I photographed from a parking lot about a mile away while on assignment for Travel/Holiday *magazine. The long lens compressed the rows of mountains and the castle into a pleasing arrangement, and the placement of the lighted castle off center according to the Rule of Thirds created tension. The magic twilight added the finishing touch.*

Nikon 8008s mounted on tripod, Nikon 80–200mm AF zoom lens, Fujichrome Velvia exposed for 1 sec. at f/4

REMEMBER YOUR LINES

The pictorialists had strong opinions about the power of fore-grounds. Most of these ideas evolved out of an attempt to lead the viewer's eye into the photograph. The use of *leading lines*, which can be found in almost any composition, is one of the easiest ways to do this. Train tracks, fences, walls, roads, rows of buildings, and mountains can all be put into service as leading lines. They are especially effective when they enter and cross the frame on a diagonal. Curved lines also lead the eye into the frame, especially the graceful *S-curve* of a shoreline or a winding road. S-curves are much harder to find than straight leading lines, but when you find one, the resulting photograph can be very strong.

A MATTER OF SCALE

Another useful compositional guideline for travel photography is the concept of scale. How many times have you photographed mountains only to have them come back from the developer look-ing like molehills? The problem is usually a lack of scale, which filmmakers use to their advantage in order to make model trains,

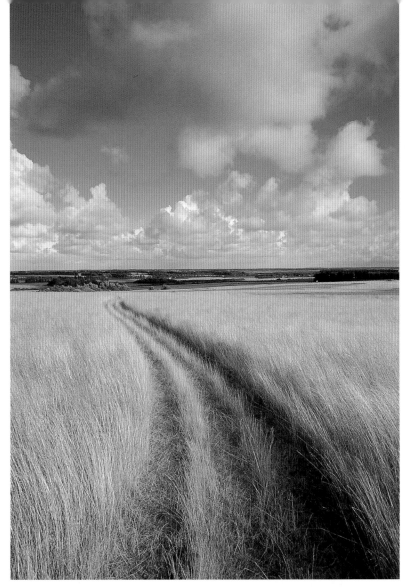

The remnants of a road through a field in Jutland, Denmark, made a very effective leading line for this landscape photograph, which I shot while on assignment for National Geographic Traveler.

Nikon 8008s, Nikon 20–35mm AF lens,
Fujichrome Velvia exposed for 1/125 sec. at f/5.6

Shooting in California's Death Valley National Park, I used a panoramic camera to capitalize on the leading lines of the dune edges.

Hasselblad Xpan, Hasselblad 45mm lens,
Fujichrome Velvia exposed for 1/125 sec. at f/5.6

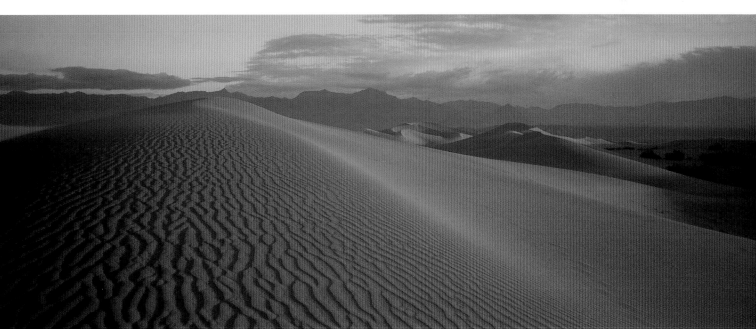

▷ *Sark, in England's Channel Islands, is lost in time. No cars are allowed on the island; the only vehicles you see are a few tractors belonging to farmers. This bridge, called La Coupe, connects two parts of the island. I shot from overhead to make the most of the S-curve of the bridge and waited until a horse cart came across to add a sense of moment.*

Nikon 8008s, Nikon 20–35mm AF zoom lens, Fujichrome Velvia exposed for 1/125 sec. at f/4

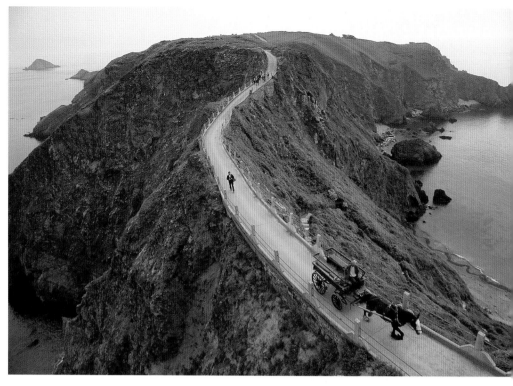

▽ *A hotly contested election was going on in Valletta, Malta, when I was doing coverage for a* National Geographic *story, and these mass political gatherings were common. To get an idea of the size of the crowd, I climbed a scaffolding erected by the Malta television network behind the speakers' platform. The high angle and the leading lines of my wide-angle lens helped to create a dramatic composition.*

Nikon FE2, Nikon 20mm lens, Kodachrome 200 exposed for 1/15 sec. at f/2.8

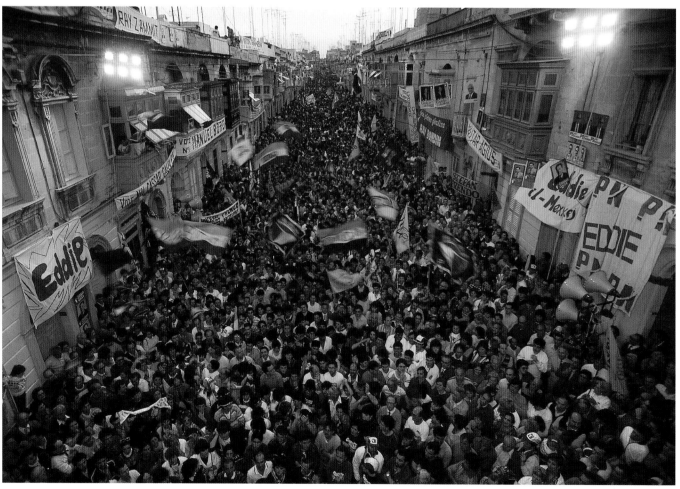

planes, and spacecraft look like the real thing. To give a picture a sense of scale, you must include something of a known size—a person, an animal, or a vehicle—to act as a visual reference. Otherwise, there is no way for viewers to know whether the mountains in your photograph are 60 or 6,000 feet high.

If these rules of composition sound daunting, take heart. They become instinctual after a while. And many of these compositional guidelines fall into place naturally when you are ready to go beyond your basic lens and begin to explore the magical properties of wide-angle and telephoto lenses.

THROUGH THE LOOKING GLASS
I'll never forget the first time I looked through wide-angle and telephoto lenses. As a fledgling photographer in college, I'd been shooting with a standard 50mm lens for about six months. Then my roommate bought a 28mm wide-angle lens and a 180mm telephoto lens. When I looked through them, I couldn't believe it. Here was a whole new perspective on the world. I was seeing images that I'd never seen through the 50mm lens, and I knew immediately that I had to get some long and wide-angle glass for myself. This happened more than 25 years ago, but I still get a thrill when I first put a new optic (lens) on my camera and take a look.

Don't get the wrong idea: the photographer, not the lens, makes the picture. As is usually the case, tools are only as good as the person using them. But unlike, say, mastering a set of woodworking tools, learning the basics of specialty lenses can rapidly improve your final product—your photographs.

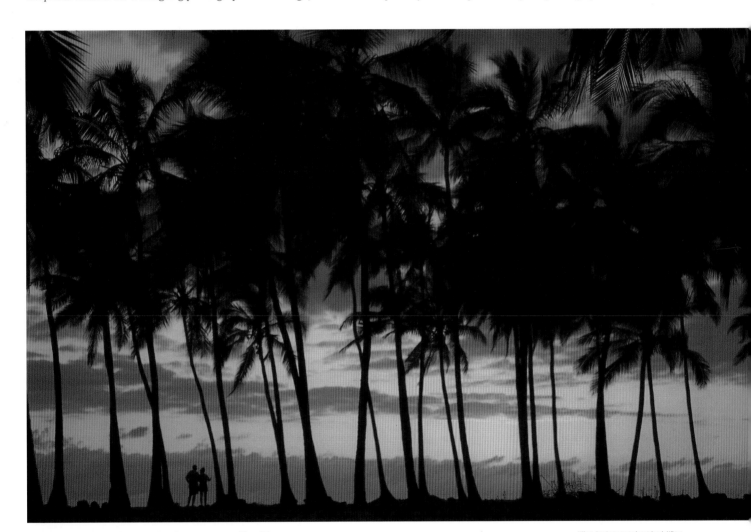

It is hard to resist a classic tropical sunset scene like this one, complete with palm trees, which I photographed at the Place of Refuge on the big island of Hawaii. The couple enjoying the sunset added the element of scale.

Nikon 8008s mounted on tripod, Nikon 80–200mm AF zoom lens, 85C warming filter, Fujichrome Velvia exposed for 1/15 sec. at f/4

Telephoto Lenses

A telephoto lens, usually a telephoto zoom lens, is the most popular accessory lens. Its image magnification alone justifies its purchase. But this lens has many other assets that make it incredibly versatile for shooting everything from landscapes to closeups.

One property of the telephoto lens that I exploit is the optic's *apparent perspective compression*, which simply means that in addition to making a scene appear closer to viewers, a telephoto makes the elements in the scene appear closer to each other. Once, while shooting in Iceland, I parked a Jeep several hundred feet in front of a waterfall in order to achieve a sense of scale. But thanks to the use of a telephoto lens, the vehicle looks as though it is right beside the cataract. You can also use the optic's compressed perspective to organize or stack elements of a scene into more graphically pleasing images. A stately colonnade, for example, can be crowded into a tight pattern when in reality the columns might be separated by 20 feet.

A telephoto lens is also a superb tool for landscape photography. The lens' optical properties help make mountains and skyscrapers loom large in the frame, creating exciting images unseen by the unaided eye and a standard lens. Magazine columnist George Lepp aptly calls this type of telephoto landscape photography "image extraction" because the lens' narrow field of view and compressed perspective are used to "extract" images out of a larger scene. Using a telephoto in this way takes practice, but the payoff can be pictures that other photographers miss.

One of the most common compositions that you can extract out of a broad scene with your telephoto lens is a *pattern shot*. Unlike a picture with one strong center of interest, a pattern shot has repeating centers of interest that form an engaging pattern rather than a mass of conflicting subjects. Patterns occur everywhere in natural and manmade environments: a cluster of beach umbrellas, a splash of autumn leaves, a mosaic of colorful flags in a stadium crowd. You can use a telephoto lens to pick out the pat-

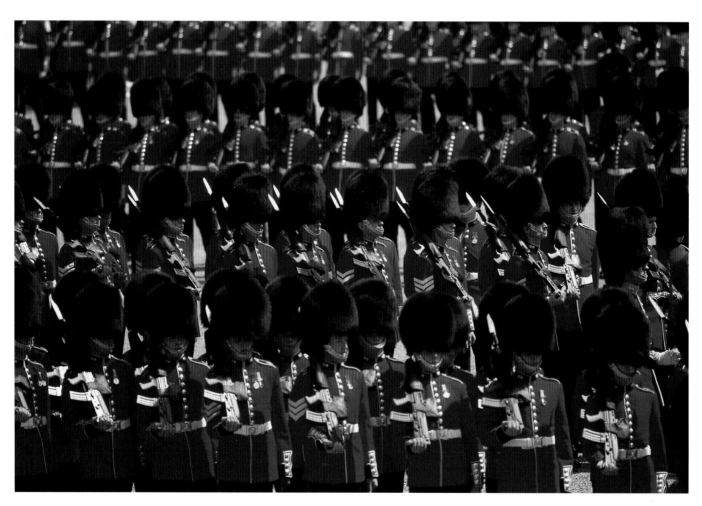

The "Trooping the Color" ceremony in London is held every year to celebrate the Queen's birthday. The perspective compression of my 300mm telephoto lens helped to stack the rows of guards together in this graphic composition.

Nikon 8008s mounted on monopod, Nikon 300mm AF lens, Fujichrome 100 exposed for 1/250 sec. at f/5.6

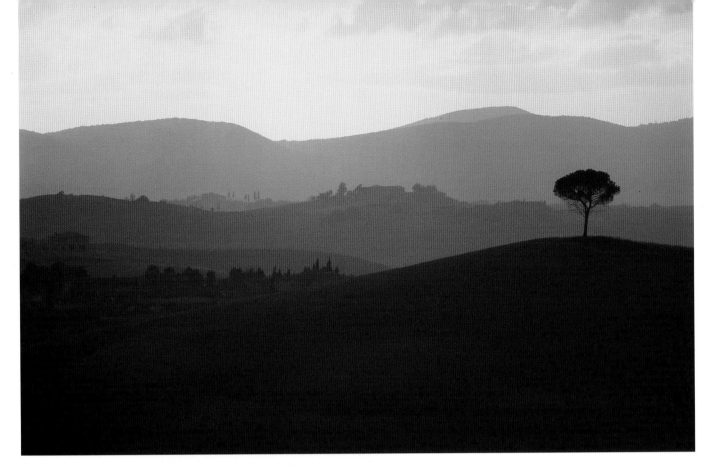

I "extracted" this composition out of a broader scene in the hills south of Siena in Tuscany using a 300mm lens. The perspective compression of the long optic stacked the hillsides, and the backlight gave the scene a nice moody warmth.

Nikon 8008s mounted on tripod, Nikon 300mm AF lens, 85C warming filter, Fujichrome Provia exposed for 1/125 sec. at f/4

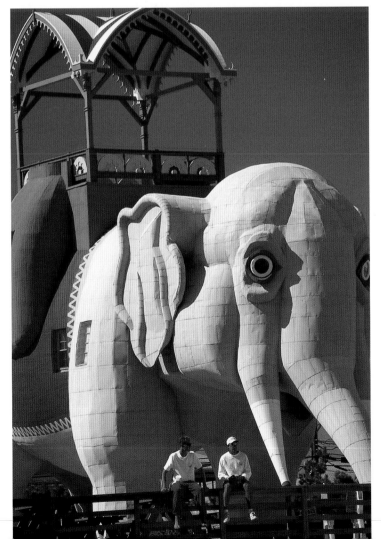

While shooting a story on the barrier islands along the Jersey shore for Islands magazine, I visited Lucy the Margate Elephant, a strange structure on the National Register of Historic Places. When I noticed these lifeguards taking their break, I decided to use a long lens in order to compress the distance between them and Lucy. The result: the elephant looks as if it were looming right behind the lifeguards.

Nikon 8008s, Nikon 80–200mm AF zoom lens, B+W circular warming polarizer, Fujichrome Velvia exposed for 1/125 sec. at f/4

23

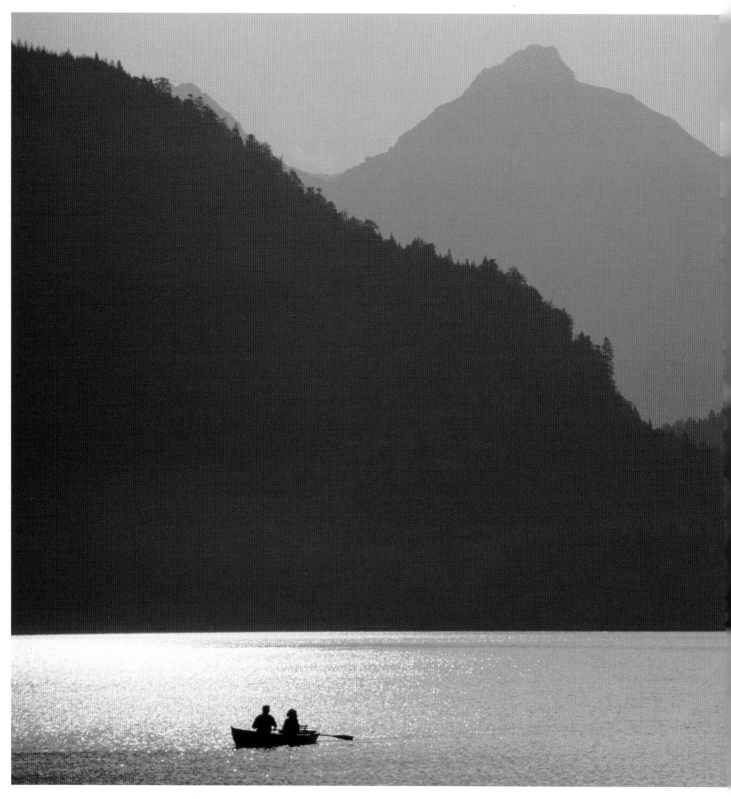

This shot of the Alpsee River in Schwangau, Germany, is another example of a long lens "extracting" a photograph out of a broad scene. The backlight simplified the composition, while the long lens helped to stack the mountains and made the boaters, who provide the element of scale, seem much closer to the mountains than they actually were.

tern from the surrounding chaos and present it in a clean, punchy composition.

Another useful property of the telephoto lens is its limited *depth of field*, which is the depth of focus in a scene. When you use lenses at wide-open apertures, such as *f*/2, *f*/2.8, and *f*/4, the depth of field is much shallower than when your lenses are *stopped down* to smaller apertures, such as *f*/11, *f*/16, and *f*/22. The telephoto's extremely shallow depth of field at wide apertures can be particularly useful in softening otherwise distracting backgrounds.

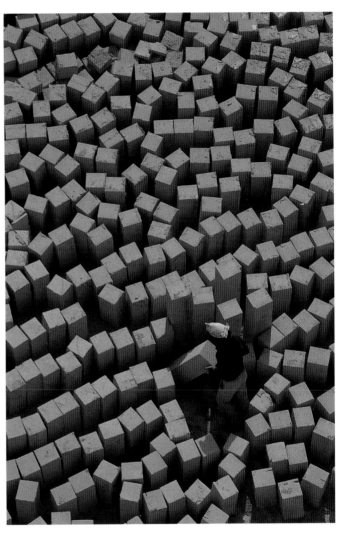

The only natural resource in Malta, these sandstone blocks are called "the building blocks of Malta" and have been used for centuries in building construction on the island. Covering the area for National Geographic, *I used a long lens to isolate a pattern shot of this worker surrounded by the cut stone.*

Nikon FE2, Nikon 180mm ED lens, Kodachrome 64 exposed for 1/250 sec. at *f*/5.6

Nikon 8008s, Nikon 80–200mm AF zoom lens, 85C warming filter, Fujichrome Provia exposed for 1/500 sec. at *f*/4

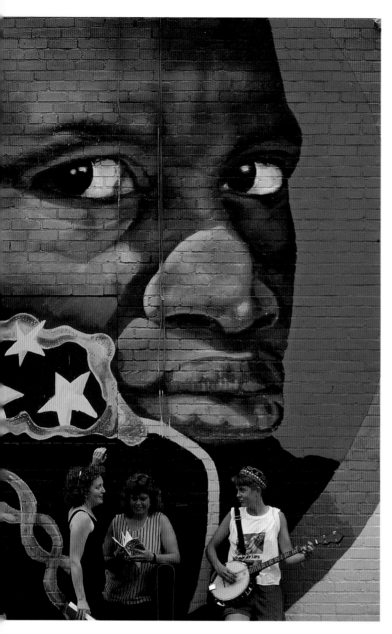

For the Insight Guide to Atlanta *I was photographing in the funky Little Five Points area in town. I was struck by the amazing mural of Paul Robeson as the Emperor Jones and waited until some denizens of the neighborhood sauntered into the frame to finish the composition.*

Nikon 8008s, Angenieux 28–70mm zoom lens,
Fujichrome Velvia exposed for 1/125 sec. at f/4

Wide-Angle Lenses

The wide-angle lens is the least-used optic in the amateur photographer's equipment. Most people haul a wide-angle lens out of their camera bag for one purpose: to fit something into a picture when they have no more room to back away. In skilled hands, however, this lens is a powerful visual tool. I rely heavily on my wide-angle lens to give my photographs a sense of place. In fact, a 20–35mm wide-angle zoom lens, which covers the entire wide-angle range, is one of the most-used optics in my camera bag.

The key to wide-angle success is to remember that the lens' *expanded perspective* (as opposed to the telephoto lens' compressed perspective) gives compositions a broad foreground that you must utilize in a compelling way in order for your photographs to work. Here are a few ways to do this.

Wide-angle lenses are well designed for exploiting the leading lines discussed earlier in this chapter. Put fences, roadways, railroad tracks, or shorelines in the foreground of a wide-angle composition, preferably on a diagonal. The resulting picture will lead the viewer's eye into an image with a depth and dynamism that you can't achieve by using longer lenses.

Wide-angle lenses also give a feeling of depth and three dimensions when used with *foreground frames*. These elements, such as windows, doorways, branches, railings, and balconies, provide natural-looking borders for the main subject in carefully arranged compositions. You can also generate foreground interest by including a pattern of fallen leaves in an autumn landscape, the bow of a boat in a beach scene, or a bed of flowers in an architectural shot. Once you establish foreground interest, try turning the camera vertically to emphasize the foreground even more; this will give additional punch to your photograph.

Remember that even with the wide-angle lens' extreme depth of field, you'll need to use as small an aperture as possible to keep both the foreground and background in focus. The soft-focus backgrounds that look so good in telephoto compositions are merely annoying in wide-angle photographs, which rely on foreground-to-background sharpness to achieve their impact.

The wide-angle lens' ability to relate foreground to background makes it very useful for environmental portraiture, which shows both the subject and its surroundings. Ideally, these surroundings reveal something about the subject's character. In a marketplace, for example, you might frame a fruit vendor with her wares, making sure to include bright, colorful produce in the foreground. And you might photograph a woodcarver with his tools and woodshavings strewn on a bench in the foreground.

Once you train your eye to look for these compositional elements and gain experience with specialty lenses, you'll find yourself looking through new windows on the world. Soon, the photographs you make will be as dramatic, compelling, and entertaining as the scenes you saw on your travels.

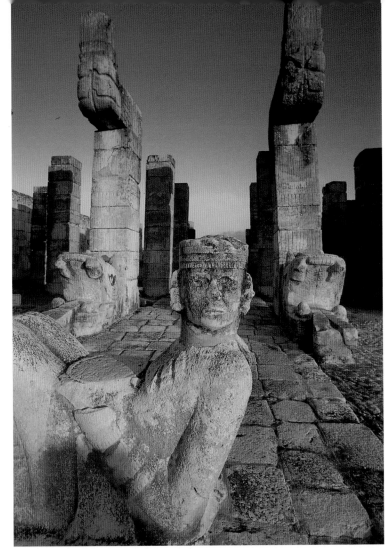

When you work with wide-angle lenses, it is important to fill the foreground. Here, I used the statue of Chac-Mool on top of the Temple of Warriors as a foreground anchor. I made this shot in the last rays of the setting sun in Chichen Itza, Mexico.

Nikon 8008s, Nikon 20–35mm AF zoom lens, Fujichrome Velvia exposed for 1/60 sec. at f/4

The branches of a live oak tree provided a frame for this wide-angle composition of historic Drayton Hall outside Charleston, South Carolina. A vertical version of this shot ran as a full page in Travel/Holiday magazine, which I'd shot the story for.

Nikon 8008s, Nikon 20–35mm AF zoom lens, Fujichrome Velvia exposed for 1/125 sec. at f/8

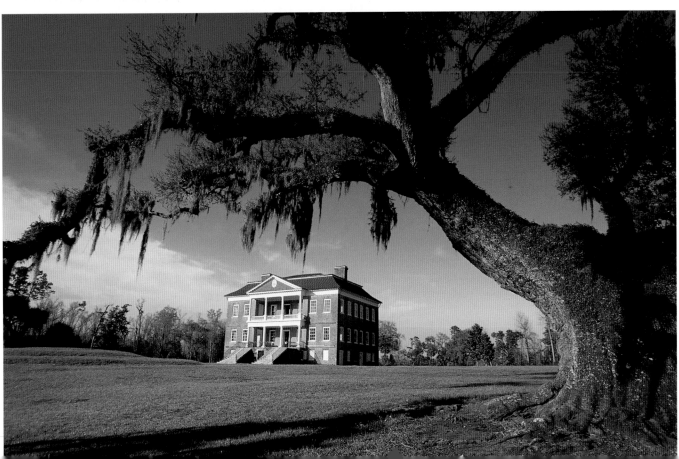

The "Grammar" of a Photo Story

At one point, you'll want to share your travel pictures, either in the form of a slide show, a print display, or even in the pages of a book or magazine. While you can build these displays around a single theme or subject, i.e., "The Faces of China" or "Churches of Rome," more often than not, you'll be trying to convey an overall feeling of the place you've photographed, rather than just a single theme, in a visual story.

There is a very definite structure to visual storytelling, and it is quite familiar. You see it every day on television and in the movies. These are both essentially visual storytelling mediums, and they use the same techniques to weave their yarns. As still photographers, we can learn a lot from these mediums. They use different types of shots, from overalls to closeups, to establish a narrative. The next time you watch your favorite television drama, try turning off the sound and just watching the mix of shots. Here is a rundown of what you'll see. These same types of shots are useful to keep in mind when you cover a place with a still camera.

- Establishing shot—Wide-angle overview shot that sets the scene. This is often an aerial or another high-angle shot that really gives a good idea of the setting.

- Medium shot—Usually a closer-up view than the establishing shot. Street scenes, for example, are shot with standard or slight-telephoto lenses.

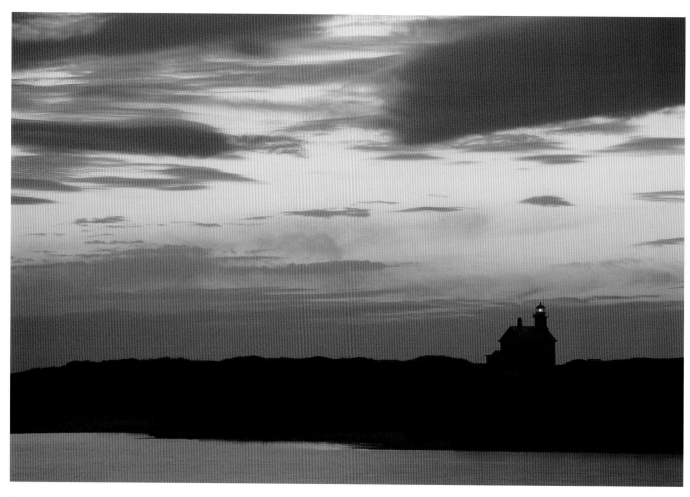

A storm was clearing at sunset and provided this very colorful dramatic sky behind the historic North Lighthouse on Block Island. I used an 85C filter to intensify the warm color. I zoomed out to fill the frame with mostly sky and to place the lighthouse in one of the Rule of Thirds intersecting spaces. I had to wait until the rotating beam faced me to make the exposure so that the lighthouse's light would register. I photographed this scene while on assignment in Rhode Island for National Geographic Traveler *magazine.*

Nikon 8008s mounted on tripod, Nikon 80–200mm AF zoom lens, 85C warming filter, Fujichrome Velvia exposed for 1/4 sec. at f/4

- Closeup shot—A shot that shows storytelling details, such as faces, hands, signage, architectural details, food, drink, and artwork.

- Point of View (POV) shot—A shot taken from the angle of a participant in an event or action, i.e., a swimmer's view of an island, shot from water level, or a motorcycle rider's view of the street whizzing by. POV shots are more of a moving-picture technique than a still-picture one, but you can make exciting POV shots from moving conveyances and unusual viewpoints, like very low or very high angles.

Every time you set out to photograph a situation, be it a street fair, a market, or a bicycle trip through the country, keep in mind this mix of shots. Each type of shot is important; if you take all establishing shots or all closeups, you'll lose the attention of your viewers. In everything you cover, get the establishing shots, the medium shots, the details and closeups, and if possible, an interesting POV shot.

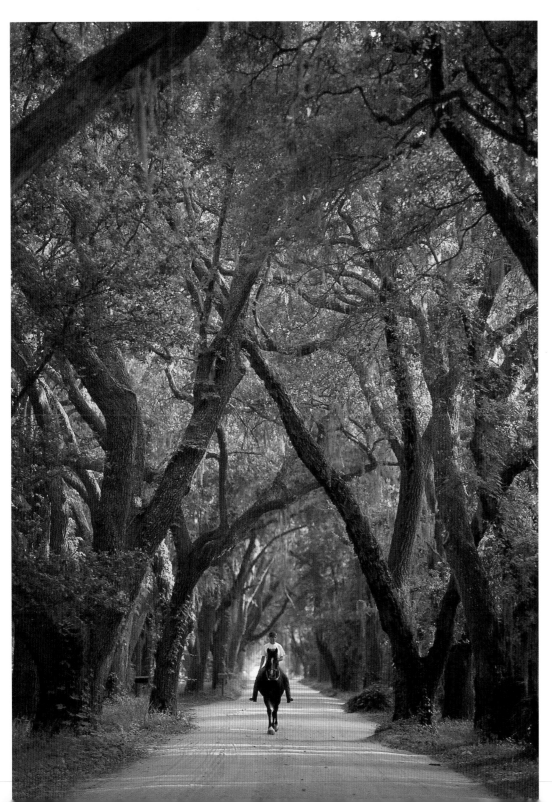

The perspective compression of my telephoto lens "stacked" all of these live oaks in a pleasing pattern. When I saw this woman working her horse in a nearby paddock, I asked her to take a ride down the road for a sense of moment for this shot of St. Helena Island, South Carolina.

Nikon 8008s mounted on tripod, Nikon 80-200mm AF lens, Fujichrome Velvia exposed for 1/30 sec. at f/2.8

The American Southwest

As the sky fades to royal blue in Bryce Canyon National Park, I'm hustling up the Queen's Garden Trail to catch the afterglow over the cliffs. Straining to see the path, I make out a figure up ahead. By the heavy tripod and view camera he's carrying, I can tell that he is a serious photographer. We walk together, making small talk. I learn that he is a frequent visitor to Bryce Canyon and its neighbor in southern Utah, Zion National Park.

"I think of these parks as symphonies in stone," he tells me. "Bryce is a Mozart concerto, ethereal and otherworldly. Zion is like Beethoven, all power and majesty." The landscape here seems to bring out the poet in everyone, including us photographers, who aren't usually given to such verbal virtuosity.

The western sky is now a blaze of red clouds, and the reflected rays bathe the canyon in an amber glow. We both shoot quickly in the waning light. Out of the corner of my eye, I see my fellow photographer bent over his tripod, his head under a focusing cloth, his arms reaching out to adjust the lens and shutter. His earlier musings seem particularly apt: he looks for all the world like a conductor trying to bring all the sections of his orchestra—light, landscape, camera, and film—into one harmonious whole. The afterglow disappears abruptly, and we fold our tripods in silence, both aware that we've just witnessed—and, we hope, captured on film—one of nature's great performances.

There is no doubt that the spectacular scenery and parklands of the American Southwest are some of the continent's primary visual subjects. The prospect of photographing National Parks like Zion, Bryce Canyon, Capitol Reef, and Death Valley is indeed a heady one. But great travel photographs are rarely products of pure chance, even in areas of obvious majestic beauty.

▶ *The moon was rising behind the famous Watchman Mountain one afternoon in Utah's Zion National Park during an assignment for Travel & Leisure. In order to render the moon large enough, I chose a long telephoto lens. The resulting closeup also emphasized the power and majesty of the peak.*

Nikon 8008s mounted on tripod, Nikon 300mm AF lens, Fujichrome Velvia exposed for 1/60 sec. at f/5.6

▼ *The salt pans at Badwater in California's Death Valley National Park form an otherworldly scene. I used a wide-angle lens to emphasize the patterns in the foreground.*

Nikon 8008s mounted on tripod, Nikon 20–35mm AF zoom lens, Fujichrome Velvia exposed for 1/15 sec. at f/5.6

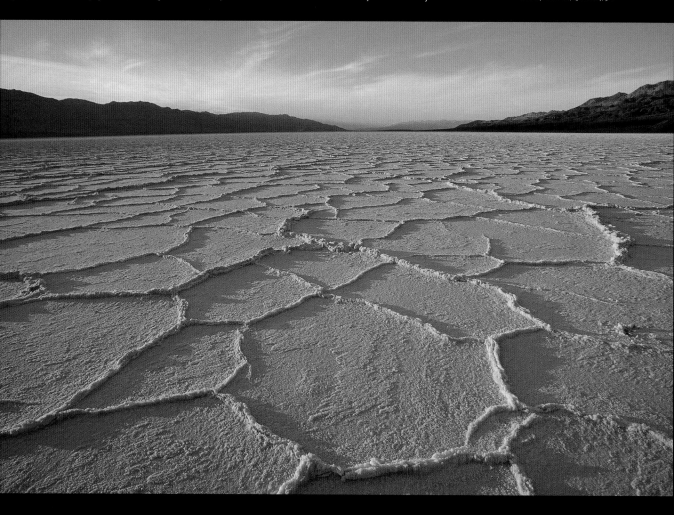

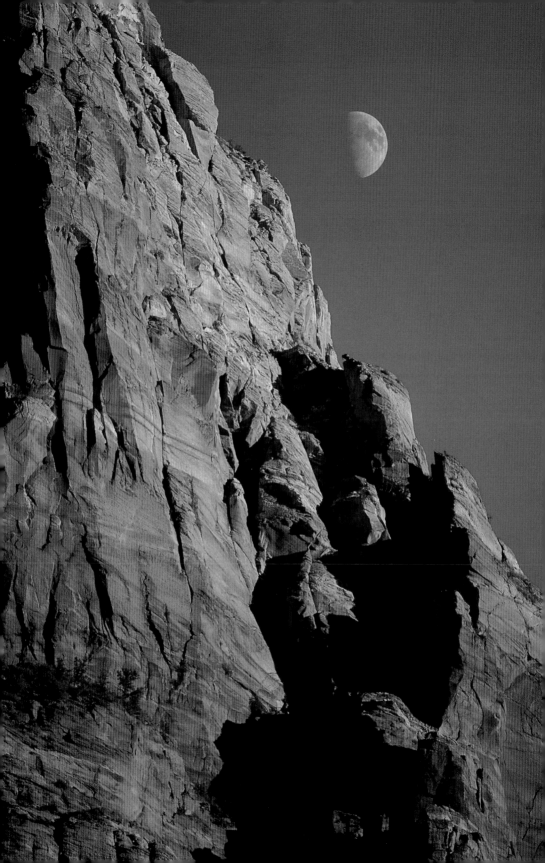

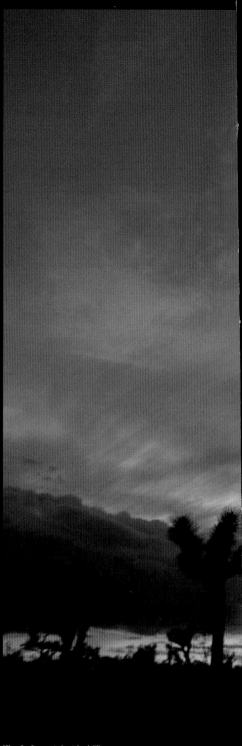

I was on a horseback trip on a distant mountain in Capitol Reef National Park in Utah when a storm approached. I set up and got off about a roll, including this shot of a rainbow, before the precipitation, in the form of ice and snow, chased me back into my tent!

Nikon 8008s mounted on tripod, Nikon 80–200mm AF zoom lens, Fujichrome Velvia exposed for 1/60 sec. at f/4

Nikon 8008s mounted on tripod, Nikon 20–35mm AF zoom lens, Fujichrome Velvia exposed for 1/8 sec. at f/4

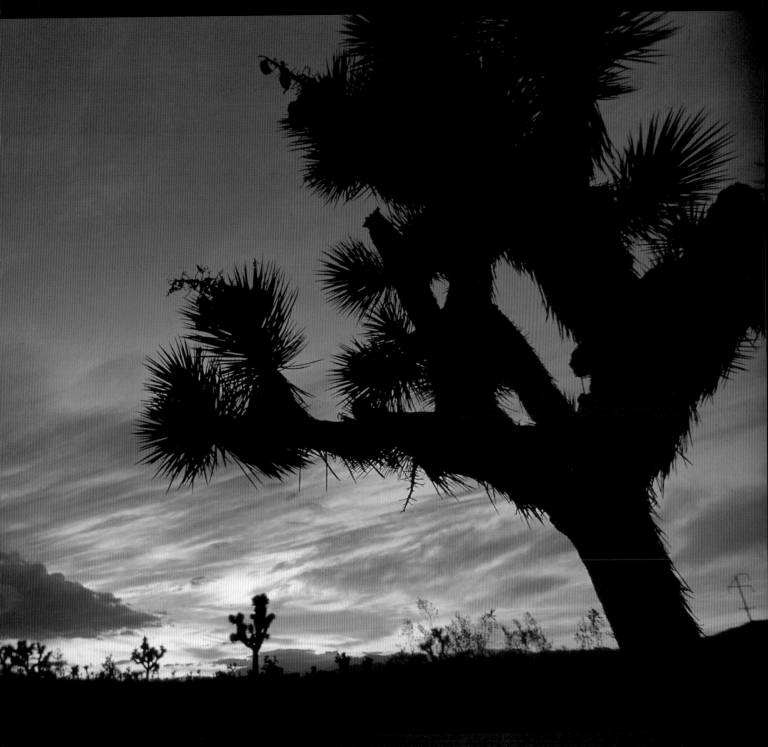

To emphasize the distinctive outlines of the trees from which California's Joshua Tree National Park derived its name, I chose a very low angle of view in order to silhouette the trees against the twilight sky.

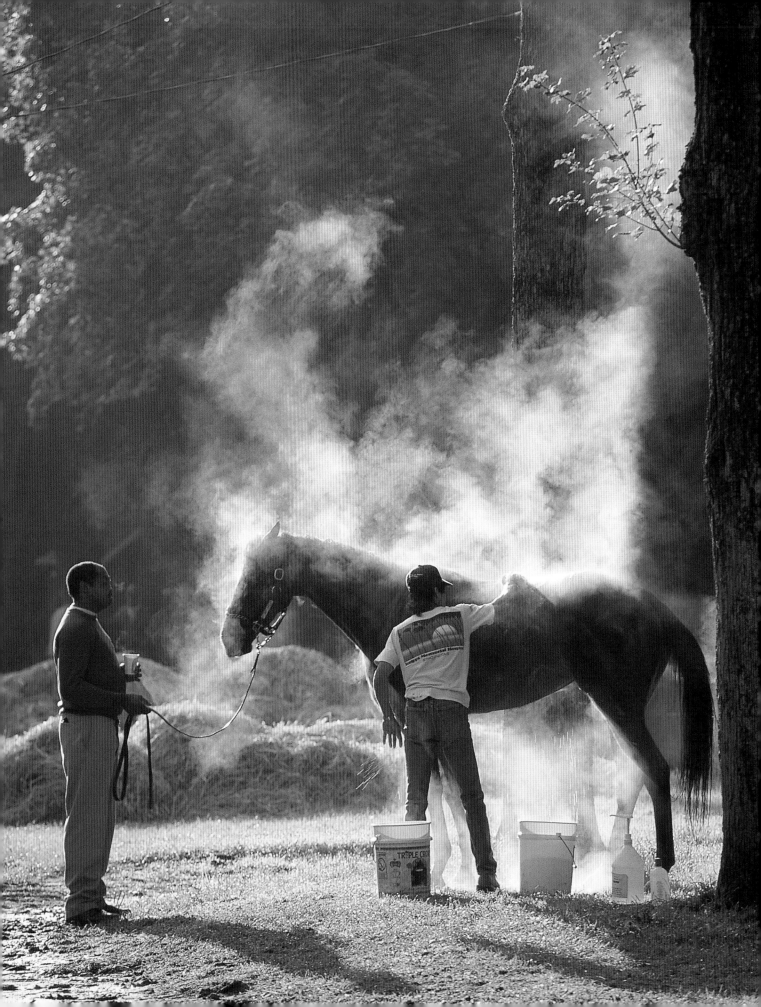

Points of Light

"My quest, through the magic of light and shadow, is to isolate, to simplify and to give emphasis to form with the greatest clarity."

RUTH BERNHARD

THE LITERAL MEANING of the word photography, which is "light writing," shows just how important light, specifically the *quality* of light, is to making great pictures. Whereas in some branches of the craft, such as photojournalism, the subject matter is king, the opposite is true in travel photography. My friend Kunio Kadawaki, who has acted as guide and translator for nearly every *National Geographic* photographer who has worked in Japan in the last 25 years, has a special name for photographers. He calls us "light and shadow warriors."

This is an apt moniker because the light is everything. Photographed in the harsh, ugly light of midday, the Taj Mahal is just another building. To capture the mausoleum's sublime beauty on film, you need to shoot in light that is as evocative as the architecture. On the other hand, even the most mundane subject matter—a line of laundry billowing in the wind, for instance—can become magical when etched in backlight.

The main reason most people are disappointed with their vacation photographs is that the pictures fail to evoke special memories of their travels. How do you capture the magic light that will summon the taste of briny air along the coast of Maine, the smell of calamari frying in a quay-side Greek tavern, or the screams of hyenas shattering the stillness of an African night? Can you find it or does it, like an elusive muse, have to find you?

The answer lies somewhere in between. No special formula exists for being in the right place at the right time to capture a rainbow arcing over the glistening green hills of Bali. That is serendipity, impossible to predict and joyous to experience. But if you combine a knowledge of the types of natural light and the subject matter each is suited for with an elemental knowledge of weather, you'll be surprised how often you'll find yourself "front row center" for one of nature's magical light shows.

After the early morning workouts at the famed Saratoga Springs racetracks in New York, the steaming horses are washed down. Shooting on assignment for Travel/Holiday *magazine, I looked for an angle that would enable the backlight to emphasize the steam plumes.*

Nikon 8008s, Nikon 80–200mm AF zoom lens,
Fujichrome Velvia exposed for 1/125 sec. at f/2.8

The Many Facets of Natural Light

All natural light comes from the sun. This single source of illumination, however, is fragmented into a seemingly infinite variety of subtle shadings. The broad spectrum of natural light extends from the deep blue of heavy overcast or twilight to the orange rays of a setting sun, evoking feelings of cold and warmth, and foreboding and well-being. The complexity of light is increased by clouds, earth, and water, which diffuse and reflect light. Even the air itself refracts light like the facets of a diamond.

Each type of light has unique properties. These strengths and weaknesses make it suitable for specific subject matter. By matching the right light with the right film and the right subject, you can dramatically improve your travel photography.

HOW FILM "SEES" LIGHT

Film cannot "see" or record light in the same way our eyes do. The human eye can perceive a *dynamic range* of 2,000:1, or about 11 *f*stops, between a bright white highlight and a dark, featureless shadow. The difference between the brightest and the darkest area in a picture is referred to as *contrast*. If a scene contains both very bright and dark areas, it is said to have "high contrast" or to be "contrasty."

Film can't record a wide range of contrast. Color-print, or color-negative, film has a dynamic range of about 64:1, or five *f* stops, while color-slide film has a dynamic range of only 8:1, or only three *f*stops! When you look at a scene that contains areas of bright sunlight and deep shadows, your eyes can perceive detail in both areas at the same time. But film, depending on how you expose it, will be able to see detail in only one of those extremes at a time. The film either will record detail in the bright highlight areas and the shadow areas will be impenetrable and black, or will record detail in the shadow areas, and the highlights will be burned out and featureless.

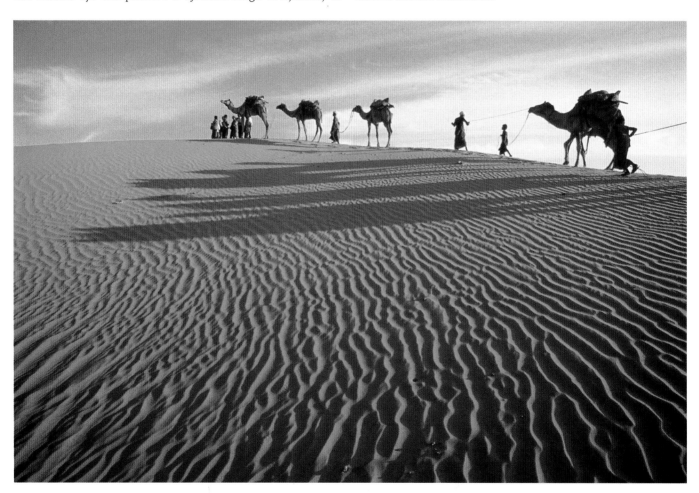

For a Travel/Holiday *assignment about a train trip across Rajasthan, I signed on for an afternoon camel ride on the dunes of India's Thar Desert outside of Jaisalmeer. The late-afternoon sidelight caught the ridges in the dunes, giving texture to this wide-angle composition.*

Nikon 8008s, Nikon 20–35mm AF zoom lens, Fujichrome Velvia exposed for 1/60 sec. at f/5.6

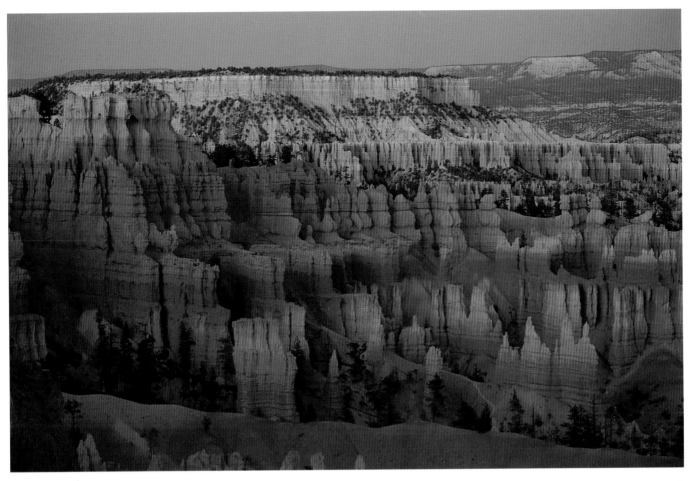

Until the sun set, I'd been sharing this scenic overlook in Utah's Bryce Canyon National Park with about a half dozen other photographers. They all packed up when the sun dropped below the horizon, but sometimes, especially if a lot of clouds in the western sky are reflecting the light, the afterglow of sunset can produce some stunning illumination.

Nikon 8008s mounted on tripod, Angenieux 28–70mm AF zoom lens, Fujichrome Velvia exposed for 1 sec. at f/5.6

Once you understand this basic limitation of film, it is easy to comprehend why, when it comes to photography, what you see isn't always what you get. However, by training your eyes to seek out the situations that will match the film emulsion's compressed recognition of tones and by matching the right light with the right subject, you can make your photographs much better.

DOES "BAD" LIGHT EXIST?

The great color photographer Ernst Haas once said, "There is no such thing as bad light." In a sense, this is true. With the right subject matter, a gifted photographer can use even the most boring light to produce memorable images. Jay Maisel, a great color photographer, transformed a picture of a pigeon wading in a puddle at high noon into a work of art. However, some types of light, such as sidelight and backlight, are better than others for capturing the three-dimensional world on two-dimensional film.

Unfortunately, most hours of the day are illuminated by two of the most mundane types of light, frontlighting and toplighting.

The majority of boring travel snapshots are taken in this middle-of-day light. The old saw admonishing photographers to "keep the sun behind your left shoulder"—which was good advice in the early days of snapshot cameras with their slow film and rudimentary optics—lives on in the collective unconscious of the photographic public. And since most sightseeing occurs in the middle of the day, it is no wonder most people's travel photographs are merely record shots that prove they were there.

CAPTURING THE MAGIC

Why is bright midday sunlight so poor for photography? *Frontlight*, or light coming over your shoulder, all but eliminates the shadows and shading that give depth to the two dimensions of film, resulting in flat, lifeless pictures. *Toplight*, or high midday sunlight, puts shadows in all the wrong places for the limited perception range of most films. This doesn't mean that you can't take good pictures in these two types of light; it simply means that you have more pleasing alternatives.

SIDELIGHT

Sidelight, the best light for capturing the mood and the majesty of landscapes, occurs in the early morning and the late afternoon, when the sun angles into the scene from the side. The resulting interplay of highlight and shadow, known as *chiaroscuro* in painting, brings out the texture and depth of a landscape. The golden tones of the sun at these times of day further infuse scenes with a special glow.

While sidelight is superb for landscapes, the sculpting shadows make it a bit too severe for people photography. Unless you want to emphasize wrinkled or craggy features with dramatic shadows, other kinds of light are more suitable for portraiture.

BACKLIGHT

Nothing beats the soft glow of *backlight* for evoking a feeling of romance. In landscapes, backlight accentuates the highlights in sea spray, fog, and smoke. In portraits, backlighting creates a halo around the subject's hair and shoulders, separating the person from the background and suppressing unflattering facial details. People react so strongly to this type of light that it has become a given in any movie scene or still picture meant to elicit feelings of nostalgia, warmth, or general well-being. However often backlight is used this way, its effectiveness never diminishes.

Backlight does have some drawbacks, though. It washes out colors, rendering the subject or landscape in monochrome. You

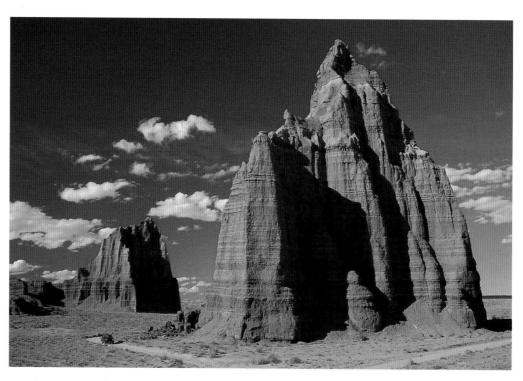

Shooting the remote Cathedral Valley portion of Utah's Capitol Reef National Park *for a* National Geographic Traveler *story, I waited until late afternoon to shoot these two monoliths, the Temple of the Moon (in the foreground) and the Temple of the Sun. The sidelight created molding shadows, and I asked my guide to drive the Jeep into the scene for a sense of scale.*

Nikon 8008s mounted on tripod, Nikon 20–35mm AF zoom lens, B+W circular warming polarizer, Fujichrome Velvia exposed for 1/60 sec. at f/5.6

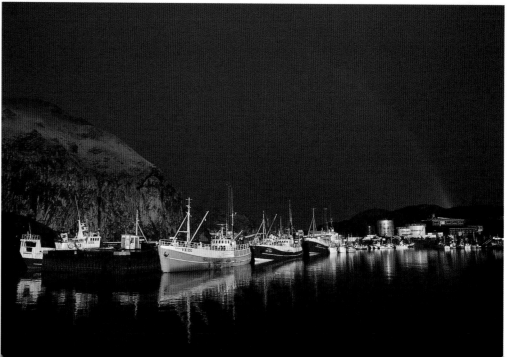

On assignment in Iceland for National Geographic, *I'd just stepped off a fishing trawler after two days of rough seas when I saw this storm approaching Heimaey. The early-morning sun was angled in from the side and made the boats stand out in relief against the black sky. The small rainbow was a bonus!*

Nikon FE2, Nikon 24mm lens, Kodachrome 64 exposed for 1/250 sec. at f/5.6

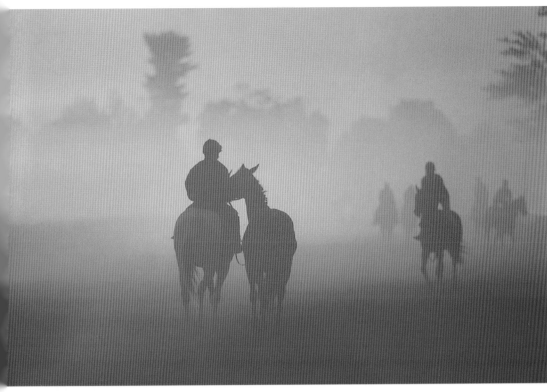

◀ I used an 85C warming filter to further intensify the warmth of the first rays of sunrise backlighting the fog. I made this shot during an early-morning workout at the racetrack in Saratoga Springs, New York.

Nikon F4 mounted on tripod, Nikon 300mm AF lens, 85C filter, Fujichrome Provia exposed for 1/125 sec. at *f*/4

▼ The Lake Palace, a former maharajah's dwelling, is now a luxury hotel in Udaipur, India. Guests must arrive by boat. I caught the structure in the warm backlight just after sunset while working on a story about a train ride across Rajasthan for Travel/Holiday *magazine.*

Nikon 8008s mounted on tripod, Nikon 80–200mm AF zoom lens, 85C warming filter, Fujichrome Provia exposed for 1/60 sec. at *f*/2.8

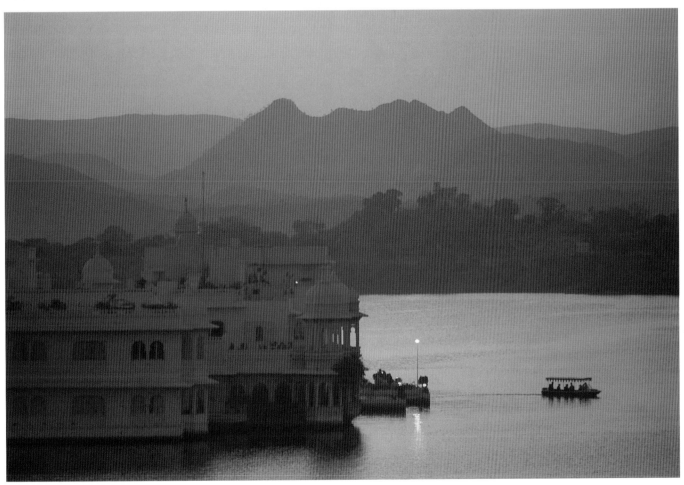

must take great care to keep the light from shining directly into the lens in order to avoid *halations* and *flare*. These are reflections of the interior glass elements of the lens that degrade the image and sometimes even show up in photographs. Backlight can also cause a camera's through-the-lens (TTL) meter to be fooled by the volume of light coming from behind the subject, resulting in underexposure. To avoid this, take a closeup reading from your subject.

OVERCAST AND OPEN SHADE

Overcast and *open shade* are probably the two kinds of light most misunderstood by amateur photographers, who usually put away their camera when they see a light cover of clouds. This is too bad because a number of common subjects in travel photography—people and street scenes—actually require the soft light of overcast or open shade. Although these lighting conditions might seem lackluster, they perfectly match the compressed range of tone recogni-

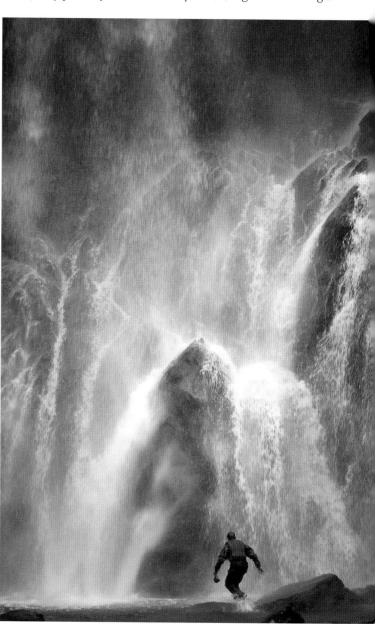

As I shot a story on peninsular Malaysia for Travel/Holiday, *it actually started to rain by the time I reached these lush tea terraces in the Cameron Highlands. I composed all of my pictures without sky and used a long lens to emphasize the wavy lines of the tea bushes. I knew that Fuji Velvia combined with the soft overcast illumination would produce rich, saturated greens.*

Nikon 8008s, Nikon 80–200mm AF zoom lens,
Fujichrome Velvia exposed for 1/125 sec. at f/2.8

Shooting a story on a scenic drive through Alaska for National Geographic Traveler *magazine, I came across a group of rafters on a river near Valdez. When they beached their craft to explore the waterfall, the leader ran toward the cataract and I caught him in mid-stride. Soft overcast illumination is ideal for photographing waterfalls.*

Nikon 8008s mounted on tripod, Nikon 80–200mm AF zoom lens,
Fujichrome Provia exposed for 1/125 sec. at f/2.8

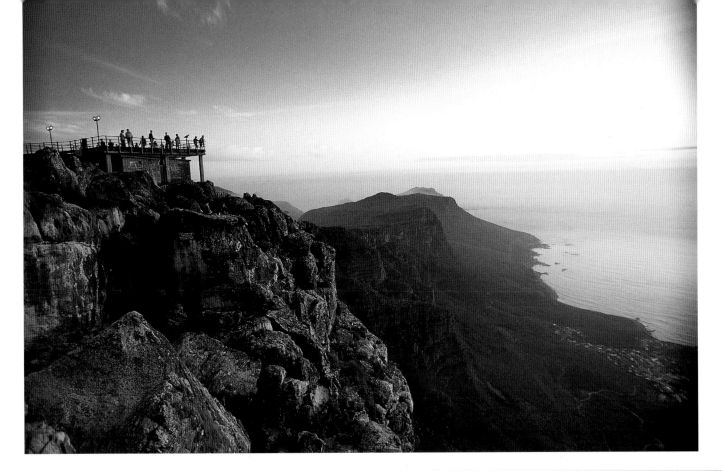

tion of film, which can't render shadows and highlights at the same time. The low-contrast light of overcast and open shade reveals details and brings colors alive with increased saturation.

The key to using overcast and open shade effectively is to find compositions that don't include sky. The sky looks bald and gray in shots made in open shade or overcast light. Look also for subjects with strong colors, or with striking graphic elements that don't need shadows to bring them out on film.

TWILIGHT AND DUSK

The "magic hour," the "blue hour," the "afterglow"—photographers have a number of pet names for dusk or twilight, the hour or so after sunset when the sky is still a rich blue before it turns black. This is the best time to shoot skylines, monuments, and fountains—almost any outdoor scene illuminated by manmade light. In fact, most "night" photography is actually shot during this period. In true nighttime, there isn't enough *ambient*, or available, light to separate buildings and other subjects from the black sky because of film's compressed tonal recognition. The resulting photographs often show nothing more than bright lights floating in darkness.

Besides the rich, moody feel twilight lends to pictures, professional travel photographers prize this light because it is basically weatherproof. No matter how gray and gloomy the day, the sky will glow royal blue during the magic hour. So even a cloudy or rainy day, which you might otherwise write off for shooting skylines and buildings, can still yield fine pictures.

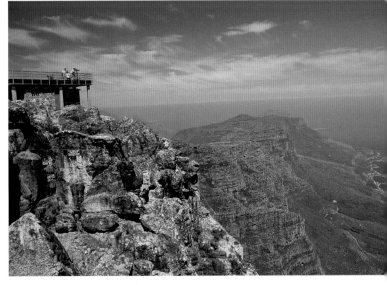

The time of day greatly affects the mood of a picture, so it isn't unusual for me to go back to the same place at different times to see what the light does. Shooting a story on South Africa for Travel/Holiday, I first visited the top of Table Mountain in Cape Town at midday (bottom). I liked what I saw and went back closer to sunset to capture a warmer, moodier version (top).

Nikon 8008s, Nikon 20–35mm AF zoom lens, Fujichrome Velvia exposed for 1/250 sec. at f/5.6 (top); Nikon 8008s mounted on tripod, Nikon 20–35mm AF zoom lens, Fujichrome Velvia exposed for 1/8 sec. at f/5.6 (bottom)

41

WINDOW LIGHT

Since the time of Rembrandt, portraitists have enjoyed the diffused quality of window light. Soft enough to flatter, yet directional enough to add shadow and a three-dimensional effect, it is nature's perfect lighting for portraits and still life. When actual window light isn't available, photographers go to great trouble to mimic its special quality by diffusing their artificial lights with umbrellas, softboxes, and panels.

Only soft, indirect light qualifies as window light. A shaft of direct sunlight, even if it comes through a window, is considered sidelight and, as such, is too harsh and *specular*, or mirrorlike, for portraits.

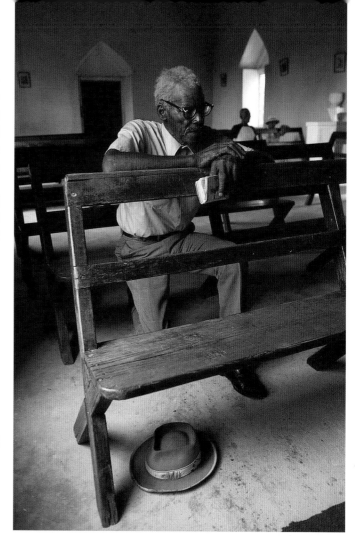

▶ *I'd arranged with church officials to photograph during a Sunday service at St. Mary Magdalen Church on Long Island in the Bahamas. I was drawn to the quiet dignity of worshipper Robert Smith, who was positioned next to a large window, which bathed him in a very soft light. He later told me he'd been attending this church for 77 of his 83 years.*

Minolta CLE, Rokkor 28mm lens, Kodachrome 64, exposure unrecorded

▼ *Shooting Mexico's Copper Canyon for* Endless Vacation *magazine, I spent a few days in the remote silver mining town of Batopilas on the canyon floor. The beautiful window light and the warm friendliness of this silver merchant struck me.*

Nikon 8008s braced on table-top tripod held against my chest, Nikon 20–35mm AF zoom lens, Fujichrome Velvia exposed for 1/8 sec. at f/2.8

METERING, BRACKETING, AND OTHER EXPOSURE MYSTERIES

Much gnashing of teeth and anxiety often accompany using the light meter in a camera. Internet bulletin boards are full of experts debating the relative merits of spot metering versus center-weighted metering, of 8-segment metering versus 12-segment metering, of Program mode versus Dual Program mode, or of some other nonsense. The sum total of all this is often complete confusion for photo enthusiasts.

In the workshops I teach, I've seen people so intimidated by their light meters, and so convinced that they have to second-guess with spot metering or other arcane practices, that they are practically immobilized—and their exposures almost always are off the mark. You have to remember only one thing when it comes to your camera's meter: it is set up to read off scenes of *average reflectance*, or a midtone, which is similar to a mid-gray. If you're aiming at something much brighter than average, say a landscape with a big bright sky, a sandy beach, or a snowy field, your meter will underexpose the scene. So you have to override the meter. On the other hand, if your composition contains a subject of less-than-average reflectance, such as a volcanic landscape of black lava, your meter will overexpose the scene. In this situation, when the scene is darker than normal, you have to give the scene slightly less exposure than the meter indicates.

This sounds like a lot to keep in mind, and it might be for a tyro. In actuality, though, if you're using color-negative film, you don't need to worry much because this film has such great latitude that good prints can be made from less-than-perfect negatives. If you're using slide film, you have to be more critical.

The easiest way to make sure that you've nailed the exposure with slide film is to do what the pros do: bracket your exposures. *Bracketing* simply means shooting extra exposures slightly above and below the camera meter's reading, as well as the reading itself. This is the quickest, easiest, and surest way to guarantee exposure success.

My usual bracketing sequence consists of three frames, one shot at the meter's recommendation, one at half a stop above the meter reading, and one at half a stop below the meter reading. Much of the time I find that two of these three frames produce acceptable results. I often find that I like one of the brackets better than the meter's exposure. In more dicey light, I might add extra frames at one full stop over and one full stop under the recommended meter reading.

Many photo enthusiasts and camera-club members look at bracketing as a kind of admission of failure. You aren't sure what the exact exposure is, so you cover all your bases. Professionals who must come back with the shot no matter what have no such foolish pride. We know that, at best, exposure is a tricky subject, so why not cover ourselves?

In some fast-moving shooting conditions, you can't bracket. This is the time when you take all your experience—picked up from examining all your previous brackets to see how your meter and film combination reacted to different situations!—and make an educated leap of faith. But these type of situations are rarer than you'd think. So don't worry, be happy—and be sure to bracket your tricky exposures!

The Color of Light

Light actually has color that varies depending on the source and the weather conditions. For example, in the early morning or late afternoon, sunlight is much more orange or red than it is at high noon, when it tends more toward the blue spectrum. In deep shade, the color of that light is even more blue.

Artificial light sources have different colors, too. These differences aren't immediately apparent because our eyes correct for these color variations—a kind of automatic "white balance" courtesy of the brain. But film can't do this. It is balanced for the color of one source, usually daylight, so it renders different light sources different colors.

This isn't always bad. Candlelight, firelight, and incandescent bulbs all emit a warm, orangy light on daylight film that isn't at all unpleasant. In fact, many photographers deliberately shoot daylight-balanced film under tungsten light in order to exploit this effect. Electronic flash has the same color as midday sunlight.

Although it has nothing to do with the actual heat generated, these variations in the color of light are referred to by the term *color temperature*. Colors toward the red/orange part of the spectrum are referred to as *warm* colors, while colors toward the blue end of the spectrum are called *cool* colors.

▶ *I was in Georgia on an assignment for the* Insight Guide to Atlanta. *The Atlanta Fire Department sets up sprinklers at the finish line of the annual 10K Peachtree Road Race to help runners cool off. I liked this backlit angle for the way the illumination highlighted the spray of water.*

Nikon 8008s, Nikon 80–200mm AF zoom lens, Fujichrome Velvia exposed for 1/250 sec. at f/2.8

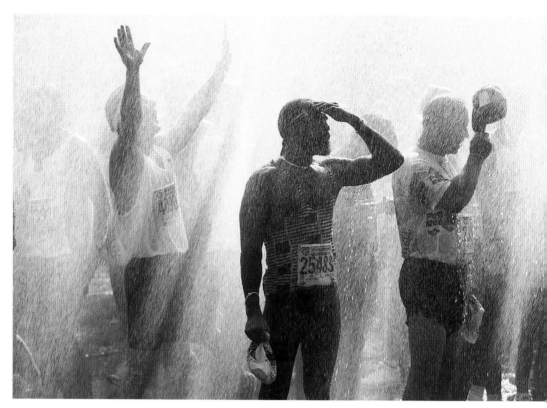

▼ *While working on a story on the French Quarter in New Orleans, Louisiana, for* Travel/Holiday *magazine, I got up early to catch a rare morning fog near Jackson Square. To emphasize the predawn blue, I shot a tungsten-balanced film without a correcting filter; I knew that the scene would be rendered even bluer because the film is balanced for very warm tungsten lighting.*

Nikon 8008s mounted on tripod, Nikon 80–200mm AF zoom lens, Kodak Ektachrome 320T exposed for 1/8 sec. at f/2.8

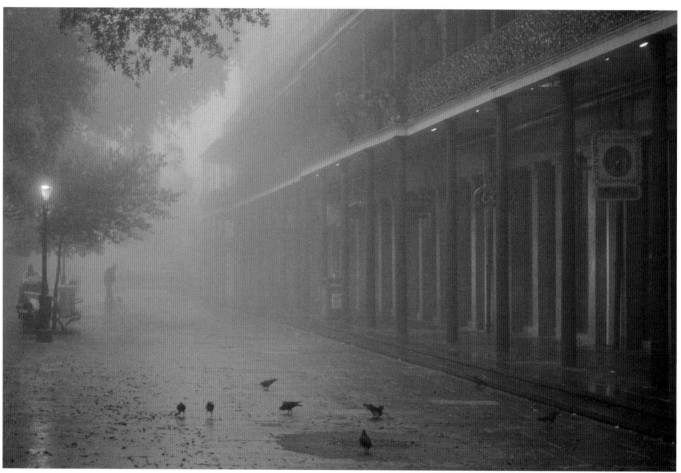

Using Filters to Modify Light

Sometimes, for a variety of reasons, you might want to alter the color of the light in which you're taking pictures. For instance, if you suddenly find yourself photographing indoors under incandescent lights with daylight slide film in the camera, the resulting pictures will be very orange because those lights have a much warmer color temperature than most daylight. In this case, you might put on a blue 80A filter to compensate. If you're shooting a portrait in deep shade, which is very blue, you might put on an 81B filter, which is a pale amber color, so the person's skin tones won't look sickly blue. The following is a roundup of some popular filters for color film and how they're used.

Protective Filters

Protective filters prevent rain, dust, grit, scratches, and fingerprints from harming lenses. These filters come in several "strengths." An *ultraviolet (UV) filter* is clear and simply filters out the excessive blue of ultraviolet light. A *skylight filter*, either 1A or 1B, adds a slightly pinkish cast to further counteract the "blues." Tiffen makes a filter designated as an 812 that combines the pink of a skylight filter with the amber of an 81A warming filter. The slight amount of pinkish warmth that skylight filters provide is always welcome in a photograph. But the protection that these filters afford your lenses is equally important.

Warming Filters

In heavy overcast or deep shade, the slight warmth of a skylight series filter won't do the trick. In these lighting conditions, the deep amber 81 series and the orange 85 series are useful. The amber 81 series increases in strength from 81A, to 81B, to 81C, to 81EF. Some photographers use an 81A or 81B filter on their lenses all the time, as they would a skylight filter. An 81C filter is a good choice for an all-around mid-strength warming filter.

The 85 series is orange and designed for shooting tungsten-balanced film under daylight. However, these filters are equally useful for "warming up" daylight. The relatively pale 85C filter is excellent for providing some natural-looking warmth in the early morning and the late afternoon. This filter gives you an extra hour or so of warm "sweet light" at those times of day. The 85B, 85A, and 85 filters are much stronger in color than the 85C. As such, they look too unnatural in all but colorful sunset and sunrise applications.

Color balance becomes a real problem when you shoot under fluorescent, mercury, or sodium-vapor lights. These light sources don't emit parts of the red spectrum. Consequently, photographs taken under their illumination have a sickly green tint that is almost always offensive. Most of the time, you can correct this by putting a CC30M (color-correction magenta) filter or a Tiffen FLD (fluorescent daylight) filter over the lens when you shoot daylight-balanced slide film under these light sources.

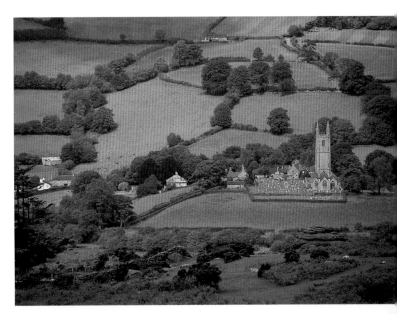

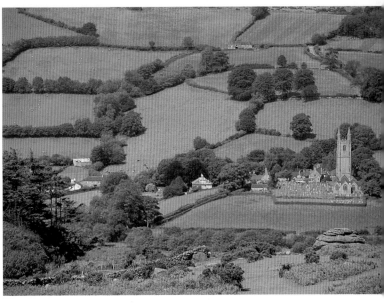

Shooting a story on Devon, England, for National Geographic Traveler, *I was frustrated in trying to get a good shot of Widdecombe-in-the-Moor. The sun didn't hit the village until it was relatively high in the sky and, therefore, emitted a bluish light (top). I counteracted this by adding a warming filter when photographing this church in the fields (bottom).*

Nikon 8008s, Nikon 80–200mm zoom lens, Fujichrome Velvia exposed for 1/250 sec. at *f*/5.6 (top); Nikon 8008s, Nikon 80–200mm zoom lens, 81C warming filter, Fujichrome Velvia exposed for 1/250 sec. at *f*4/5.6 (bottom).

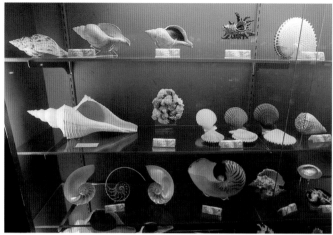 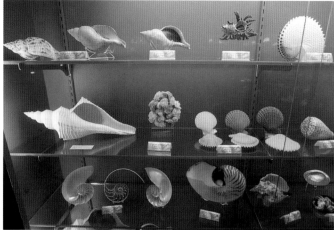

▲ This wonderful collection of shells at the Underwater Institute in Bermuda is displayed under fluorescent lighting (left). For this closeup, I added a magenta filter to counteract the heavy green cast of the lighting (right).

Nikon 8008s mounted on tripod, Angenieux 28–70mm AF zoom lens, Fujichrome Provia exposed for 1/4 sec. at f/5.6 (left); Nikon 8008s mounted on tripod, Angenieux 28–70mm AF zoom lens, CC40 magenta filter, Fujichrome Provia exposed for 1/2 sec. at f/5.6 (right)

▶ While photographing in Bergen, Norway, I came upon these historic Hanseatic-era warehouses. Called "the Bryggen," these buildings are on the UN World Heritage list. I backed off, using a long lens to compress the warehouses, and the backlight created the warm glow.

Nikon 8008s, Nikon 80–200mm AF zoom lens, 85C warming filter, Fujichrome Velvia exposed for 1/250 sec. at f/4

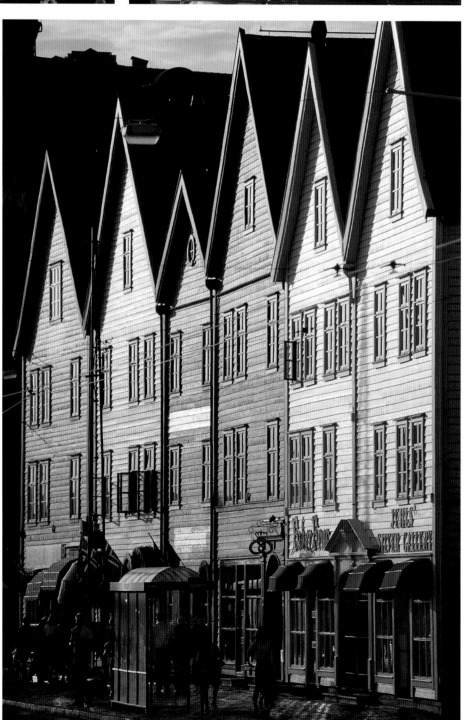

Polarizing Filters

By *polarizing*, or focusing, otherwise scattered light rays, a *polarizing filter*, or *polarizer*, performs a variety of small miracles. This particular type of filter eliminates reflections on all but metallic surfaces, creating deeper, more saturated colors. It also minimizes the effects of aerial haze, producing deep blue skies.

A polarizer works best at a 90-degree angle to the sun. So at midday, when the sun is directly overhead, a polarizer works almost anywhere you point it along the horizon, making it especially useful when you need to shoot landscapes at that time of day. Any landscape that includes water and greenery will benefit from polarization.

There are two types of polarizers, *linear* and *circular*. These terms don't describe the shape of the filters, merely the way they achieve polarization. Most autofocus cameras require the use of a circular polarizer because a linear polarizer might interfere with autofocus and meter functions. Check your camera's instruction manual to see what type the manufacturer recommends.

Graduated Neutral-Density Filters

Graduated neutral-density (ND) filters, or *grads*, feather from a neutral gray at the top to clear on the bottom. They're used primarily in landscape work to hold detail in both the foreground and the sky, which is usually much brighter than the land beneath it. These are the least-understood filters because the human eye has no problem seeing details in both light and dark areas. To understand when to use a graduated ND filter, just remember the way film sees: it has a much more limited range of tones and can't record wide ranges of contrast.

A common picture situation that illustrates the need for a grad is the classic sunset. How many times have you shot a beautiful sunset, only to get back a picture in which the foreground is completely black and the sky is well exposed, or the foreground is well exposed and the sky is washed out? Here, a graduated ND filter would have helped by darkening the sky enough to register detail in it and the foreground at the same time. This isn't the only time a grad would help, but it is one of the most easily identifiable situations. The more you use this filter, the more you'll get a feel for when it is necessary.

Graduated ND filters come in a variety of strengths. Commonly, there are one-stop grads, often referred to by the designation ".3"; two-stop grads, .6; and three-stop grads, .9. A two-stop grad is a good overall choice because it darkens skies enough to register without appearing unnatural.

Besides neutral-density gray, grad filters are available in other colors, including blue and amber. The graduated blue filters are useful for deepening the blue of skies, while the graduated amber filters can effectively intensify a warm, colorful sunset sky. These two types of filters aren't as versatile as the neutral-density gray version, which is neutral in color and can be used in a variety of situations.

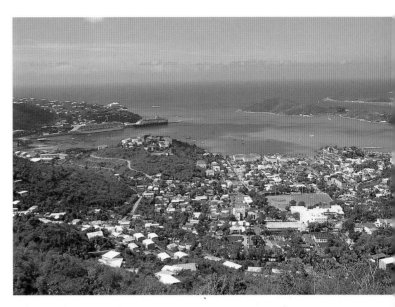

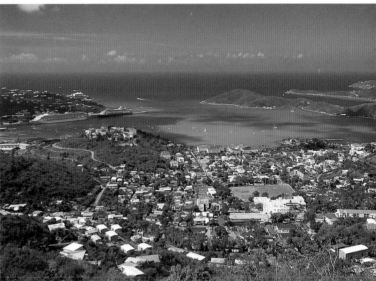

When you are stuck shooting in the middle of the day, a polarizer can really save you. I made one shot of Charlotte Amalie on St. Thomas in the U.S. Virgin Islands without a polarizer (top). Then I added the filter, which intensified the blues of the water and the greens of the foliage, as well as made the red rooftops pop (bottom).

Nikon 8008s, Nikon 20–35mm AF zoom lens, Fujichrome Velvia exposed for 1/250 sec. at f/5.6 (top); Nikon 8008s, Nikon 20–35mm AF zoom lens, B+W circular warming polarizer, Fujichrome Velvia exposed for 1/125 sec. at f/4 (bottom)

FILTER TABLE

FILTER	*F*-STOP INCREASE	USE
Skylight (1A)	None	Warms blue cast in open shade and on overcast days. Front-of-lens protection.
Ultraviolet	None	Cuts UV-radiation haze common in distant shots. Removes some blue cast at high altitudes. Front-of-lens protection.
81A	1/3	Slightly stronger amber cast than skylight filter. Further warms blue cast in open shade and on overcast days.
81B	1/3	Stronger amber cast than 81A filter. Same uses.
81C	2/3	Stronger amber cast than 81B filter. Same uses.
81EF	1/3	Strongest of amber series filters. Same uses.
85C	1/3	Palest of orange series filters. Used for exposing tungsten-balanced film in daylight.
85B	2/3	Stronger orange cast than 85C filter. Same uses.
80A	2	Blue filter. Used for shooting daylight-balanced film under tungsten light.
80B	1 2/3	Slightly weaker blue than 80A filter. Same uses.
Neutral-Density	Varies	Neutral-colored filter that blocks light. Available in various strengths (1, 2, 3 *f*-stops). Allows for choice of wider aperture or slower shutter speed with no color shift.
Graduated Neutral-Density	Varies	These filters feather from neutral density on top to clear on bottom. Available in various strengths. Useful for holding detail in both sky and foreground in landscapes.
Polarizing	1 1/3	Strengthens color. Darkens sky. Reduces some reflections and glare.
FLD	1	Magenta-tinted filter. Used for obtaining correct color when shooting daylight-balanced film under fluorescent light.
CC30M	1	Stronger magenta cast than FLD. Same use.
FLB	1	Magenta-and-orange cast filter. Used for shooting tungsten-balanced film under fluorescent light.

Flash Points

Even if you tried, you couldn't invent an uglier light than the illumination that comes from a small electronic flash unit. The cold, blue color and the harsh, stark quality of this light can even make someone as beautiful as actress Michelle Pfeiffer look like the Bride of Dracula. Inevitably, the harsh glare in the foreground of flash pictures, as well as the rapid light falloff in the background, produce photographs that are far from aesthetically pleasing. For photojournalists this isn't a concern, but most travel photographers don't want their pictures to look like tabloid snaps of "perp walks," which are those familiar newspaper photographs of suspects heading toward or away from courtrooms. It really is no wonder that many photographers would rather just skip taking an unappealing picture than face the result: a shot made with an on-camera flash.

But this is precisely the kind of light traveling photographers are forced to use. A small, shoe-mount electronic flash remains the most convenient lighting tool ever developed for still photography. Is there a way to make the color and quality of that light good, as well as convenient? Fortunately, the answer is yes. And the new generation of "smartflash" units developed for use with autofocus single-lens-reflex (SLR) cameras makes it easier than ever to go gently into that good light.

Get the Blue Out

Correcting the color is the first, and easiest, order of business. Flash manufacturers balance the color of their units to equal that of the midday sun—which is, technically, the mean color of daylight. However, as any photographer knows, midday sun is about the least flattering light, in terms of quality and color, for pictures of people. The light is high in UV radiation, which makes it cold and slightly blue.

The easiest way to counteract this blue color is to tape an amber-colored filter over the reflector of your flash unit. These filters are available at theatrical-lighting outlets and well-stocked, professional camera stores. Rosco and Lee are two manufacturers of color-correction filter material for lights (see Resources on page 158). Each company offers inexpensive swatch books of gel mate-rial, featuring a small piece of every color available. These pieces are almost exactly the size of most shoe-mount flash reflectors and can be easily trimmed to fit your flash.

A swatch book is a great idea because you can experiment with different shades of amber until you find the one you like. All my flash units are covered with a piece of Roscolux #2, a color called "Bastard Amber." It provides a nice, healthy-looking Caucasian, Asian, or African skin tone without looking unnaturally warm.

Once you correct the color of the light that your flash unit emits, you still have to deal with the quality of light. In most cases, people benefit from being photographed in soft, diffused light. It is natural looking without being harsh, similar to the light of an overcast day.

Making the Most of a Small Flash

The reason the illumination from an on-camera flash looks so harsh is simply a matter of physics: the smaller the light source (in relation to the subject), the harsher the light. In order to produce flattering light for a waist-up portrait, for example, you need to place a light source that is about 2 x 4 feet in size not more than 4 feet from your subject. Most on-camera flash reflectors are only 1 x 2 inches, so when you do the math, it isn't hard to see why the light from an on-camera flash unit is so awful, severe, and unforgiving.

The devices most professionals used to soften the flash—umbrellas, softboxes, and light panels—are too big and cumbersome for most traveling photographers. But a number of smaller diffusion devices, developed primarily for newspaper photographers, can help. They are inexpensive, easy to use, and compact. While not as effective as full-sized umbrellas or other diffusion devices, they take the edge off your flash and make your pictures more professional looking. The following are a few of the more popular devices.

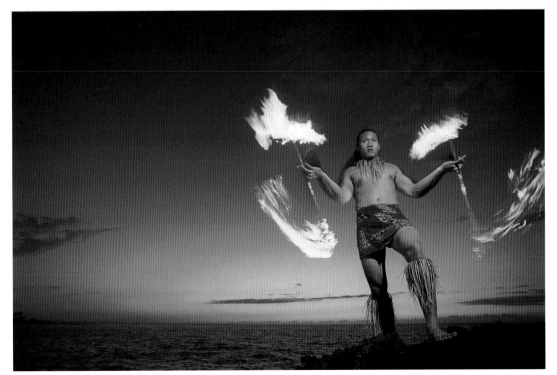

As 1 of 20 or so photographers invited to participate in the Great Hawaiian Shootout sponsored by the tourist board, I'd seen this Samoan fire dancer perform the night before in the hotel folklore show in Hilo. I'd made arrangements to meet him the next night at sunset in order to photograph him in more controlled conditions with a better background than the hotel stage.

Nikon 8008s, Nikon 20–35mm AF zoom lens, Nikon SB24 flash set to -1 with SC17 extension cord, Kodachrome 200 exposed for 1/30 sec. at f/4

Bounce Cards

Most good flash units have a swivel head that allows the flash to be bounced off the ceiling or wall rather than directly at the subject. This is the easiest way to get softer, more natural-looking lighting. But bouncing light off the ceiling renders your subject's eye sockets dark; this known as the "raccoon look" among photographers. To counteract this, many photographers attach, with a rubber band, a small, about 3 x 5 inches, white card on top of a swivel-head flash. This *fill card* should overhang the flash unit by a couple of inches. When the photographers point the flash unit at the ceiling, most of the light from the flash reflector heads in that direction; however, this card catches some of the light and redirects it back toward the subject. The result: a little bit of light

that serves to *fill*, or "open up," those eye-socket shadows in a flattering and natural-looking way. Some photographers fashion a fill card out of white plastic and attach it to their flash units with Velcro. This is a faster and more durable solution than rubber bands and index cards.

Diffusion Domes

Sometimes the ceiling is off-color, too dark, or too high for bouncing a flash. On these occasions, you reach for a *diffusion dome*, which is a 2-inch-high, white plastic cap that fits over the top of your flash reflector. This dome takes the concentrated beam of light from the reflector and spreads it more evenly in every direction. Because of this wide area of coverage, the diffusion dome is ideal for use with wide-angle and ultrawide-angle lenses. Undiffused flash doesn't cover the same angle as these optics, resulting in flash pictures that are illuminated toward the center and get darker toward the edges of the frame. Diffusion domes eat up a lot of light, so you have to work close to your subject. Sto-Fen makes these domes to fit several different flash models (see Resources on page 157). Make sure to specify your flash unit when ordering.

Pocket Bouncers

The LumiQuest Pocket Bouncer is a clever device for bouncing a flash when you don't have a wall or ceiling to work with (see Resources on page 158). The gadget is a fan-shaped piece of white vinyl, about 4 x 8 inches, that attaches to your flash with Velcro. When the flash is aimed upward, the fan spreads out over the reflector at about a 45-degree angle, creating, in effect, a mini-ceiling. Accessory colored inserts are available for this device, so you can warm or cool your flash's color temperature for special effects.

Kitty Cole was one of the more flamboyant candidates in the mayoral race in a desert resort town. I photographed her posing in a Rolls Royce as part of a story I was shooting about Palm Springs, California, for Private Clubs *magazine.*

Nikon 8008s, Nikon 20–35mm AF zoom lens, Nikon SB24 flash set to -1 in matrix-balanced, fill-flash mode with stretched SC17 cord and mounted on lightstand, Fujichrome 100 exposed for 1/250 sec. at f/4

RoscoPak W

Rosco, the lighting-gel manufacturer, offers an ingenious little package that doesn't attach to your flash, but rather to a wall or the ceiling. The Roscopak W is a 4 x 4½-foot piece of extremely lightweight foil, white on one side, silver on the other, that crunches up into a little pouch and weighs less than 2 ounces. When you find yourself in a room with a dark ceiling and dark walls, you can tack up this sheet of foil, using gaffer's tape or Blu-Tak, and create your own bounce surface. This setup produces beautiful light. It takes a little more time to use than the other devices discussed here, but the results are much better. I keep a Roscopak in the back pocket of my camera bag at all times.

In the old days, bounce flash required some arcane calculations because of the light loss involved in bouncing and spreading the coverage of the illumination. With today's *dedicated "smart-flash" units*, all the exposure calculations are done through the lens of the camera (see page 52). All you have to do is to know enough to swivel the head toward a nearby wall or ceiling or put one of the above devices on the front of your flash reflector.

Bounce light and diffusion do eat up power, so you have to use a larger aperture, such as $f/2.8$ or $f/4$, than you would if you were shooting straight flash. Also, you can't stand too far from your subject, 6 to 10 feet tops. You can't work with ceilings that are more than 10 feet high.

Another option is to buy an accessory cord that enables you to take the flash off the camera, hold it in one hand with your arm outstretched, and direct the light from high and on one side of your subject. This technique produces natural-looking, sculpting shadows and helps eliminate the stark look that you get when the flash sits right on top of the camera. The resulting illumination still tends to be specular—that is, it has a hard quality—but the shadow placement somehow makes it look more natural and three-dimensional. I try to use my flash on an extension cord at all times, whether I'm bouncing it, using it directly, or using it for fill flash.

I'd actually finished shooting the sunset in another portion of this park, called the Place of Refuge, on the big island of Hawaii and was heading back to my car when I noticed that a bit of a dramatic sky was still visible behind these carvings. I set up the tripod and held the flash off-camera to evenly illuminate both statues and got off a few frames before the sky went completely dark.

Nikon 8008s mounted on tripod, Nikon 20–35mm AF zoom lens, Nikon SB24 flash set to -1 with SC17 extension cord, Fujichrome Provia exposed for 2 seconds at $f/4$

Fill Flash

To produce better flash pictures, you should work *with* the available light rather than try to overpower it. Think of the flash as the second light in a two-light setup, with the sun, ambient room light, or street light acting as the main source.

Probably the most exciting thing about the "smartflash" units is their ability to do just that: to automatically calculate *fill flash*, which is a contrast-lowering technique that used to be very complicated and difficult to pull off. Essentially, fill flash utilizes the flash as the secondary light, with the sun or the other sources of available light serving as the main light.

Why would you want to use a flash outdoors on a sunny day? Remember the discussion about the compressed tonal recognition of film? Basically, film can't see as many tones from light to dark as our eyes can. So if you have a sunny-day situation, with bright

"SMARTFLASH" MODES

Mastering this technique used to take months of experimentation and calculation, and was a constant source of vexation to photographers who tried it. In what must be the quietest part of the autofocus revolution, camera manufacturers have managed to completely automate this task. Again, you have only to learn to set the right mode on your flash, and the unit does the rest. The manufacturers have different names for this mode: Fill-In Flash, Always-On Flash, Slow-Synch Flash, Matrix-Balanced Fill Flash, and so on (see below). For many of us, these new flash capabilities are more valuable than the autofocus itself.

Flash-On Mode

This mode, which is also called Always-On mode, tells the camera to use the flash for every exposure, even out in bright sunlight, and to balance the exposure between the available light and the flash light. This is, essentially, computerized fill flash and is useful for opening up shadows on faces of people on sunny days, as well as for adding a bit of color and sparkle on overcast days. Most people pictures shot outdoors benefit from a touch of flash, but be sure to keep the subjects within the range of the flash, which is usually 4 to 12 feet.

Slow-Synch Mode

This is essentially the same as Always-On mode. Slow-Synch mode, which is also referred to as Nighttime-Flash mode, tells the camera to keep the shutter open long enough to record the background in a night shot, while the flash puts out just enough light to illuminate the people near the camera. This mode is useful when you want a picture of someone standing in front of an illuminated monument or city skyline at night. In normal mode, the flash would properly illuminate the subject, but the background wouldn't record because most cameras automatically default to their highest synch speed when the flash is activated.

Flash-Off Mode

This is the mode to use when you're taking night shots without any people in the foreground. The camera opens the shutter to record the dim available light, but since there is nothing to record in the foreground, there is no need to use the flash. Remember, most on-camera flash units can illuminate subjects only up to about 20 feet away; with any subject farther away, you're just wasting batteries. Be sure to have your camera properly supported by a tripod or some other support, otherwise the long shutter speeds will cause unsharpness due to camera movement.

Red-Eye Reduction Mode

Depending on the make and model of the flash unit, this mode sets off either a series of bright pre-flashes or one long glow in order to close down the pupils of your subject. Red-eye is caused when the light of the flash reflects off the blood vessels in the back of the retina. The effect becomes visible because, in dark rooms, most people's pupils are widely dilated. Red-eye occurs when the flash is placed closed to the axis of the lens. This is why red-eye is so prevalent in pictures taken with compact, point-and-shoot (P&S) cameras, whose flash sits just above the lens.

FILL-FLASH TIP

Many photographers find the factory-default fill-flash settings on their "smartflash" units to be a bit too hot; that is, the flash is still a bit too bright. If your flash unit permits you to program in an exposure adjustment to fill-flash settings, try starting with a -1 setting. Many users of Nikon and Canon flash units find this to be a good starting point for getting perfect yet subtle fill flash.

highlights and deep shadows, or any other contrasty-light situation, the film will record only one or the other. If you give enough exposure for the shadows to be readable, the highlights in your picture will burn out to a featureless white, especially on slide film. If you expose for the highlights, which is what most slide shooters will do, the shadows will be an impenetrable black.

Fill flash describes the process of using the flash to fill, or simply open up, the shadows with just the right amount of flash to make them readable without looking unnatural, as if two suns were shining in the sky. This technique works at night or indoors, too. But in these situations, instead of using the sun as the main source, you use the existing street or room lights, with just a "pinch" of flash to open up the shadows. Fill flash makes for very natural-looking photographs that don't have that telltale "flash look."

I use this technique both in bright sunlight and in low-light situations, such as room interiors or nighttime parades. In low light, the idea is to use a slow enough shutter speed to register the ambient light in the background, and to use a pop of flash on the subject in the foreground. Ideally, the blend of the two light sources will be so seamless as to look very natural and normal.

I was shooting pictures of the windmill at the historic Whim Plantation on St. Croix for a story about the U.S. Virgin Islands for the German magazine GLOBO *when this local youngster wandered over and asked me to take his picture (top). Although the ambient light was relatively soft, I used the fill-flash mode to clean up the shadows on his face (bottom).*

Nikon 8008s, Nikon 20–35mm AF zoom lens, Nikon SB24 flash, Fujichrome Provia exposed for 1/250 sec. at f/5.6 (top); Nikon 8008s, Nikon 20–35mm AF zoom lens, Nikon SB24 flash set to -1 in matrix-balanced, fill-flash mode (bottom)

England

"You haven't seen England proper until you've watched from the high ground in the Cotswolds as the hunt thunders past," the barman at the Black Horse Inn at Naunton stated flatly. Until that time, I thought I'd been doing a fair job of exploring the sceptered isle, the land where my mother grew up.

I'd tramped the high fells in the Lake District, tended bar in a London pub for a year of my life as a young man, danced at village fairs in Somerset, explored nearly every mile of the rugged coasts of Devon and Cornwall, and spent a few weeks among the "dreaming spires" of Oxford. Wherever I went, what impressed me the most about the landscape is the way that the hand of man and that of nature seem to be in perfect balance—every village, every hedgerow, every stone church tower are just where they're supposed to be.

And the light. Much is made of the quality of light in Provence or Tuscany, but not in Britain. Here, the talk is always of rain and foul weather. Yet I can't think of anywhere I've been where the light is more dramatic and fleeting. I hadn't really appreciated its properties, however, until one morning, taking the advice of the Black Horse barman, I stood on a foggy ridge overlooking Kineton. The village fairly glowed through the morning mist as 60 riders from the North Cotswold Hunt club galloped up the wold. The night before, in the hotel library, I read the words of J. B. Priestley describing what he calls the Cotswolds' "lovely trick." He wrote, "Even when the sun is obscured . . . the walls are still faintly warm and luminous, as if they know the trick of keeping the lost sunlight of the centuries glimmering about them." I disagree with Priestley in only one regard: I think the whole of England is privy to the secret.

▲ Working in Devon, I liked the way the window both provided the light for this tea-service shot and gave a glimpse into the English garden behind it.

Nikon 8008s, Angenieux 28–70mm AF zoom lens, Fujichrome 100 exposed for 1/60 sec. at f/2.8

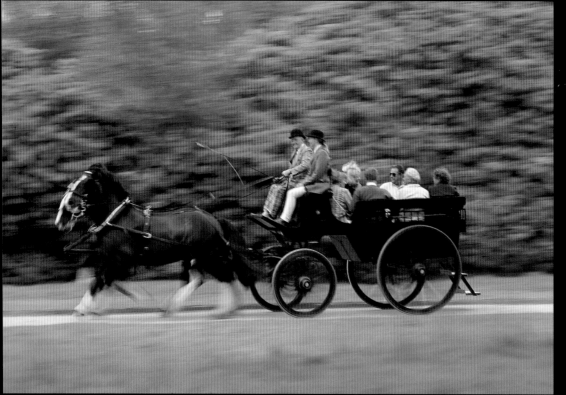

◀ I used a slow shutter speed and panned the camera to give a feeling of motion to this shot of people on a carriage ride at Arlington Court, a National Trust property in northern Devon.

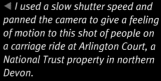

Nikon 8008s, Nikon 80–200mm AF zoom lens, Fujichrome Velvia exposed for 1/30 sec. at f/8

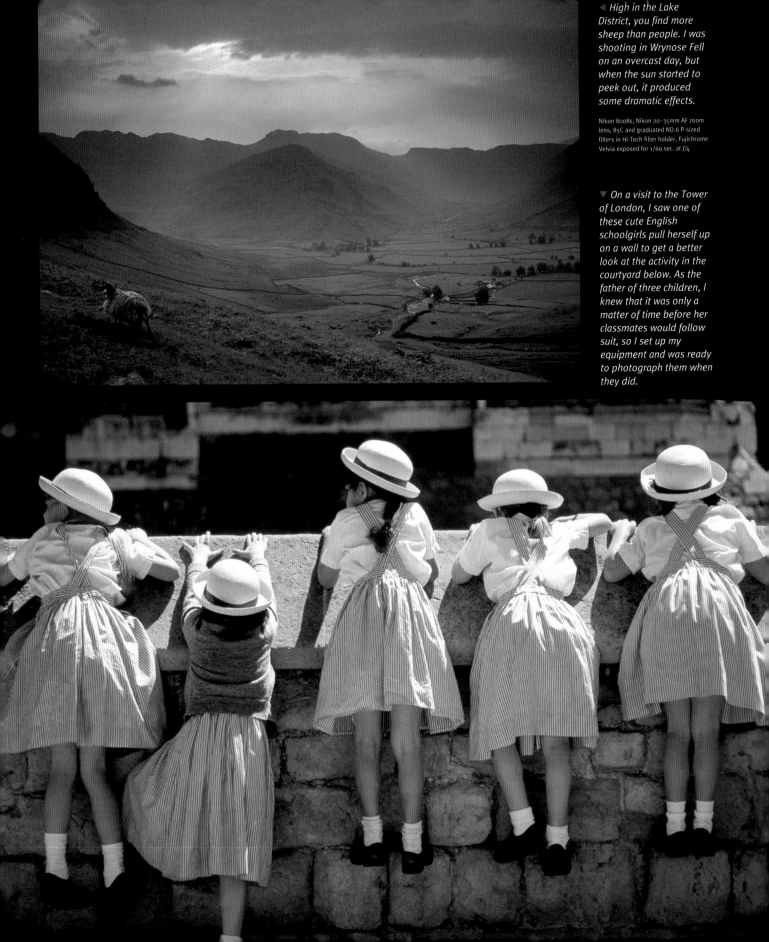

◀ *High in the Lake District, you find more sheep than people. I was shooting in Wrynose Fell on an overcast day, but when the sun started to peek out, it produced some dramatic effects.*

Nikon 8008s, Nikon 20–35mm AF zoom lens, 85C and graduated ND.6 P-sized filters in Hi-Tech filter holder, Fujichrome Velvia exposed for 1/60 sec. at f/4

▼ *On a visit to the Tower of London, I saw one of these cute English schoolgirls pull herself up on a wall to get a better look at the activity in the courtyard below. As the father of three children, I knew that it was only a matter of time before her classmates would follow suit, so I set up my equipment and was ready to photograph them when they did.*

▶ *The cobblestone walkway to St. Michael's Mount off the coast of Cornwall is amenable to walking or riding only during low tide. When the tide comes in, you can reach the castle just one way: by boat.*

Nikon 8008s, Nikon 20–35mm AF zoom lens, 85C warming and graduated ND.6 P-sized filters in Hi-Tech filter holder, Fujichrome Velvia exposed for 1/60 sec. at f/5.6

▼ *I was on my way home from riding with a hunt club when I spotted this artist by a riverbank in Lower Slaughter. The day was gray and overcast, so I used an 81C filter to counteract the bluish light, and a two-stop graduated neutral-density filter to emphasize the cloud cover.*

Nikon FE2, Nikon 24mm lens, 81C warming and graduated ND.6 P-sized filters in Cokin filter holder, Kodachrome 64 exposed for 1/60 sec. at f/5.6

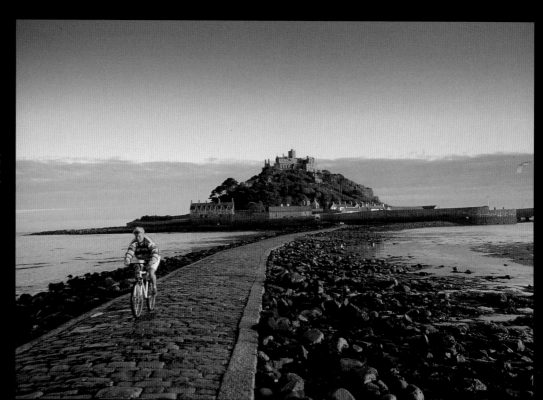

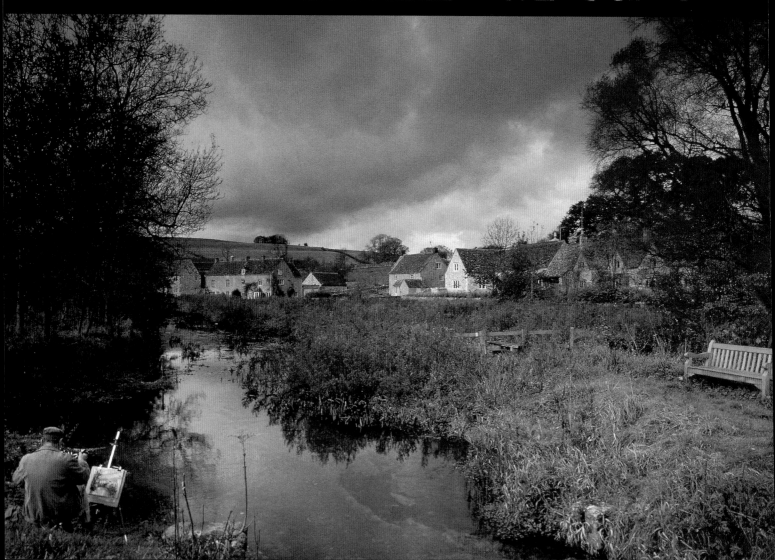

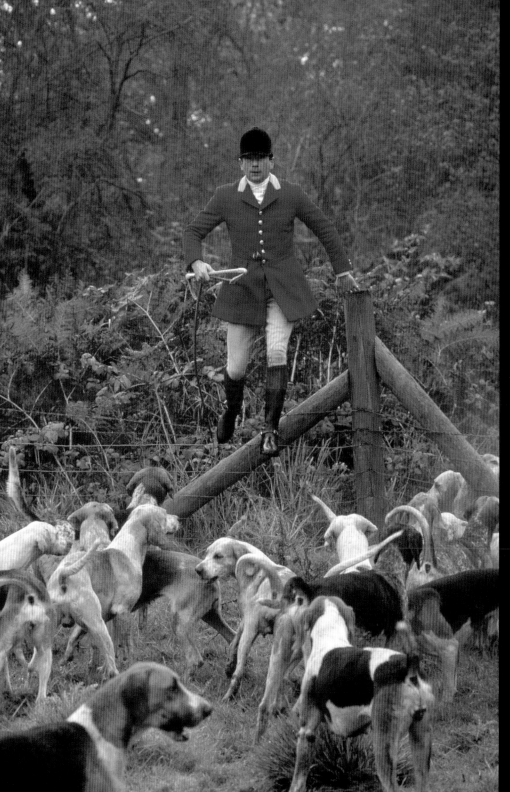

▲ I was trolling the pubs on market day in Moreton-on-Marsh, looking for some interesting old characters who might be quenching their thirst while their wives were shopping, when I came across this four-legged character. Max, the pub dog, was seated comfortably near a window, which provided the illumination for this portrait.

Nikon FE2, Nikon 24mm lens, Kodachrome 200 exposed for 1/60 sec. at f/2.8

◄ When the hunt slowed down and this huntmaster had to dismount to check out what the dogs had found in Kineton, I was only too glad to get off my horse as well. When I saw him climb over the fence, I knew he had to come back the same way, and I was ready when he did.

Nikon FE2, Nikon 105mm lens, Kodachrome 200 exposed for 1/125 sec. at f/4

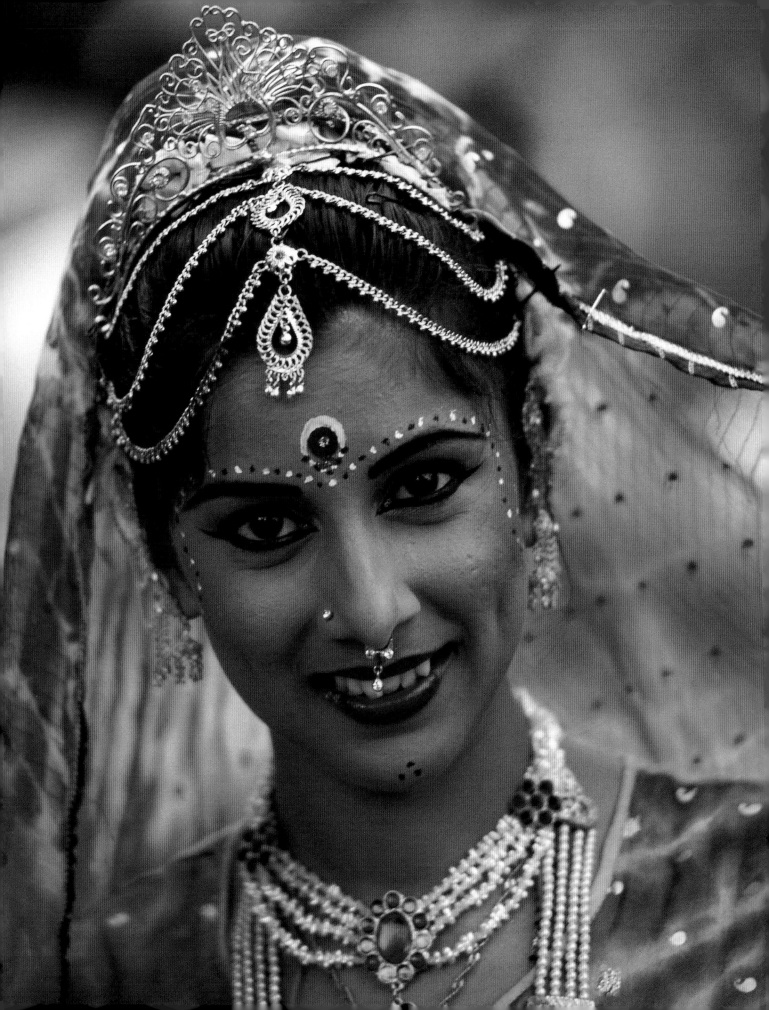

Photographing People

"There is no great secret, except time, to developing an intimacy with your subject. Honesty is your best opening card. Somehow you have to project—through your words, your mannerisms, something in your voice—that you're trustworthy, because you're asking to be allowed to be a witness, to be present."

WILLIAM ALBERT ALLARD, *National Geographic* photographer

I HAVE A FRIEND who is an adventurous traveler and talented amateur photographer. He has trekked the Himalayas, rafted the rapids of several wild rivers, and parasailed over Mexico's Pacific Coast. And he has some great pictures to prove it. In all his travels, only one photo subject has terrified him. "People," he confesses. "I'd love to get some good people pictures from these places, but I just freeze."

My friend isn't alone. A lack of people pictures is one of the most common reasons that vacation slide shows can turn into visual lullabies for friends and family. What causes even the most skillful photographer to overlook this one important aspect of travel photography? Shyness is the main factor. "I just feel awkward approaching a stranger and asking to take his picture," says my friend. He laments, "You can always tell the pros when you're out shooting. They're the ones who aren't afraid to walk up to someone and start taking pictures." While this is an exaggeration, it is true that breaking the ice is the most difficult part of photographing people.

While covering the annual Chingay procession held to celebrate Chinese New Year in Singapore for Islands *magazine, I spotted this woman in a troupe of Indian dancers. She was very beautiful and self-assured, and as soon as she saw me she struck a pose and lighted up with a smile. I just needed to use a large aperture to blur out the distracting background.*

Nikon 8008s, Nikon 80–200mm AF zoom lens,
Fujichrome 100 exposed for 1/125 sec. at f/2.8

Breaking the Ice

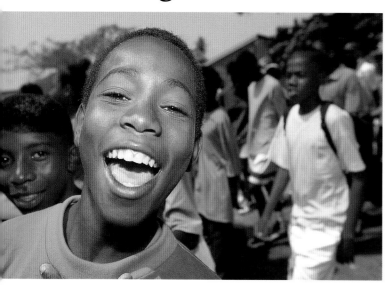

It might be hard to believe that strangers won't react with annoyance or hostility when approached for photographs, but the fact is that many people are quite flattered by the idea. I photograph hundreds of people a year in the course of my assignments; only a handful ever refuses to cooperate. A few years ago, the Maine Photographic Workshops conducted a study and found that in a test group of more than 300 people, less than 25 percent felt any unease when being photographed.

Obviously it isn't potential subjects who are the problem; it's the photographers themselves who resist getting up close and personal. Some photographers automatically equate being aggressive with being obnoxious. The stereotype of the paparazzi badgering the harried celebrity is hardly typical. Most accomplished people photographers are really quite charming (if we do say so ourselves!). So, after you've decided that it really is okay to photograph an appealing stranger on the street in Paris or Podunk, what next?

▲ *On assignment for* Insight Guides, *I was photographing a school parade in the village of Soufrière, St. Lucia, when this ebullient boy literally stuck his face right in front of the lens. I got off just one frame before he bolted. Even though he was closer than the lens' minimum focusing distance and, therefore, not tack sharp, I like this shot anyway for its energy and spontaneity.*

Nikon 8008s, Nikon 20–35mm AF zoom lens, Nikon SB24 flash set to -1 in matrix-balanced, fill-flash mode, Fujichrome Velvia exposed for 1/250 sec. at f/5.6

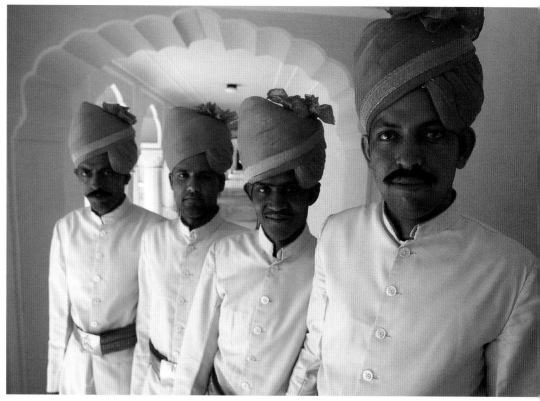

▶ *I was working in Rajasthan, India, on a* Travel/Holiday *assignment when I noticed that these guards at the City Palace were very interested in me and my equipment. Sensing that I might be able to capitalize on their curiosity, I requested permission for a group shot. I took the guards out of the harsh sun in the courtyard and into the soft light in the arcade running along the perimeter of the palace for this shot.*

Nikon 8008s, Nikon 20–35mm AF zoom lens, Fujichrome 100 exposed for 1/60 sec. at f/4

▶ *Strolling through the "blue city" in Jodphur, India, which is the Brahmin section where all houses are painted blue, I spotted this woman chatting in a doorway with a neighbor. Out of the corner of her eye, she saw me raise my camera, and when she didn't object, I simply made a bracketed series of exposures.*

Nikon 8008s, Angenieux 28–70mm zoom lens, Fujichrome 100 exposed for 1/60 sec. at f/2.8

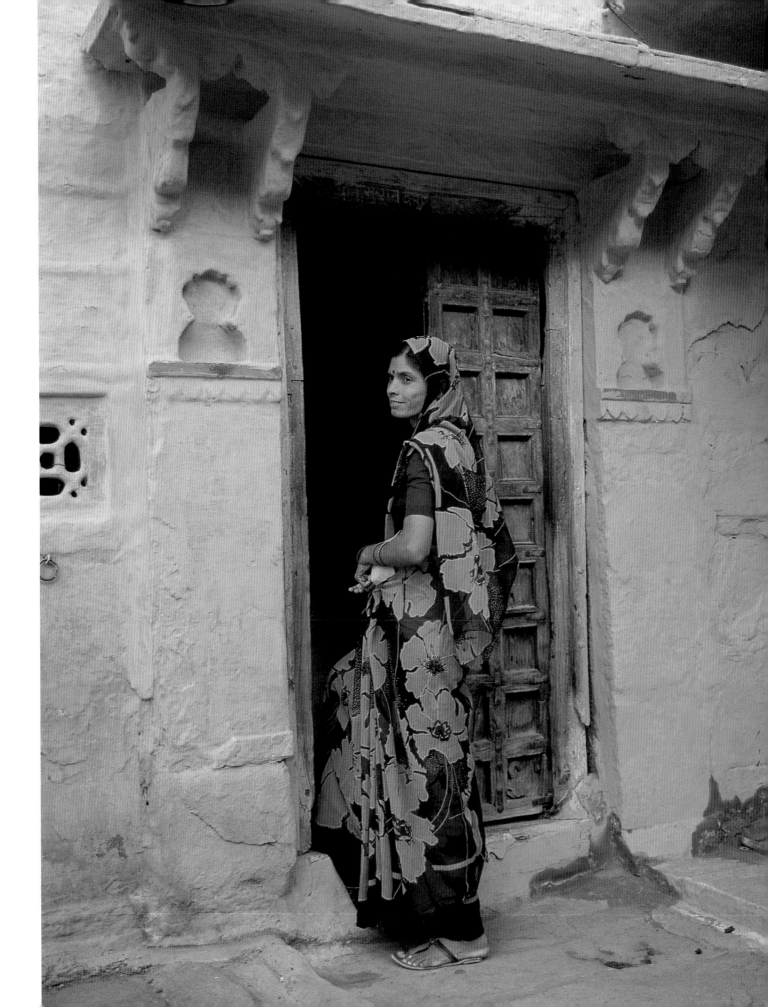

Making Small Talk

Unless English is the language of the place you're visiting, try to learn a few phrases in the native tongue. Something like "I'm a photographer from _____. May I take your picture?" will do. By approaching people using their own language, you show that you're making an effort. It works wonders even if you do mangle the words. Avoid the common pitfall of expecting foreigners to understand English just because you're speaking it slower and louder than you do at home.

Try to keep up a patter after you've started to photograph, with lots of smiles, pantomime, and any other appropriate phrases in the native tongue. I recall a lively conversation I had with a Haitian woman on her way to the market. While I photographed her, she rattled away in Creole, I chattered in English and French, and we both laughed and had a great time. Even though neither of us understood a word the other was saying, our mutual incomprehension was no impediment to our photographic communication.

If you're still reluctant to approach potential subjects cold, try photographing the people you naturally interact with during your travels. Waiters, doormen, taxi drivers, street vendors, shopkeep-ers, and street artists are all used to requests from travelers and are usually happy to pose for a picture or two. Peggy, my wife and a talented amateur photographer, capitalized on this technique during a trip through Portugal. Each day, she put together a picnic lunch, stopping at butcher shops, bakeries, fruit and vegetable vendors, wine shops, candy shops, and so on. After chatting, or attempting to chat, with each shopkeeper and making her purchase, Peggy pulled out her camera, smiled sweetly, and asked for a picture. What she ended up with was a lovely, warm set of personal portraits—and great picnic lunches.

You don't, however, have to buy something from possible subjects in order to make contact with them. The friendly police officer who gives you directions and the woman behind the counter at the tourist office will almost always pose for a picture. Doormen, waiters, cab drivers, and bellhops are usually happy to oblige, especially since you're probably tipping them for their services anyway. After you've had your first few photographic encounters with these types of subjects and discovered how easy and fun they can be, you'll feel more confident and ready to handle more challenging portraiture.

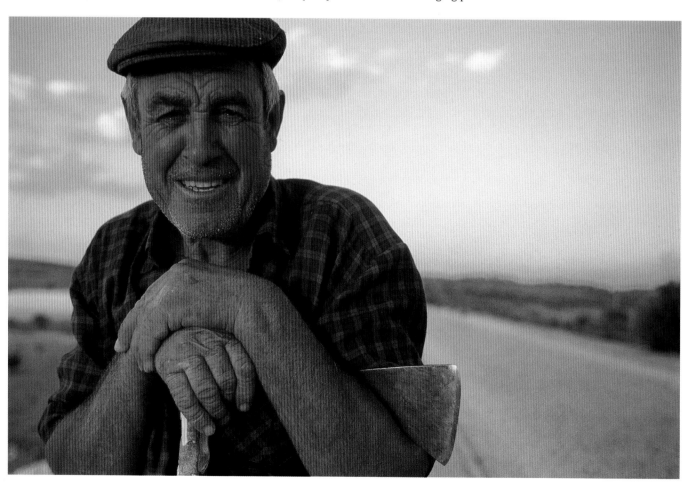

▶ *Shooting on assignment for* National Geographic, *I was walking down a small street in a village on Gozo, Malta, when I saw this duo waiting for a bus. I went over and introduced myself and started cooing over the child, smiling and making jokes. The grandmother got into the act, and when she started hugging, I was ready with my camera.*

Nikon FE2, Nikon 35mm F1.4 lens, Kodachrome 64 exposed for 1/60 sec. at f/4

◀ *I came across this shepherd tending his flock in the last rays of the setting sun when I was shooting in Alentejo, Portugal, for an article for* Travel & Leisure *magazine. He didn't understand English, and my Portuguese is nonexistent. But I kept chatting to elicit a range of expressions from him.*

Nikon 8008s, Angenieux 28–70mm zoom lens, Fujichrome 100 exposed for 1/60 sec. at f/4

I was in Savannah, Georgia, photographing the real-life characters from the book Midnight in the Garden of Good and Evil *for a story in* Travel/Holiday *when I met John and Victoria Duncan, a thoroughly delightful couple who run an antique map store and are mentioned in the book. I let the ambient light burn in to register the warmth of the surroundings. My biggest problem was getting the dog to look at me!*

Nikon 8008s mounted on tripod, Nikon 20–35mm AF zoom lens, Nikon SB24 flash set to -1 in matrix-balanced, fill-flash mode with SC17 extension cord and bounced into small umbrella mounted on lightstand, Fujichrome Provia exposed for 1/4 sec. at f/4

Give Yourself a Mission

National Geographic photojournalist Jim Richardson says that one reason professional photographers seem to be more adept at overcoming their shyness and photographing strangers is that we have a clear-cut "mission": we are on a professional assignment. When I take the time to explain my project to potential subjects, more often than not they want to jump on board and help me with my task. It is downright amazing how quickly perfect strangers can become willing co-conspirators once you explain your quest.

Jim suggests that amateur photographers try the same approach. Rather than just asking someone in, say, Ireland if you can take his or her picture, try giving yourself an assignment ahead of time and asking about that. Then, for instance, you explain that you're doing a slide show called "Portraits of the Irish" for your local school or church group, or perhaps that you're working on "a personal photographic project about village life in Ireland." Try to impart your excitement and passion about this project to your subject, and you'll have a much better chance of getting cooperation.

If you're traveling in a country where you don't speak the language, take the time to write a letter explaining your project. Then get it translated into the local tongue. Putting this on professional-looking letterhead that says something like "John Doe, Documentary Photographer" only adds to the importance of your mission.

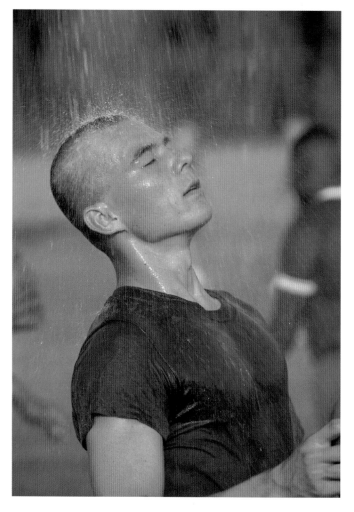

In Apia, Samoa, the village leaders, or matais, all sport these full-body tattoos as signs of their manhood and leadership. On assignment for Islands magazine, I'd persuaded this young man, who had Western-style tattoos along with the more traditional kind, to pose for me near the shoreline. By not showing his face, I turned him from an individual into something of a symbol.

Nikon 8008s, Nikon 20–35mm AF zoom lens, Fujichrome Velvia exposed for 1/125 sec. at ƒ/5.6

▶ I came across this fisherman mending his nets while on assignment in Choiseul, St. Lucia, for Islands magazine. The hanging nets made a great background for the portrait, adding color and texture while revealing something about the man himself and how he makes his living.

Nikon 8008s, Angenieux 28–70mm AF zoom lens, Fujichrome Velvia exposed for 1/60 sec. at ƒ/4

◀ I spent a day photographing Marine recruits undergoing boot-camp training on Parris Island as part of a story about the Low Country of South Carolina for Islands magazine. I could have photographed many more dramatic scenes of recruits slogging through mud, undergoing hand-to-hand combat, rappelling, etc., but I liked this quiet image of a recruit cooling off in the outdoor showers that are set up around the facility to prevent heat exhaustion.

Nikon 8008s, Nikon 80–200mm AF zoom lens, Fujichrome Velvia exposed for 1/125 sec. at ƒ/2.8

Nikon 8008s, Nikon 80–200mm AF
zoom lens, Kodachrome 200
exposed for 1/250 sec. at f/2.8

The striking eyes of this gentlemen were what first caught my attention as I prepared to board a train at the Jodphur station in India. I made eye contact with him, raised my camera in query, and he nodded. I shot a few frames before the train pulled away.

Tipping

The subject of tipping for pictures is a touchy one. For people who make their living by tips—waiters, street entertainers, bellhops, and so on—I have no problem offering a small tip in exchange for tying up their time in a short photo session. But the same gesture might be an insult to the average person in the street. In some developing countries, profligate tipping for pictures has elevated expectations among natives cashing in on the local travel boom.

No hard-and-fast rule governs gratuities for photographs. In general, it is best to avoid tipping entirely. But if the local precedent has already been set and you're being hassled for payment, consider offering a "gift" instead of cash. Something as simple and inexpensive as a balloon is appropriate for children. Older children and adults might appreciate pens, which are cheap to buy in bulk and easy to pack.

Some professionals carry an instant-picture camera, like a Polaroid SX70, to act as an icebreaker. The resulting Polaroids serve as a way to offer your subjects something tangible, in the form of a picture of themselves. I admit to carrying one of these cameras, especially in areas like the Caribbean, rural outback areas, and other places where people might be reluctant to be photographed.

On assignment in Iceland for *National Geographic* magazine, I'd made arrangements to spend a couple of days photographing the activities of a large family on a remote farm. During the first morning, the family members were polite but somewhat distant. When the patriarch started lifting his grandchildren onto ponies to ride to herd sheep, I snapped a few instant pictures. All farming activity stopped as the children and their grandfather examined their photographs with unabashed delight. Soon other family members gathered round, and I snapped a few more pictures. Now I was not only a guest, but also a friend. At the family's insistence, my two days stretched to four, and the experience yielded some great pictures for me and my hosts.

Be selective and discreet when using your instant-picture camera as an icebreaker. News of "free" pictures travels fast, and you can easily find yourself surrounded by dozens of people clamoring for complimentary snaps. I found this out the hard way when I took an instant picture of a children's dance troupe in Portugal. I had a mini-riot on my hands until all 16 children got a copy!

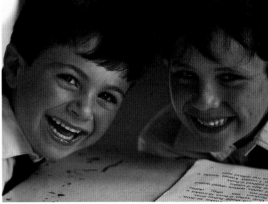

▲ *I was photographing in a school in Gozo as part of my coverage of Malta for* National Geographic. *I noticed that while most of the students were paying close attention to the teacher, these two rascals were in a more playful mood. I worked quickly from across the room because I didn't want to disrupt the educational atmosphere.*

Nikon FE2, Nikon 180mm ED lens,
Kodachrome 64 exposed for 1/60 sec. at f/2.8

◀ *Covering a Carnevale parade on assignment for the Puerto Rico Tourism Company, I noticed these two musicians taking a break on a porch in Ponce. I pantomimed for them to pick up their tubas, which they did willingly.*

Nikon 8008s, Nikon 80–200mm AF zoom lens,
Fujichrome Provia exposed for 1/125 sec. at f/2.8

Go With the Flow

Once you've broken the ice, work efficiently before the water freezes over again. The fastest way to lose the attention of your newly won portrait subjects is to spend an inordinate amount of time fussing with the controls of your camera. You've got to be familiar enough with the workings of your camera so that you can keep chatting with your subjects to keep them relaxed, and can shoot quickly enough to prevent them from getting bored. If you use your camera only once or twice a year, brush up on your camera-handling techniques before you leave on your trip. This sounds tedious, but it can be fun if you practice on family and friends.

If you don't have the time to practice, consider using an auto-everything, point-and-shoot (P&S) camera for your people encounters. These cameras relieve you of many photographic decisions and operations that can slow you down. Also, using this type of camera might make for a more relaxed session for both you and your subjects.

At one of the classes I lead every summer at the Maine Photographic Workshops, I had a student who carried a small P&S camera along with her single-lens-reflex (SLR) gear. In every encounter we had with the local people, her more heavily equipped colleagues were hunched over their tripod-mounted SLR cameras as she snapped away with her "toy" camera while walking, talking, and generally charming her subjects. When we reviewed the daily results, her people pictures were always the most spontaneous and pleasing.

I have a Contax G2, a rangefinder camera with interchangeable lenses, as well as a Ricoh GR1, a high-quality P&S camera with a 28mm lens, that I carry with me on most assignments. I find them extremely useful when I need to get professional-quality pictures without looking like a professional photographer. For example, on one assignment on the island of St. Lucia in the Caribbean, the editor wanted coverage of the lively street party held every Friday night in the village of Gros Islet. While the locals don't seem to mind tourists taking snapshots, anyone who appears to be taking pictures for profit—that is, a photographer laden with sophisticated gear—gets hassled and stirs up resentment. I wandered about and shot freely with my two little cameras, and got plenty of good pictures without upsetting anyone.

I was shooting a story on the Ozarks for Travel/Holiday *magazine when I came across these fellows outside a cafe in Arkansas. I engaged them briefly in conversation about the weather and then asked permission to photograph them. I solved the problem of contrasty light by using fill flash, but I had to shoot from a very low angle, literally crouching in the gutter, to hide the reflection of the flash in the cafe window. The guys got a kick out of watching my contortions and relaxed entirely while I worked.*

Nikon 8008s, Nikon 20–35mm AF zoom lens, Nikon SB24 flash set to -1 in matrix-balanced, fill-flash mode, Fujichrome Velvia exposed for 1/250 sec. at f/5.6

Get the Best Shot Possible

A keen sensitivity to light is also essential for good people pictures. As discussed earlier in the chapter on light, it bears repeating that direct sunlight is extremely unflattering for people photography. I'll almost always look for open shade or backlight when photographing people. These lighting conditions are more flattering, and the lower contrast enables the film to work its magic, revealing subtle details and shades that would otherwise be missed in contrasty sunlight.

But light isn't your only consideration. You should also try to vary the composition of your people shots. One approach that I've borrowed from television and film is to start with a few wide-angle establishing shots that show the subjects in their environment. Then I move in a bit tighter for some medium shots, which show the subjects at full or three-quarter length. Finally, I move in closer still for some closeup *head-and shoulder shots.* If you shoot this way, you'll have a choice of

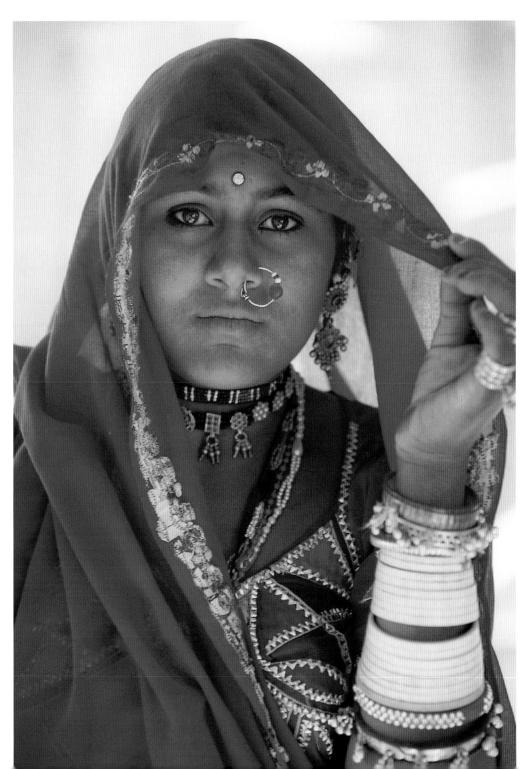

Shooting a story about a train trip across Rajasthan for Travel/Holiday *magazine, I was in a market in Jaisalmeer, India, when I noticed this woman in her striking garb. Once I got her to agree to pose by pantomiming my request, I moved her to the edge of the shaded market canopy. I knew that the sun beating off the nearby sandy road would act as a fill card.*

Nikon 8008s, Nikon 80–200mm AF zoom lens, Fujichrome 100 exposed for 1/250 sec. at f/2.8

what to show later on, and you can inject some variety into your slide shows or print presentations. Be sure to switch from a wide-angle lens to a telephoto lens for head shots; the distortion that results when a wide-angle lens is used close to a subject would even make actor Tom Cruise look like Frankenstein's monster.

You can learn a lot by studying the people pictures that grab your eye in magazines. Notice where the subjects are placed in the composition, how they are posed, and how the light hits them. Try to use some of the same techniques in your own travel portraiture. You'll be pleasantly surprised at how the intelligent application of a few basic principles will greatly improve your pictures.

▲ *I was shooting a feature on the majestic Blantyre, a bed-and-breakfast establishment in Pittsfield, Massachusetts, in the Berkshire Mountains, for* Travel & Leisure *magazine. The owner and her manager made an elegant pair, and I posed them next to a big bank of windows for a classic, window-lit portrait.*

Nikon FE2 mounted on tripod, Nikon 24mm lens, Kodachrome 64 exposed for 1/4 sec. at f/2.8

▶ *As part of a* National Geographic *assignment, I'd arranged to shoot a portrait of some of the few remaining Knights of Malta who actually reside on the island in the historic Knights' Palace in Valletta. I'd planned to light the picture with battery strobes, but they malfunctioned. So I found a nice bit of window light and positioned the knights accordingly.*

Nikon FE2 mounted on tripod, Nikon 24mm lens, Kodachrome 64 exposed for 1/8 sec. at f/2.8

I came across the local priest in a historic wooden church near the village of Lom in central Norway. I liked the way the window light blended with the warmth of the church's incandescent lights, so I set up for this environmental portrait to take advantage of this appealing combination.

Nikon 8008s mounted on tripod, Nikon 20–35mm AF zoom lens, Kodachrome 200 exposed for 1/30 sec. at f/4

MODEL RELEASES

Without a doubt, the most commonly asked question about people photography at my lectures and workshops concerns model releases. Are model releases necessary? I wish there were one definitive answer, but there isn't. It depends on what you want to do with the pictures.

Although a general erosion of First Amendment-type rights has taken place around the world lately, it is still fairly safe to say that for most editorial purposes, you don't need a model release in order to publish a picture of a person. This assumes that the person was photographed in a public place, and the picture doesn't denigrate the person in any way. However, this isn't always the case; recent court decisions in Canada and the United States have ruled otherwise. For the most part, though, this is still a relatively safe assumption.

You should have a model release for any person shown in a picture that will be used in an advertising or promotional way. This is why stock agencies insist that all pictures of people are model-released. The agencies don't want to have to think about the possible usages and legal ramifications of unreleased pictures, so they simply make a blanket requirement for model releases. In a society in which you can be sued for millions of dollars for serving people the cup of hot coffee they ordered—and lose the case, to boot—you can't be too careful. So, if you're courting a stock agency, you better get model releases. I've heard stories of photographers' assistants trailing behind the photographers, getting everyone within lens range to sign a release. This sounds like an unwieldy and disruptive process, and I can't imagine being a guest in a foreign land and doing this.

I'll try to get a model release if I feel that the picture has some commercial potential, such as a particularly attractive child or person in a great situation. However, during many of my encounters overseas, I've spent an inordinate amount of time "courting" my subject, establishing a fragile bond of trust in order to get the picture taken. Whipping out a model-release form with the "legalese" at the end of such an exchange seems crass at best and could engender real mistrust and hurt at worst. So I often pass on the model release, even when I know I should try to get one. I'm getting a little better at asking, but I still cherish the moment more than the stock value of some of my encounters—and this is probably why I drive a Mazda instead of a Mercedes.

Festivals, Parades, and Special Events

When you study travel magazines, you'll notice that, very often, story layouts contain pictures of parades, festivals, street fairs, and the like. This is no accident. Professional travel photographers know that people just love to look at interesting pictures of other people, and these exciting celebrations are the best place to get these pictures. The first thing I do when I receive an assignment is to check that area's calendar of events. I might even schedule my whole trip around one that has great visual potential.

Since shyness is a major stumbling block to getting good people pictures, the events are very important. Folks involved in festivals and parades make it easy for photographers because they not only don't mind being photographed, they actually invite it and

These dancers from a remote island in Malaysia were marching in the annual Chingay Parade in Singapore. As they lifted their compatriot up on the pole, I snapped away, shooting handheld.

Nikon 8008s, Nikon 20–35mm AF zoom lens, Nikon SB24 flash set to -1 in matrix-balanced, fill-flash mode, Kodachrome 200 exposed for 1/15 sec. at f/2.8

Part of the Chinese New Year celebration at a temple outside Kuala Lumpur, Malaysia, is this wild Lion Dance. Because of the surging crowds and my desire to show a little of the movement of the dancers, I handheld my camera during the long exposure; I knew that the flash would render parts of the scene sharply.

Nikon 8008s, Nikon 20–35mm AF zoom lens, Nikon SB24 flash set to -1 in matrix-balanced, fill-flash mode, Kodachrome 200 exposed for 1/8 sec. at *f*/2.8

enjoy it. The festive atmosphere brings out the best in everyone, and the usual barriers of language and shyness come tumbling down. In addition, the special decorations, costumes, fireworks, bonfires, cultural-dance displays, and other activities associated with these events also provide wonderful photo opportunities.

DO YOUR HOMEWORK

But photographing a festival or parade require some planning and preparation—it isn't just a matter of pointing and shooting. The first step is to track down any events that might be taking place during your visit. This sounds fairly straightforward, but you would be surprised how inexact the information available in guidebooks and brochures can be. For example, "The spring festival in early May is not to be missed." In order to get more specific information, you should contact the U.S.-based tourist-board office of the country or region you're going to be visiting, or the state tourist office if you're planning a domestic trip, and ask for a

current calendar of events. National Tourist Office websites can be helpful, but only if the host organization updates the coming-events calendars frequently.

Once you've spotted an event that you think might have potential, don't be shy about calling back with specific questions and requesting a detailed schedule of the festival's activities. Your research shouldn't stop once you arrive at your destination, though. The more detailed information you have about the event, the better you'll be able to plan your photography.

How important is this? Early in my career, I found myself in the small village of Vila Franca De Xira in Portugal. I'd come from Lisbon for the day because of a Festa Brava, which is a local event centered around bullfighting. I hadn't bothered to track down a specific schedule of events and was wandering around a dusty square near the village center when I noticed that most of the streets entering the square were barricaded and people were gathering on porches and balconies.

Suddenly, six angry bulls rocketed out of a side street into the square. This, as it turns out, was the part of the festival when the young men of the village prove their bullfighting prowess in the streets. Instead of photographing the event, I'd become part of it! A mad dash and a scramble over an 8-foot wall saved me, but both my cameras and my pride were slightly dented. Needless to say, since then I leave no stone unturned when it comes to researching the minutiae of festival schedules.

If no major events are scheduled during your trip, don't give up. Even a minor happening, if it is the right kind, can provide fodder for your camera. I was on assignment in the charming but very quiet village of Ebeltoft in Denmark, hoping for something to bring a little life to the pictures of quaint architecture and cobblestone streets. The town's calendar of events announced that every evening at 8, 9, and 10 P.M., two men carrying lanterns and wearing the traditional night-watchman uniforms made their way through the streets, singing out cries of "All's well." This wasn't a big deal to be sure, but I followed up on it and was able to get a nice atmospheric picture. After a while, you become adept at interpreting these calendars. An evening lecture or slide show, for instance, doesn't have much picture potential, while something as simple as a folk-dance demonstration or as silly as a crab race can provide plenty of superb photo possibilities.

THE RIGHT PLACE AT THE RIGHT TIME

Once you've tracked down an event, the next step is to actually shoot it. This often involves photographing the parades and processions that are a staple of many festivals. But these can be frustrating to photograph because of crowds, bad backgrounds, and,

in some large parades, limited access. Don't worry; you don't have to be stuck on the sidelines with everyone else. There is a simple way to work around this.

Using the detailed information and schedules you obtained in your research, find out the parade's starting point. You should plan on arriving there about an hour or two before the procession is scheduled to begin. For example, if the parade is going to start at 10 A.M., plan on arriving between 8 and 9 A.M. While the parade route itself might be roped off, lined with spectators, and accessible only to credentialed members of the press, the starting point is usually easily reached. Marchers are required to gather early, and while they're lining up and waiting, you can get close-up portraits of individuals and groups. In large parades, the groups often start marching *blocks* before the actual starting point, and you can walk along with them and shoot freely without incurring the wrath of spectators or officials. Even if I have official credentials to cover an event, I show up early and usually end up getting my best shots then.

Mobility is critical when you choose equipment to cover these events. I often leave my camera bag behind and wear a multi-pocketed photo vest. Although you really need only one camera body, in order to eliminate downtime spent changing lenses I rely on two cameras, each fitted with a zoom lens, a 20–35mm and an 80–200mm. I use the 20–35mm wide-angle zoom lens to get overall shots of the festival grounds and groups of marchers, and I use the 80–200mm zoom lens to photograph individual portraits. Shooting at wide apertures, such as $f/2.8$ and $f/4$, to exploit the limited depth of field at the telephoto end of the 80–200mm is a handy way to soften busy backgrounds that often

This shot shows another group of lively dragon dancers from the annual Chingay procession in Singapore celebrating the Chinese New Year.

Nikon 8008s, Nikon 20–35mm AF zoom lens, Nikon SB24 flash set to -1 in matrix-balanced, fill-flash mode, Kodachrome 200 exposed for 1/15 sec. at $f/2.8$

mar otherwise strong pictures. An electronic flash unit, which is useful for lightening shadows on faces during the day, rounds out my gear.

You'll react more quickly to fast-moving events if you take your film out of the boxes and canisters and carry it in a clear plastic bag. Estimate how many rolls you think you'll shoot and then double that number; you don't want to be searching for film when you should be shooting it. Film choice is a matter of taste, but I prefer an ISO 100 slide film like Fuji Sensia 100 or Kodak Elitechrome 100, along with a roll or two of faster ISO 200 film like Kodak's Elitechrome 200 for low-light situations. Carry a spare set of batteries for both your camera and flash unit. Murphy's Law clearly states that if you don't, your batteries are guaranteed to give out at the peak moment of any event.

During most festivals, your people-picture opportunities won't be limited to just parades. Folk dances and craft demonstrations are also popular. Arriving 10 to 15 minutes early will usually ensure you a front-row seat at these events. Since most stages are elevated, try shooting from the stage-floor perspective. This dramatic angle is especially effective for photographing dancers because it emphasizes their footwork.

MIX UP YOUR SHOTS

If the light is low and you're using flash, try setting your shutter speed to 1/4 sec., 1/8 sec., or 1/15 sec. instead of the camera's higher synch speed. These slower shutter speeds will cause the fast-moving dancers to blur slightly, while the pop of flash will freeze them. The combination of blur and sharpness can create exciting images with a strong sense of movement.

Look for storytelling closeups and detail shots. Whether you're shooting Mozart candy at the Salzburg Festival in Austria or elaborate headgear at New York City's Easter Parade, these symbolic pictures help to convey the feel of the event. Include a symbol in your portraiture whenever possible, For example, a closeup of a cute little kid waving the Stars and Stripes at a Fourth of July celebration tells you much more about the event than a straight headshot.

Keep in mind, though, that once you get caught up in the spirit of the celebration, it is easy to forget the all-important scene-setting shot of the parade or festival. The best view is often from above, such as from a balcony, an office, or an apartment window. Sometimes photographing this kind of perspective requires making previous arrangements, but more often than not I simply look up, try to catch someone's eye, and lift my camera hopefully. I've been invited into countless homes and gotten plenty of great overall views using this approach. The big problem, you'll find, isn't getting invited in but exiting gracefully amid all the invitations to eat, drink, and be merry with the locals.

Covering a Victorian Weekend in the seaside resort town of Ilfracombe, England, while shooting a story on Devon for National Geographic Traveler, *I was struck by this little girl's incredible eyes and her flowered dress. I got some shots of her with her mother and grandmother, who were dressed in similar outfits of the same material, but then decided to concentrate on the little girl and her wonderful expression.*

Nikon 8008s, Nikon 80–200mm AF zoom lens, Ektachrome 100SW exposed for 1/125 sec. at f/2.8

A Festival in Southern India

The south of India is a place apart. Tamil, the native language, has been spoken for thousands of years. Also, the culture is more fully preserved here than in the north because the south was never taken over by Muslims and has remained Hindu. Much of the towns' temple architecture, built during the Chola Dynasty, which began in the 10th century, remains intact. The Rathas, in Mahabalipuram, were carved directly out of the huge granite outcroppings near the coast. A few hundred yards away, the beautiful Shore Temple dominates the beach. The huge bas-relief in this town depicts the Hindu epic, *The Mahabharata*. Many of the scenes of the bucolic countryside depicted in stone can be seen in real life on the roads just outside the town itself.

In the early winter, the Pongal harvest festival is celebrated with events that have remained unchanged for centuries. Women buy special bowls to prepare the harvest feast and decorate the ground outside their homes with intricate, colorful patterns drawn with colored rice powder. Men decorate their livestock with similar colors, and in villages around Mahabalipuram, they prepare to run in front of charging bulls, plucking rupee notes from the horns of beasts in a ritual, called the Jellikatu, that predates Spain's Pamplona Bull Run by centuries.

In the temples whose towers dominate the landscape from Madras to the very southern tip of the subcontinent, the priests conduct rituals. From the Srirangam Temple in Trichy, where the bathing ghats are filled with pilgrims bathing in the Cauvery River (which is considered almost as sacred as the Ganges), to the Sri Minakshi Temple in Madurai, where temple elephants bless the faithful and nightly torch-lit processions honor the god Siva, the mosaic of Indian life is presented in the same way it has been for centuries.

▼ *While photographing in Mahabalipuram, I caught these children at play among the elaborately carved temples made from huge single stones.*

Nikon 8008s, Nikon 20-35mm AF zoom lens, Fujichrome Velvia exposed for 1/60 sec. at f/2.8

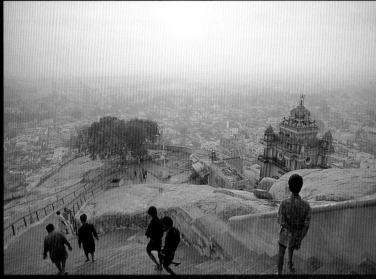

◀ Pilgrims rush to bathe in the temple pond following the blessing of a god's statue in the same waters in Trichy. I didn't want to intrude while making this shot, so I positioned myself at the opposite end of the pool and used my telephoto lens' compressed perspective.

Nikon 8008s, Nikon 80–200mm AF zoom lens, Fujichrome Velvia exposed for 1/125 sec. at f/5.6

▲ It is a tradition for pilgrims to view sunrise from the temple at the top of the Rock Fort high above the plains of Trichy.

Nikon 8008s, Nikon 20–35mm AF zoom lens, 81C warming filter, Fujichrome Velvia exposed for 1/60 sec. at f/2.8

The chanting and clapping first drew me to this clutch of holy men in the Srirangam Temple in Trichy. My presence wasn't bothering the men, so I used fill flash to open up the dark foreground.

Nikon 8008s, Nikon 20–35mm AF zoom lens, Nikon SB24 flash, Fujichrome 100 exposed for 1/60 sec. at f/4

▲ To prepare the garlands and the colored rice powder used during the Pongal festival, women and children gather flowers for weeks before the event. I used a long lens to isolate this woman in a sea of yellow blooms in Chidambaram.

Nikon 8008s, Nikon 80–200mm AF zoom lens, Fujichrome Velvia exposed for 1/250 sec. at ƒ/5.6

▶ Women of the village paint these beautiful freehand designs outside their homes in Madurai using colored rice powder.

Nikon 8008s mounted on tripod, Nikon 20–35mm AF zoom lens, Fujichrome Velvia exposed for 1/8 sec. at ƒ/4

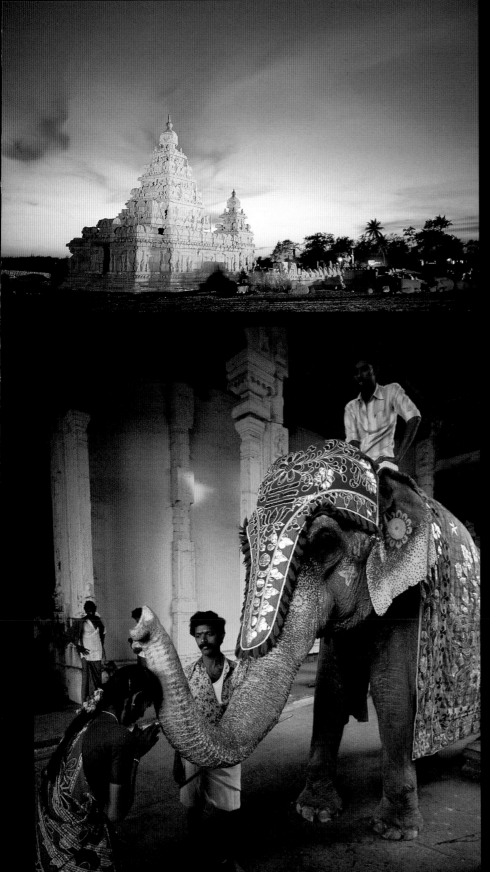

◀ *The Shore Temple is illuminated at night during the festival and makes for a dramatic presence against the dusk sky in Mahabalipuram.*

Nikon 8008s mounted on tripod, Angenieux 28–70mm AF zoom lens, Fujichrome Velvia exposed for 1/8 sec. at f/4

▲ *When I came across some members of a traveling street circus taking a break in between acts on the street in Madurai, I decided to take this headshot of one of the performers.*

Nikon 8008s, Nikon 80–200mm AF zoom lens, Fujichrome 100 exposed for 1/125 sec. at f/2.8

◀ *At a temple in Madurai, people pay a small fee to receive a blessing from the temple elephant.*

Nikon 8008s, Nikon 20–35mm AF zoom lens, Kodachrome 200 exposed for 1/30 sec. at f/2.8

Capturing the Essence of a City

"You step off the plane and you have a lot of film that has not been exposed. And a roll of film with no pictures on it is absolutely frightening."

DAVID ALAN HARVEY, *National Geographic* photographer

A STORY HAS MADE THE ROUNDS so often among photographers at *National Geographic* that it has become part of the department's unofficial folklore, even though it is probably apocryphal. It concerns an eager, young photography intern whose assignment for the summer was to provide coverage of a major city. The intern was the picture of energy as he packed cases of film, cameras, clothes, and sundry equipment and flew off to begin his assignment.

Once on site, however, the intern's attitude began to change. He was overwhelmed by both the size of the city and the scope of his assignment and just couldn't leave the hotel room; he literally didn't know where to begin. Finally, after agonizing a day, he called his picture editor and asked sheepishly, "Okay, now that I'm here, what do I do?"

Capturing the heart and soul of a city on film is one of the most exciting, and difficult, challenges a photographer can undertake. Each city has a unique flavor and pace, and it takes more than luck to shoot pictures that convey that feeling. It isn't unusual for a photographer visiting a new city to feel like that intern did: completely overwhelmed.

Anyone who has ever visited a major metropolis knows the dilemma of having countless activities and sights to see, and usually not enough time even to visit, let alone photograph, them. Whether shooting for your own slide show or a major-magazine article, you need to present a well-rounded portrait of a city in order to hold audience attention. A show full of pictures of only one subject—for example, buildings, people, or street scenes—is a guaranteed "snorefest." The following ideas for subject matter and techniques will help you capture the essence of the next city you photograph.

Architectural details are important to providing a flavor of a city. These backlit flowers and lamppost, along with the railings in the background, just said "Savannah, Georgia."

Nikon 8008s, Nikon 80–200mm AF zoom lens,
Fujichrome Velvia exposed for 1/60 sec. at f/2.8

Getting Organized

Great photography doesn't happen by accident; it is the result of planning that puts you in the right place at the right time. The best way to start out and to stay organized is to do what most of my colleagues and I do when covering a city. We make a shot list, which consists of a list of categories. Here is an example of some categories to think about:

- Skylines

- Street scenes

- People—including local celebrities and characters

- Recreation—weekend activities in parks, participatory sports

- Culture—performing arts, museums, and galleries

- Historic monuments and buildings

- Shopping

- Hotels and restaurants (dining)

- Entertainment—nightlife, clubs, and bars

- Storytelling closeups or detail shots—i.e., beer steins and pretzels in Munich, baguettes and wine glasses in Paris

- Neighborhoods—ethnic or distinctive neighborhood scenes

- Festivals, street fairs, and parades

- Aerials

If you come home with several good shots in each of these categories, you'll have a nicely rounded portrait of the city.

When I've been assigned to photograph a city for publications like *Travel/Holiday*, *National Geographic Traveler*, and *Islands* magazine, I have a limited amount of time to do a broad coverage. It is important that I get oriented quickly, so I can make the most of my time. The easiest way is to take one of the one- to three-hour bus tours offered in most major cities. These tours are short and reasonably priced, and hit the sightseeing highlights. You probably won't get any good photographs on this type of tour, but it will help to give you the lay of the land and to determine what time of day is best to photograph the highlights. The exception is the open-topped, double-decker buses in use in Great Britain, New York City, and some other cities; the upper deck of these buses makes a great shooting platform.

◀ The Holy Week ceremonies in Malta are amazing. On Good Friday, hooded penitents, their feet in chains, walk in processions held in many towns across the island. Because I wanted to retain the moodiness of this scene, which I shot in Mosta, I didn't want to use fill flash. So I had to work with a very fast film and a fast lens for this photograph, taken as part of a National Geographic *assignment.*

Nikon 8008s, Nikon 28mm AF lens, Fujichrome 1600 exposed for 1/30 sec. at f/1.4

▲ I was shooting the Imperial Ball, held on New Year's Eve in the magnificent Hofburg Palace in Vienna, Austria, while on assignment for Gourmet *magazine.* The ball is a formal, black-tie affair, so I couldn't exactly lug my big bag of gear. Instead I took one rangefinder camera body, a Contax G2, with 21mm, 28mm, and 45mm lenses, and a small table-top tripod, all of which fit into a discreet little shoulder pouch. For this shot of the crowded ballroom, I braced the camera and tripod on a railing in the gallery overlooking the dance floor.

Contax G2 rangefinder mounted on Leitz table-top tripod, Biogon 21mm lens, Fujichrome 64T exposed for 1/2 sec. at f/2.8

The beautiful Palace of the Winds is located on a busy street in Jaipur, India, and has a series of telephone lines running right in front of it. I shot the structure from several angles from across the street and then decided to get right below and look up, despite the distortion. The Singh-Ray intensifier punches up colors in the red spectrum, while leaving other colors untouched. I don't use this filter often, but it came in handy here.

Nikon 8008s, Nikon 20–35mm AF zoom lens, Singh-Ray Intensifier P-sized filter, Fujichrome Velvia exposed for 1/125 sec. at f/5.6

Wanting to put a bit of a different twist on the familiar New York City skyline, I hired a helicopter in order to shoot some sunset and dusk aerials. The gyrostabilizer helped to counteract the vibration and to allow slower than normal shutter speeds. Even so, this picture exhibits just barely enough sharpness. But the novelty value of the light and the composition save the day.

Nikon F4, Nikon 28mm AF lens, Ken Lab KS6 gyrostabilizer, Fujichrome Velvia pushed one stop to ISO 80, exposure bracketed around 1/30 sec. at f/1.4

◀ *I shot this classic view of the lower New York City skyline from a sightseeing boat while shooting an assignment for Korean Air's in-flight magazine.*

Contax G2 rangefinder, Sonnar 45mm lens, Fujichrome Velvia exposed for 1/250 sec. at f/5.6

▼ *Twilight skylines are a dime a dozen, but twilight-skyline aerials are rare indeed. Even though I used an ultrafast film and an ultrafast lens when making this shot of Lower Manhattan, my shutter speed was only around 1/8 sec. The steadiness that both the gyrostabilizer and the skillful helicopter pilot provided enabled me to knock off a few frames that are barely acceptable in terms of sharpness but are above average in the novelty-value department.*

Nikon F4, Nikon 28mm AF lens, Ken Lab KS6 gyrostabilizer, Ektachrome 200 pushed two stops to ISO 640, exposure bracketed around 1/8 sec. at f/1.4

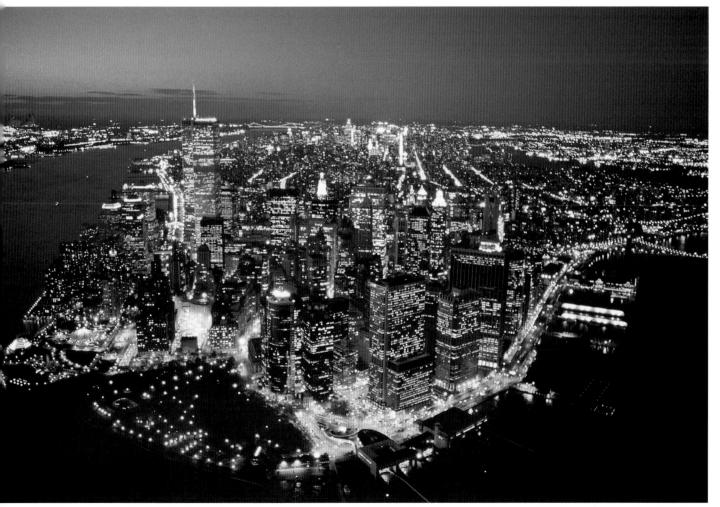

The Challenge of Shooting Skylines

A city's skyline is its signature and an important scene-setter. The challenges in photographing it are twofold. First you have to find the right angle, then you have to make the most of it photographically.

To aid in the first challenge, check the postcard racks and souvenir-photo books for some skyline ideas. The guide on your city-tour bus, hotel personnel, and staff members at the local tourist office will know the location of these favorite angles. If you are in luck, there will be some in-town vantage points from which you can shoot the skyline. Sometimes, however, a trip outside the city limits is required. In San Francisco, for instance, you have to head over to neighboring Marin County in order to include the Golden Gate Bridge when you shoot the city. And in Toronto, you take a ferry to one of the nearby islands. But in Salzburg, Austria, several good angles to shoot from are right in town.

To rise to the second part of the challenge, capturing the drama of a skyline, you should photograph the skyline when the bright lights of the big city are at their best. This usually means shooting at sunset and twilight, which is the half hour or so after sunset. At this time, the sky is still a deep royal or navy blue, and there is enough detail in the unlighted areas of the photograph to register on film. The light level of the buildings' interiors balances with the sky and any exterior lights, creating a very rich, colorful effect on film. Professional travel photographers especially prize this magic hour because it is weatherproof: even an overcast gray sky will glow blue at dusk.

Since a long exposure is required at this time of day, you'll need a tripod and a cable release to ensure sharp pictures. A small, sturdy table-top tripod will do the job if you rest it on a solid sur-

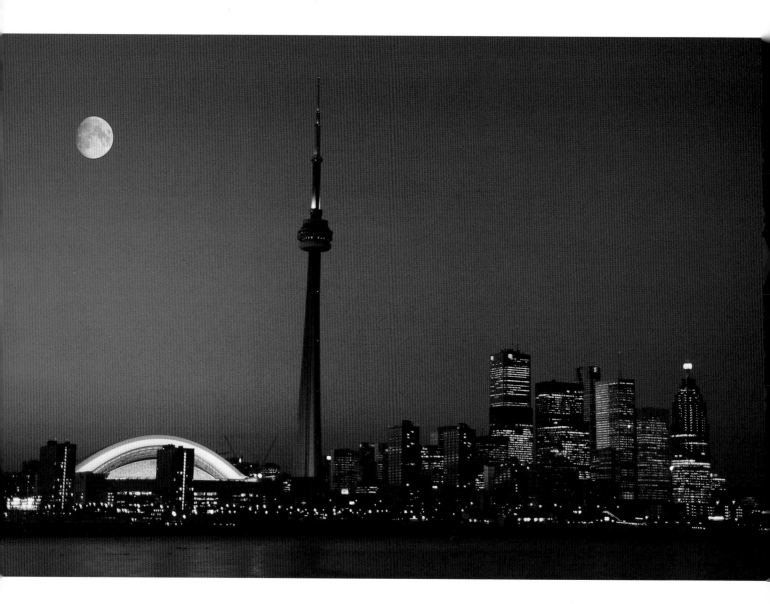

face like a wall or a mailbox. Your through-the-lens (TTL) meter will put you in the ballpark for exposure readings, but in situations like this it will often be wise to bracket your exposures if you're using slide film. Remember, bracketing means taking three or more exposures: one at the designated meter reading, one at a half or a full *f*stop higher than that reading, and one at a half or a full stop lower than the first. For ISO 100 film, I find that an exposure of 2 seconds at *f*/5.6 is a good starting point for many illuminated-building shots at dusk.

If the skyline consists of modern structures, you'll notice that many of the buildings are illuminated with fluorescent lights, which register green on film. To correct for these lights when you shoot indoors, a magenta filter, such as a CC30M, or a Tiffen FLD™ is recommended. The good news is that you can also use these filters when you shoot buildings from the outside. These filters take the green out of the fluorescent lights in windows, and the magenta cast adds some color and drama to the night sky.

◀ I shot this view of the Toronto, Canada, skyline from Centre Island. The full moon was in a different part of the sky, so I made a closeup exposure of it in the upper-left corner, leaving the rest of the frame empty. Then I double-exposed the main scene on the same frame of film.

Nikon FE2 mounted on tripod, Angenieux 28–70mm AF zoom lens, Fujichrome Velvia exposed for 4 seconds at *f*/5.6 (general scene); Nikon FE2 mounted on tripod, Nikon 80–200mm AF zoom lens, Fujichrome Velvia exposed for 1/60 sec. at *f*/5.6 (moon)

▲ Twilight is my choice for shooting illuminated structures like buildings and fountains. I made this shot of the Plaza las Delicias in the historic city of Ponce while on assignment for the Puerto Rico Tourism Company.

Nikon 8008s mounted on tripod, Nikon 20–35mm AF zoom lens, Fujichrome Provia exposed for 1/2 sec. at *f*/5.6

Shooting Architecture

The famous poet Goethe called architecture "frozen music." Unfortunately, many photographers who shoot pictures of buildings, monuments, and landmarks during their city explorations do justice only to the frozen half of that description. Their architectural pictures are cold and lifeless.

Just because architecture is static and solid doesn't mean your pictures of it have to be. During my assignments, I've photographed architectural subjects from the Taj Mahal to the Statue of Liberty. I know only too well how easy it is to make even the most magnificent structure look like just another mass of bricks or steel. But with a little work, you'll find that it isn't too hard to "thaw out" some of that beautiful architectural music.

SELECTING A VANTAGE POINT

The first decision to make when approaching an architectural subject involves a point of view. In many cases, the structure's location makes this decision for you; there is a limited number of places to stand and photograph, and most of these are at street level. Even if you're using a wide-angle lens in the 20–28mm range, which is ideal for this type of photography, to get the entire architectural subject in you have to tilt the camera upward. By doing so, you immediately run into the most common problems in architectural photography: a phenomenon known as *keystoning*.

Keystoning is simply the slanting of parallel lines that takes place when the camera's film plane isn't parallel to the vertical lines of the building it is aimed at. This effect occurs with any type of lens, but it is most pronounced with wide-angle optics, which are the lenses that most people use to shoot architecture. You've seen the results of keystoning; the buildings in a picture appear to be tilting or falling over backward, like a good action shot of a big earthquake. Although keystoning can add drama to a composition, especially if exaggerated for effect, in most cases it is a major annoyance.

To combat this problem, professional photographers using 35mm single-lens-reflex (SLR) cameras can make use of *perspective-control (PC) lenses* or *tilt/shift lenses*. These are expensive wide-angle optics whose front elements shift up and down, eliminating the need, in most cases, to tilt the camera. But don't feel that you have to take out a second mortgage to improve your architectural pictures. You can combat keystoning in several ways, none of which involves large capital outlays.

When confronted with a tall structure, your first step is to *turn the camera and shoot a vertical*. Sounds painfully obvious, doesn't it? You would be surprised, though, at how many photographers, professional as well as amateur, fall prey to "locked-elbow syndrome." Don't be afraid to back off somewhat. There is no law that says you have to be standing right in front of a structure with a wide-angle lens in order to photograph it. Put on a standard 50mm or a longer lens, and try the view from across or down the street a bit. If the structure fronts on a park, river, or canal, you can give yourself even more working distance and won't have to tilt the camera as much.

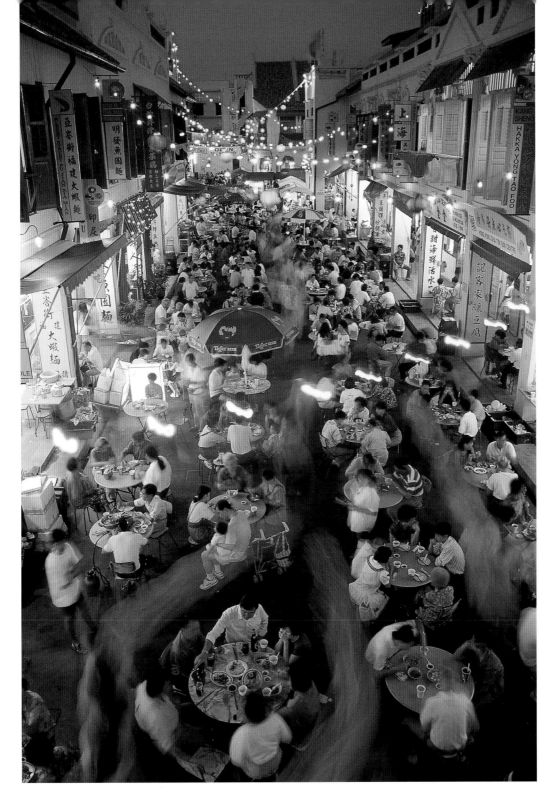

◀ *The magic hour of twilight is a great time to shoot architecture. You can actually see both the inside and the outside of most buildings simultaneously because the light levels are similar. Some firefighters had hosed down the sidewalk in front of this historic building, which added a nice touch.*

Nikon 8008s mounted on tripod, Nikon 20–35mm AF zoom lens, Fujichrome Velvia exposed for 2 seconds at f/5.6

▲ *I am continually on the lookout for overhead angles, which are great for giving a sense of place to pictures. To shoot this action at Singapore's Bugis Street outdoor-dining area, which used to be the city's red-light district, I found a balcony overlooking the street and fired away.*

Nikon 8008s mounted on tripod, Nikon 20–35mm AF zoom lens, Fujichrome Velvia exposed for 1 sec. at f/4

Keep your eyes open for any elevated viewing area that looks onto the subject, such as an outdoor restaurant on a first- or second-floor terrace, raised plazas or fountains, or even an open window in a store, cafe, or public place that is a floor or two above street level. Similarly, in interior situations—cathedrals, lobbies, and atriums—search out choir lofts, open stairwells, and galleries that provide an elevated vantage point. I often make use of these types of overlooks as a "poor man's PC lens"; instead of elevating only the lens' front element, this strategy raises the entire camera, photographer and all.

Sometimes, though, no matter how hard you look, you're stuck on the ground level, shooting vertically with your wide-angle lens. In situations like this, if you're holding the camera straight, the structure will fill the top part of the frame, but you'll be confronted with too much empty foreground area in the bottom half. You have two choices here. You can move closer and tilt the camera or you can use the foreground by filling it with people, flowers, fences, or some other point of interest. In most cases, filling the foreground is preferable. Color-print-film users who face this problem can simply crop the negative to eliminate the foreground in the final print.

One final note on keeping vertical lines vertical. A *spirit level*, a relatively inexpensive item, can help you in your quest to "stay straight." The spirit level slips into your camera's hotshoe where it works just like a carpenter's spirit level: when the bubble is in the middle, the camera is level. The best such device actually has two spirit levels, so you can make sure that your camera is plumb both horizontally and vertically. This accessory is available at most well-stocked camera stores.

LONG VIEWS

Telephoto lenses are useful for adding one more important element to your architectural pictures: people. Nothing emphasizes the scale of a large building or monument better than juxtaposing a human figure against it. And nothing livens up a picture more than a little human activity going on in front of it. A long lens is ideal because you can work freely and let the lens' apparent perspective compression "place" the people next to the structure.

I used a telephoto lens to put a different spin on the Taj Mahal photographs mentioned above. When I crossed the river and shot the activities of the ferrymen and laundry workers who inhabit an island in the middle of the river, the telephoto perspective enabled the Taj Mahal to hover majestically in the background of these everyday scenes. Similarly, in Lisbon, I used a telephoto lens to have visitors looking up at the Monument of the Navigators, thereby emphasizing the size of the huge statue's figures.

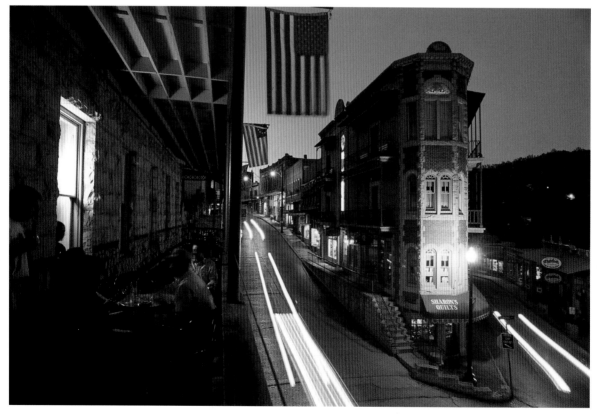

Nikon 8008s mounted on tripod, Nikon 20–35mm AF zoom lens, Nikon SB24 flash set to -1 and bounced off porch ceiling with SC17 cord, Fujichrome 100 exposed for 1 sec. at *f*/4

This restaurant porch provided the perfect spot to get an overall of the historic town of Eureka Springs, Arkansas, and enabled me to include a bit of the restaurant scene in the foreground. I made this shot at twilight for Travel/Holiday *magazine.*

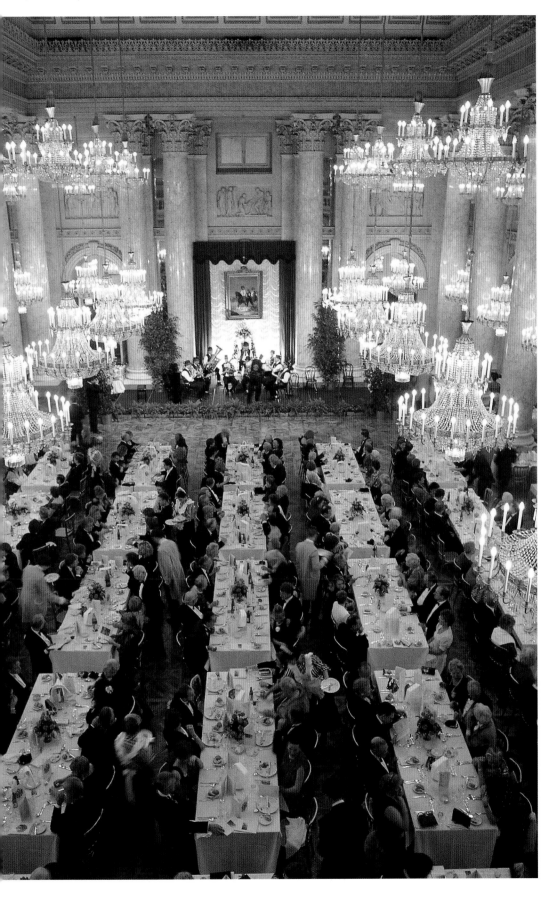

Covering the Imperial Ball for
Gourmet *magazine, I was struck by*
the elegant symmetry of the dining
rooms in the Hofburg Palace in
Vienna, Austria. A high angle from
an overlooking balcony was the
best place to shoot the scene, so I
braced my camera and table-top
tripod on the balcony railing.

Contax G2 rangefinder mounted on table-
top tripod, Biogon 28mm lens, Fujichrome
64T film exposed for 1/8 sec. at f/4

Classic View or Cliché?

No coverage of a city is complete without a few pictures of its symbol or icon. But this presents a tricky dilemma for travel photographers. How do you photograph the great signature shots or classic views of a particular location in a new or different way? Undeniably, the world has seen enough straightforward views of the Eiffel Tower, the Taj Mahal, the Statue of Liberty, and Big Ben. On the other hand, travel magazines, brochures, posters, and calendars routinely use pictures of these symbols. Whenever these have space for only one photograph of a location, they often use an image that features the location's main symbol as a kind of visual shorthand for saying, "We're talking about Paris, or New York, or London here."

The naive answer to this dilemma is simply to say, "I won't shoot these cliché views." In that case, you don't have to worry about coming up with something fresh. You also don't have to worry about making an income because travel pictures without a sense of place are about as saleable as sand in the desert.

Another facile, but ultimately unsatisfying, approach that some trendy publications favor is the arch, hipper-than-thou view. To obtain this, you hold a postcard of the famous view in your hand and photograph it in the foreground of a wide-angle composition of the same view. You can also plop a body part, like a hand or a foot, in the foreground of the picture, or stick a big, out-of-focus image of a woman in a slinky dress in the foreground. Yes, these are different takes on a familiar view, but what do they mean? If an idea is truly clever, it might indeed have some shelf-life as a travel photograph. Most of the time, however, it is just gimmicky.

Finding truly useful advice on handling this dilemma is no less of a chore. Pick up any book or article about travel photography and without fail, the author will at some point exhort you to "go beyond the postcard views!" This has become a worse cliché in travel-photography how-to writing than the standard views are in travel photography!

If you've looked at postcards lately, you'll know what I mean. While some horrendous, soulless views that look like they were taken in the 1950s still lurk in the postcard racks, in many places, especially popular tourist meccas, the postcards are absolutely stunning. They often show images from coffee-table books made by talented local photographers who have the time to scout for the very best angles, as well as to wait for the very best or the most unusual weather conditions to shoot from those great angles.

I always check both the postcard racks and the coffee-table books in order to see what has been done on the famous views. More often than not, I get a bit discouraged because chances are I won't have the time, the weather conditions, or the access to the special viewpoints, such as the building rooftops or apartment balconies, that the postcard photographers did. Nevertheless, I peruse the racks, not looking to imitate specifically, but to get inspired. Keep in mind the following tips when you're faced with photographing the "iconic view." (Just as the CIA never "assassinated" anybody during the Cold War—they merely "terminated with extreme prejudice," professional travel photographers never refer to cliché shots but instead call them iconic views!)

Look for Unusual Weather or Light

This is serendipitous, but capturing a city's primary symbol in fog, rain, mist, or driving snow immediately adds a twist that takes your photograph out of the cliché category. Check the weather reports, and don't be put off by bad weather. Remember, rainbows appear after storms in the late afternoon or early morning. While I was on a recent assignment in New Orleans, the meteorologist predicted early-morning fog. So I was up at dawn and photographed Jackson Square looking much more ethereal than it does in the muggy sunshine, which is the norm.

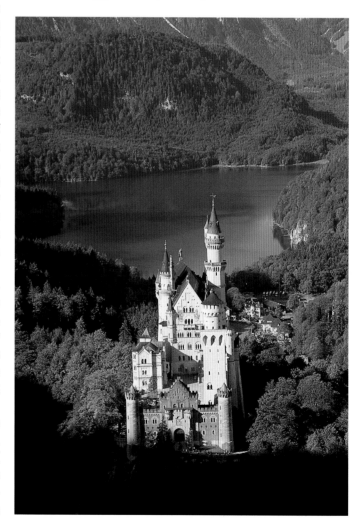

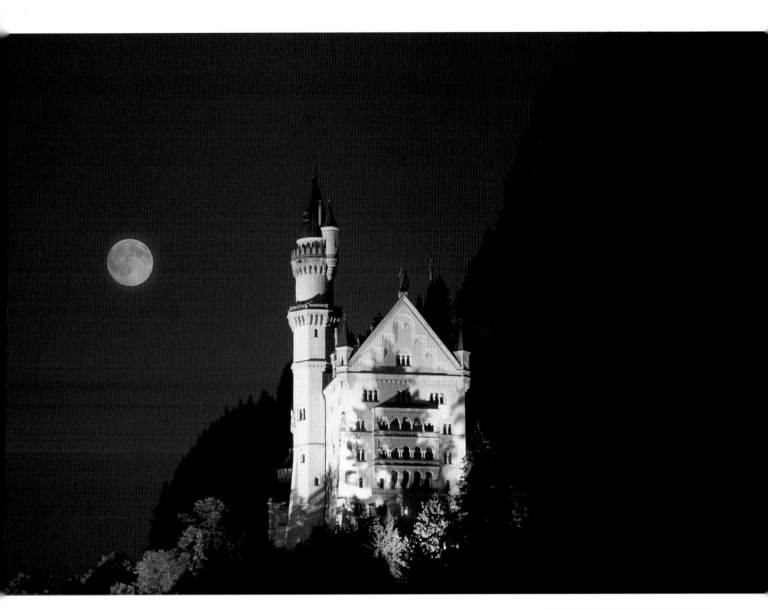

▲ *After shooting the classic view of Neuschwanstein Castle in Schwangau, Germany, I went looking for something different. I walked around behind the castle one night for a different perspective. The full moon was just out of the frame, so I shot closeups of it, leaving the rest of the frame blank. Then I rewound the film and put it through the camera a second time, exposing the rest of the scene. A vertical version of this shot was used on the cover of* Travel/Holiday *magazine.*

Nikon FE2 mounted on tripod, Nikon 80–200mm zoom lens, Fujichrome Velvia exposed for 1/60 sec. at f/5.6 (moon); Nikon FE2 mounted on tripod, Nikon 80–200mm zoom lens, Fujichrome Velvia exposed for 1 sec. at f/4 (castle)

◄ *This view of Schwangau's Neuschwanstein Castle has become the classic, and overdone, image representing Germany, but you can't visit here and not shoot it. I'd tried to find the viewpoint myself on previous trips, but to no avail. This time, however, I broke down and hired a local guide. I was shooting a story about King Ludwig's castles while on assignment for* Travel/Holiday, *and although I knew the magazine wouldn't use this view, I wanted it for my stock files.*

Nikon 8008s mounted on tripod, Angenieux 28–70mm zoom lens, B+W circular warming polarizer, Fujichrome Velvia exposed for 1/60 sec. at f/4

Check Out Reflections

Another good wrinkle on the symbolic structure involves looking for reflections. You can find these, for example, in rain puddles, in highly polished car roofs or hoods, in nearby glass skyscrapers, in the inverted reflection in a glass of wine, in shop windows, and in an onlooker's sunglasses. One of the best photographs of New York City that I've ever seen showed the Empire State Building reflected in the roof of a yellow taxi. The photographer ingeniously combined two cliché symbols of New York into one very clever photograph.

Shoot Just a Part of the Structure

Most city symbols are so visually distinctive and well known that even a portion of them, such as one tower of the Tower Bridge or one parapet of the Taj Mahal, tells the story. Look for ways to work in just an identifiable part into the background of a photograph. One of the best-selling shots of Paris in the catalog of a stock-photo agency I work with shows a couple out on an apart-ment balcony. Looming behind them is a portion of one stanchion leg of the Eiffel Tower. The shot, which was made at twilight, perfectly epitomizes "romantic Paris."

Look for Unusual or Humorous Juxtapositions

An effective way to identify a city without making the symbolic structure the centerpiece of your photograph is to work it into the background of an otherwise interesting image. For example, in Paris you can get a great shot of the skateboarders on Place d'Etoile with the Eiffel Tower in the background. In Agra, countless everyday-life tableaux go on with the Taj Mahal looming in the background: farmers plowing their fields, laundry wallahs washing clothes, holy men meditating, and ferrymen taking people across the river. Humor can also work. You might photograph a child with a foam Statue of Liberty headpiece imitating the pose in front of the actual structure in New York City, or a miniature Arc de Triomphe tourist souvenir hanging from a kiosk in front of the real structure in Paris.

Photographing a familiar structure like the Louvre in an innovative way is difficult. Fortunately, the wind was dead calm the day I was shooting in Paris, so the pools in the courtyard acted as mirrors. I needed a very low angle to connect the reflection to the building facade, and getting the knees of my pants dirty seemed like a small price to pay for an interesting shot of France.

Nikon 8008s, Angenieux 28–70mm zoom lens, 81C warming filter, Fujichrome Velvia exposed for 1/125 sec. at f/5.6

Trying to put a different spin on a shot of the CN Tower in Toronto, Canada, one of the city's signature sights, I decided to shoot its reflection in the glass skyscrapers of the business district. I made this shot while on assignment for National Geographic Traveler *magazine.*

Nikon 8008s, Angenieux 28–70mm zoom lens, Fujichrome Velvia exposed for 1/125 sec. at f/4

Explore Offbeat Angles

The last way to break the cliché mode when faced with a well-known subject is to explore extreme or offbeat angles. Forget keystoning and the other "rules" of architectural photography, and point your camera straight up or straight down. As with any experimental approach, you'll probably experience more misses than hits, but you might be pleasantly surprised and come up with a fresh look.

Go Ahead, Just Shoot the Cliché!

A cliché image isn't the shot that will cement your reputation as one of the most creative travel photographers who ever lived, but it might earn you a few bucks in the stock-photography market. So check your artistic integrity at your hotel's front desk, and just shoot the cliché view—but make sure that the conditions are ideal. If they aren't, the shot won't stand a chance of selling. When I was a struggling young actor, one of my teachers, a well-known New York City stage actor, continually exhorted me to reach deeper and deeper inside to come up with some raw, true emotion. If this approach didn't work, however, he did admit that "you can never underestimate the power of a *well-executed* cliché!"

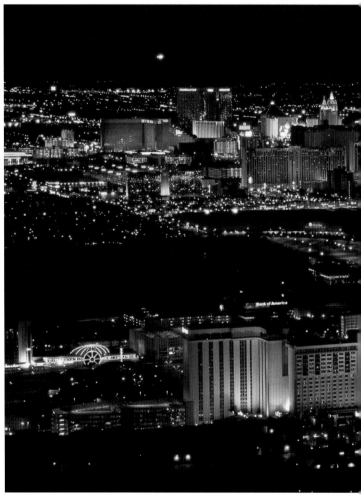

▲ When I photograph parades and processions, I always keep an eye on the crowd as well as the marchers. Covering Atlanta, Georgia's July 4th parade for National Geographic Traveler *magazine, I found this man's relaxed patriotism irresistible.*

Nikon 8008s, Angenieux 28–70mm AF zoom lens, Fujichrome Provia exposed for 1/125 sec. at f/4

▶ Las Vegas, Nevada, is larger than life. So to capture this scene, I used a panoramic camera that produced a transparency nearly twice as long as the standard 35mm frame. I made this shot of the skyline from the roof of a casino.

Hasselblad Xpan mounted on tripod, Hasselblad 90mm lens, Fujichrome Provia exposed for 1 sec. at f/4

Street Scenes

Street scenes give an up-close and personal look at the life of a city. It is, however, surprisingly difficult to capture the excitement of the street in a photograph; it is hard to organize the many urban elements into a coherent picture. But a couple of techniques can help.

Use a Telephoto Lens
Experienced photojournalists and dedicated street photographers can make dramatic pictures with a wide-angle lens. But a telephoto lens is often a better choice for amateurs who want to shoot street scenes. This type of lens' perspective compression can organize the buildings and crowds on the street into exciting graphic compositions.

Avoid Contrast
Stay away from scenes that contain both bright sunlight and deep shadows. The contrast is just too much for most films to handle, and the results are always disappointing. Look for uniform lighting conditions—overcast, all sun, or all shade—for your street pictures.

In sunlight, you'll find that positioning yourself so the sun comes from behind your subjects often leads to more interesting pictures than standing so the light comes over your shoulder. Of course, you don't want the backlighting to shine directly into your lens. Backlight adds a certain atmosphere that direct sunlight doesn't.

Wait for the Action
Sometimes you'll find that it is easier to stop and let the street scenes come to you, rather than your seeking them out. For example, if an outdoor cafe or a park bench on a street has some lively activity, I'll often sit at a table, camera at the ready, and wait for the action to come to me. I find it easy to remain inconspicuous this way, which raises the odds of capturing some good candid people pictures. Similarly, if I come across an interesting background, like a colorful mural, a group of posters, or an architectural façade, I'll often plant myself nearby. This way I can wait until someone walks in front of my subject or some other activity occurs, to add a sense of moment to my pictures.

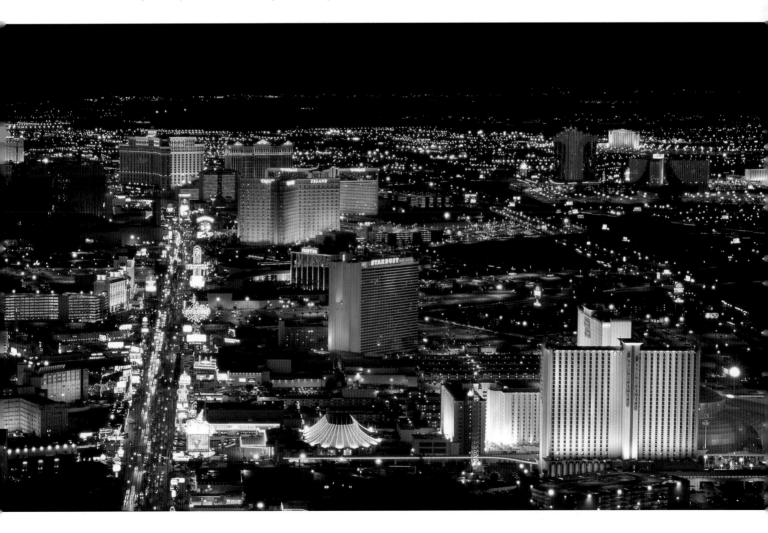

Photographing City Dwellers

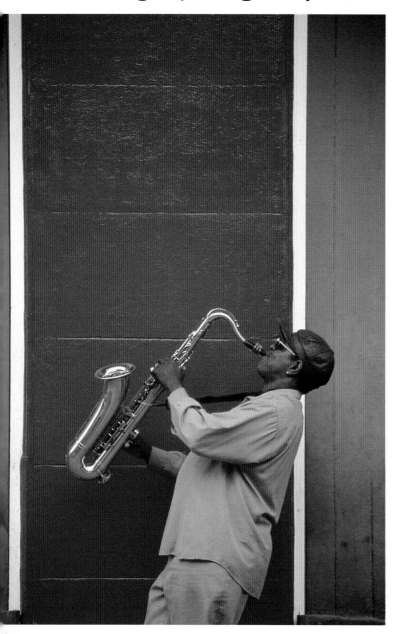

No city profile is complete without a look at its people, who are often as distinctive and characteristic as its architecture. Street entertainers and artists are particularly good subjects because their activities are often directly tied to the city in which they're performing. Nothing sets the scene better than a shot of a jazz musician playing his horn on a corner in the French Quarter of New Orleans, or a street artist creating a chalk portrait of Mozart in a Salzburg byway.

Since most people in these jobs earn their living in tips, it is appropriate to offer one in return for taking a few pictures. Don't offer to send pictures or prints back unless you are certain you'll follow through on your promise. It is all too easy to forget it once you are home, and that creates bad feelings for the next photographer who comes along.

Once you've gotten your subject in the viewfinder, remember a few technical points about people pictures. Try to avoid shooting in direct sunlight; it's the most unflattering type of light. The soft, shadowless illumination of overcast light or open shade is preferable. If you can't move your subject out of the sun, use a flash to soften the shadows. Most point-and-shoot (P&S) cameras and autofocus SLR cameras have a fill-in feature designed to do this operation automatically, often in Program mode.

Be aware of distracting background elements, including light poles and telephone wires, that might crop up behind your subject. The best way to avoid them is to back off a bit and use a telephoto lens at a wide-open aperture of *f*/2.8 or *f*/4. The resulting shallow depth of field can turn a busy background into a soft blur.

I photographed New Orleans jazz musician Rasheed Ahkbar in several locations in the French Quarter for a magazine story. The rich colors and soft light of this location made for an ideal background.

Nikon F100, Nikon 80-200mm F2.8 AF zoom lens, Fujichrome Provia exposed for 1/250 sec. at *f*/2.8

I needed pictures of the Virginia Highlands neighborhood of Atlanta, Georgia, while on assignment for Insight Guides. *Shooting at twilight enabled me to reveal the Edward Hopper-esque scene going on inside the landmark Majestic Diner, as well as to show its exterior.*

Nikon 8008s mounted on tripod, Angenieux 28-70mm AF zoom lens, Fujichrome Provia exposed for 1/8 sec. at *f*/4

◀ *Aarhus, the second city of Denmark, has a lively cafe scene. I made this shot as part of an assignment about the Jutland peninsula for* National Geographic Traveler. *I like using my rangefinder camera for nighttime city shots because it is smaller, lighter, and less obtrusive than an SLR.*

Contax G2 rangefinder mounted on tripod, Sonnar 90mm lens, Ektachrome 200 exposed for 1/4 sec. at f/2.8

▼ *During one trip to Montmartre, my favorite neighborhood in Paris, France, the streets were crowded during a wine festival. So I positioned myself on a corner, waited until the streets were at their busiest, and then made a series of exposures in the warm, late-afternoon light.*

Nikon 8008s, Angenieux 28–70mm AF zoom lens, Fujichrome Provia exposed for 1/60 sec. at f/4

Recreation

Another excellent time to photograph city inhabitants is when they're relaxing or at play. Walk into any city park on a nice weekend day, and you're guaranteed to see a myriad of people-picture possibilities: skateboarders, rollerbladers, picnickers, paddleboaters, horseback riders, and kite flyers, for example. The list is endless. Again, in these relaxed circumstances, people don't seem to mind being photographed. In fact, some individuals are downright exhibitionists.

A telephoto lens, especially a telephoto zoom in the 80–200mm range, is perfect for photographing people involved in these activities.

The zoom enables you to quickly change the framing depending on the activity. In order to capture the essence of the particular city you're visiting, look for activities or backgrounds that are unique to or characteristic of that location. In Amsterdam's Vondel Park, for instance, you can see every manner of people and goods being transported by bicycle, from bass fiddles to baskets of flowers. The Chinese Tower Beer Garden, with its large pagoda structure, is unique to Munich's English Garden. These types of situations give your city pictures a distinctive sense of place.

City parks on weekends are great places to catch pictures of people enjoying their recreation. On assignment in Atlanta, Georgia, for National Geographic Traveler *magazine, I positioned myself at the finish line of the annual Peachtree Road Race and captured these ebullient girls celebrating their finish in the spray from hoses set up to cool off the runners.*

Nikon 8008s, Nikon 80–200mm AF zoom lens, Fujichrome Velvia exposed for 1/125 sec. at f/2.8

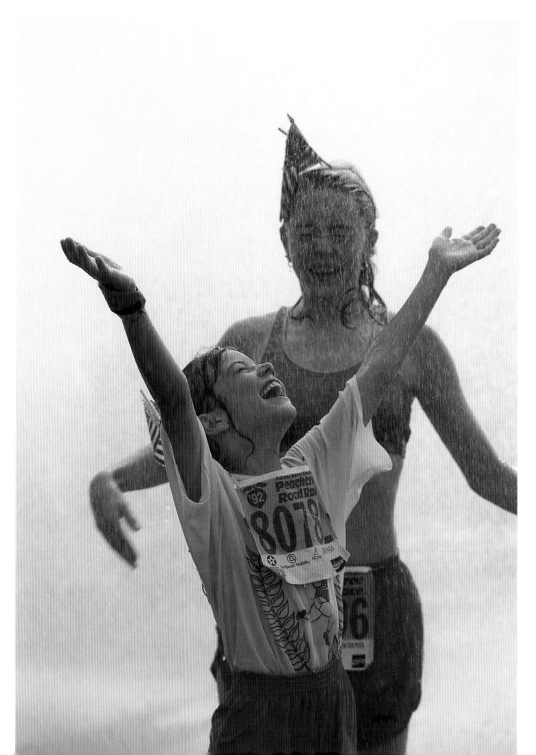

Arts and Entertainment

Try to capture a bit of the city's vitality by including pictures of its cultural scene—its performing and visual arts—and its nightlife. Unfortunately, many professional stage and musical performances don't allow photography for various legal reasons. However, the rules are often far less strict for amateur and outdoor presentations. If you happen to attend one of these latter events, observe the following guidelines for both good pictures and peaceful relations with the other audience members and the performers onstage.

Do Not Disturb

First and foremost, don't use a flash. This will distract the performers and the audience. In addition, using a flash won't result in decent pictures because the light is very harsh and doesn't carry for more than a few rows. Turn off the camera's motor drive, and manually advance the film if possible; if your camera has a "quiet" mode for its motorized advance, be sure to use it. If you can do neither, wait for a crescendo in sound or for the audience to break into applause, so the sound of your camera doesn't disturb your neighbors.

Live performances are an important part of a city's cultural offerings. Unfortunately, photography is prohibited at many of them. So you need to track down cultural events that don't require you to secure permission to shoot in advance, like this commedia dell'arte performance. Held several times daily at the outdoor Chinese Theatre in Denmark's Tivoli Gardens amusement park in Copenhagen, this is a wonderful show, and you can set up a tripod and shoot with abandon from behind the last row of seats.

Nikon 8008s mounted on tripod, Nikon 80–200mm AF zoom lens, Ektachrome 320T exposed for 1/60 sec. at f/2.8

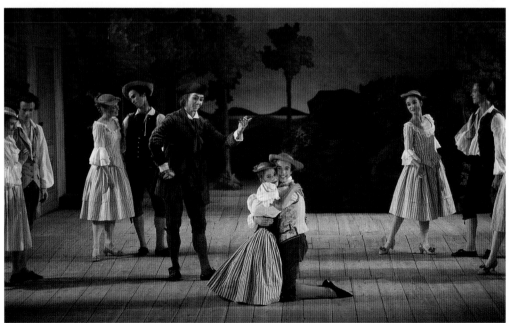

While working on a story about Stockholm, Sweden, for National Geographic Traveler *magazine, I'd made arrangements to shoot a dress rehearsal of the Swedish National Ballet performance at the Jewelbox Theater in Drottningholm Castle. The light levels were very low, so I had to wait until the dancers paused to make this exposure.*

Nikon F4 mounted on tripod, Nikon 80–200mm AF zoom lens, Ektachrome 320T pushed one stop to ISO 640 and exposed for 1/60 sec. at f/2.8

Nikon 8008s, Nikon 80–200mm AF zoom lens, Ektachrome 320T pushed one stop to ISO 640 and exposed for 1/125 sec. at f/2.8

Shooting on assignment for China's Hong Kong Convention and Visitors Bureau, I obtained permission to photograph the members of a Chinese opera troupe putting on their makeup for a performance. I shot into the mirrors they used so that I wouldn't disrupt the process.

Shoot "Fast"

You need a fast film with a speed of at least ISO 400 and, ideally, a lens of F2.8 or "faster" for these types of pictures. Because stage and concert lighting is balanced for tungsten and not daylight film, slide-film users will need to use the proper film. Kodak's Ektachrome 320T (EPJ) film is balanced for this type of light. This film can be *push-processed* one stop, to EI 640, with little loss of the film's excellent grain and color saturation. Color-print-film users can pick from a host of ISO 1600 emulsions, which are all very sharp for their speed. The films' color balance is automatically corrected when printed, so you don't have to worry about the color of the light source.

Support Your Camera

Even with a fast film and a fast lens, you'll be working at the lower range of shutter speeds for sharp handheld pictures. Bringing a full-sized tripod into a theater or nightclub usually isn't an option. I often mount my camera on a small table-top tripod, which I brace against my chest. This arrangement isn't as stable as a big tripod, but it is better than handholding the camera without any support.

Check Restrictions

It is often easier to shoot in museums, galleries, and historic building interiors than to photograph in such venues as theaters and concert halls. Again, the first step is to determine that no restrictions regarding photography exist in the particular place you're visiting. Any such warnings are usually clearly marked near the facility's entrance.

Scout Locations

Once you've established that you are free to photograph, the next step is to look for potential locations within the building. Avoid small, artificially illuminated rooms, and look to the skies for help. Since good light is essential to art displays, you'll often find that galleries and museums have huge skylights. This diffused lighting is perfect for photography; you can get pictures of people admiring various works of art without using a flash. An ISO 400 or faster film and a small table-top tripod braced against your chest are probably all you'll need.

Street Smarts

In many cities, it is amazing how quickly you can wander from the tourist district into no man's land. So besides keeping your photographic wits about you, you should study the lay of the land in order to know where you are at all times. This is especially true if you're carrying and using expensive camera equipment.

Frankly, it is impossible to tote expensive photo gear and still be completely inconspicuous. You can minimize the impact of photography gear if you don't accessorize it with fancy camera bags, flashy jewelry, and expensive clothing, such as leather or fur jackets. I use a beat-up old camera bag, a photo vest that is somewhat threadbare, and well-worn, utilitarian clothing. The total effect may not say "poverty," but it doesn't scream, "This is brand-new stuff I bought for my vacation" either.

More important than what you wear is how you carry yourself and react to situations. During my tenure as a newspaper photographer in Jersey City and Hoboken, I found out that an easygoing friendliness and a sense of humor help a lot on the streets, as does an ability to make small talk. I try to take a genuine interest in the people I meet and photograph on the street, and I never refuse anyone who approaches me and asks to have his or her picture taken, whether I want the photograph or not. Your refusal might cause offense, which can quickly escalate into other unpleasantness. It is easier just to snap a frame, say thanks, and keep moving.

Sometimes you can diffuse a potentially difficult situation with a little quick thinking and humor. Assigned by *National Wildlife* magazine to shoot a story about the pollution of the Bronx River in New York City, I was taking pictures of the river from a bridge in the notorious South Bronx when I was surrounded by several aggressive young men who wanted to know how much my cameras were worth. I was calculating my chances of getting out of there without having to file both medical- and equipment- insurance claims, when one of them asked if I was from television. I had a flash of desperate inspiration, said yes, and proceeded to do an "interview" with them, using my camera and a small tape recorder I carry for caption information. When I finished asking my questions, I said I had to get back to the station to get the interview on the air that night and left unharmed. As a still photographer, it hurts me to admit this, but you can never underestimate the power of television!

Nikon 8008s, Nikon 16mm AF fisheye lens, Fujichrome Provia exposed for 1/60 sec. at *f*/5.6

A traveling, interactive art exhibit called "Colorspace" was in Copenhagen, Denmark, during one of my assignments for the Danish Tourist Board. Visitors walked through these plastic tubes of intense color. I used a full-frame fisheye lens to show several of the tubes at once, and I waited for other people to walk through to use for scale.

New York City's Fifth Avenue

Few streets capture the essence of a city more thoroughly than Fifth Avenue does New York City. The 132-block-long thoroughfare—which literally divides Manhattan in half, between east and west—begins at Washington Square Park in the south and heads north nearly to the banks of the Harlem River. Fifth Avenue also runs the cultural and economic gamut of the city, from the very rich and privileged, to the poor and disenfranchised.

But mostly Fifth Avenue is known as the place where New York City displays its treasures. Whether it is the cultural cornucopia of the Museum Mile; the architectural gems like the Empire State Building, the New York Public Library, and St. Patrick's Cathedral; or the elegant shops like Saks, Lord & Taylor, Harry Winston, Cartier's, and Tiffany's, Fifth Avenue is home to all the best New York has to offer.

It is also where New Yorkers themselves like to strut their stuff. From the major events, such as the St. Patrick's Day, Columbus Day, and Easter Parades, to lesser-known processions, such as "The Captive Nations" Parade, the avenue plays host to gatherings of New Yorkers who can trace their roots to the far corners of the world.

Fifth Avenue is brash, bold, and vital, like an artery that carries lifegiving blood to the heart. New Yorkers like to think that their city is the center of the universe, and after spending some time there, I am not so sure they are wrong.

▶ *I was only a few feet behind the statue of Prometheus that overlooks Rockefeller Center, so I needed to use an ultrawide-angle lens in order to show both the statue and the buildings surrounding it.*

Nikon 8008s mounted on table-top tripod braced on a wall, Tamron 14mm lens, Fujichrome Provia exposed for 1 sec. at f/5.6

▼ *In the window of elegant Saks Fifth Avenue the mannequins seemed to strut with the same gait as the passing pedestrians.*

Contax G2 rangefinder, Biogon 28mm lens, Fujichrome Provia exposed for 1/125 sec. at f/5.6

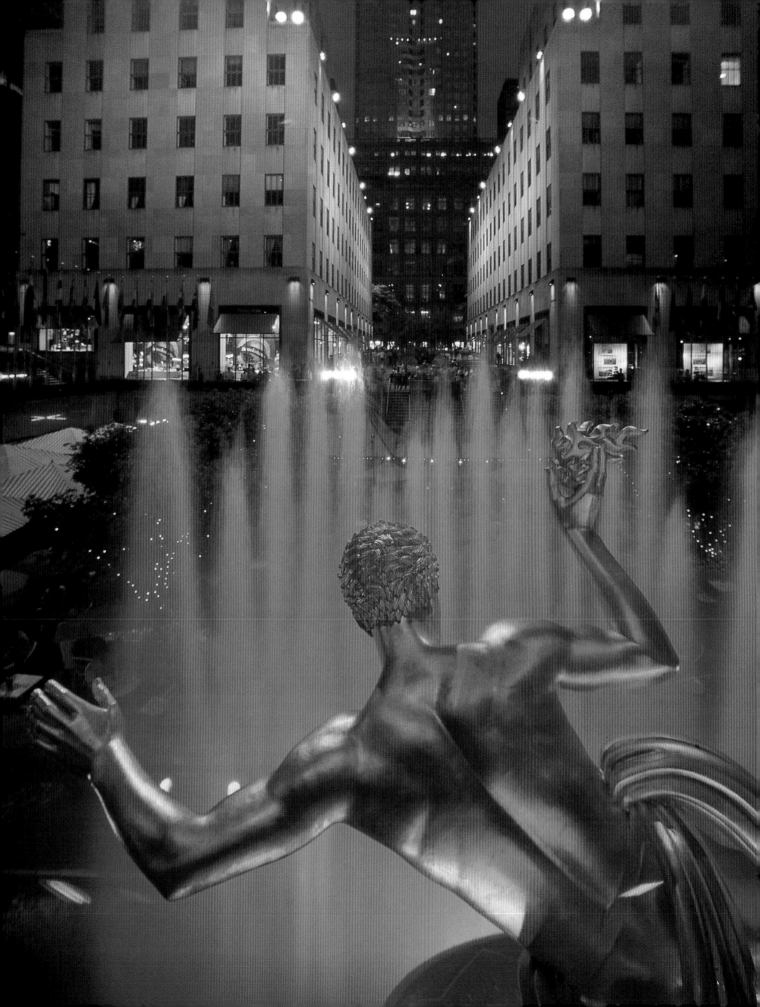

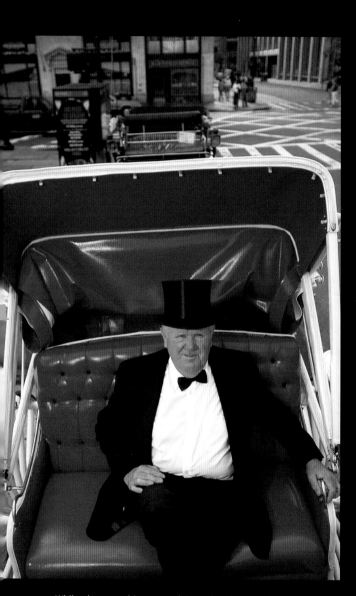

While photographing around Central Park, I was drawn to the classic look of this hackney driver and the plush red interior of his horse-drawn carriage. Although the day was overcast, I used some fill flash to brighten up the shot, and chose a high angle from the driver's seat to eliminate most of the distracting background.

Nikon 8008s, Nikon 20–35mm AF zoom lens, Nikon SB24 flash set to -1 with SC17 extension cord, Fujichrome 100 exposed for 1/250 sec. at f/4

I loved the juxtaposition of the huge faces of the children with their

UNIT
OF B

Nikon 8008s, Angenieux 28–70mm zoom lens,
Fujichrome Velvia exposed for 1/250 sec. at f/4

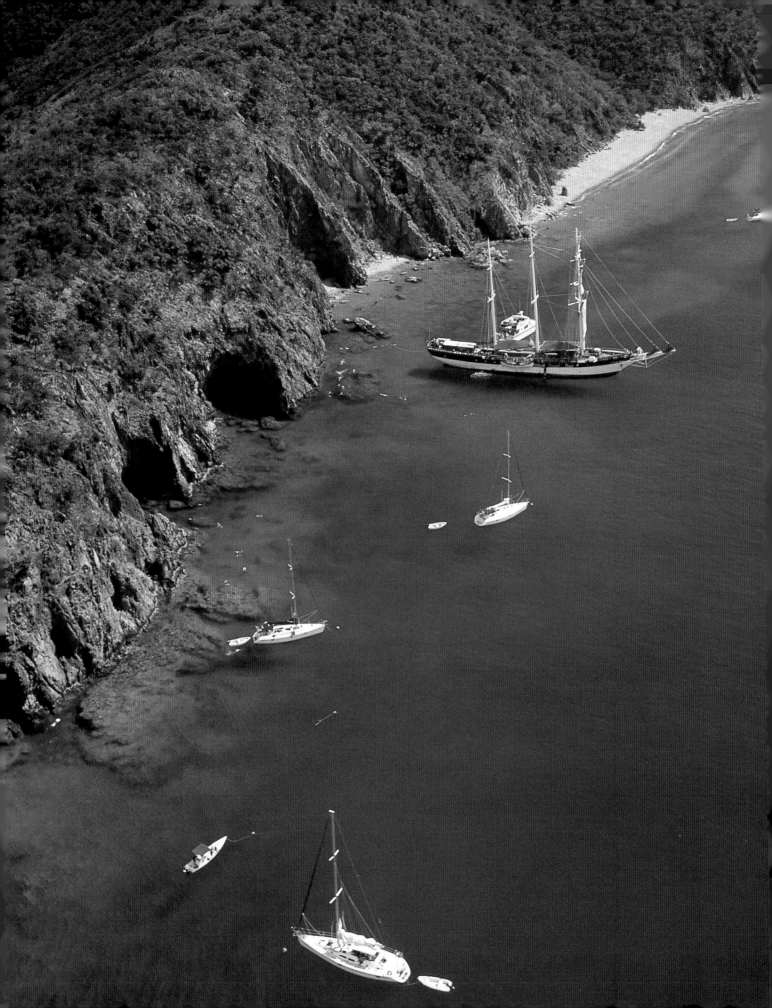

Shooting the Tropics

"The added difficulty of keeping cameras dry and working in jungle humidity and river spray . . . made the photographer's state of mind another matter. A writer can always reassemble a scheme from his notes, but the photographer must catch it as it flies, and in consequence, even the calmest hum with inner tension on an assignment."

ANDRO LINKLATER, from the book
Wild People: Travels with Borneo's Head Hunters

B Y THE THIRD HOUR of an all-day hike through the undergrowth in Costa Rica's Monteverde Cloud Forest, I had yet to take a picture. These dark, steamy woods would be considered a rainforest if their elevation wasn't so high. Rainforest or cloud forest, I was getting nowhere photographically. What most ecotourism outfitters don't tell you, and what most editors don't realize, is that although there are said to be more species per square foot in the rain forest than anywhere else on earth, all of them live in the forest canopy, 300 feet above your head! The only critters on the forest floor, besides me and my guide, were kamikaze mosquitoes.

Andreas, a local biologist, was leading me on this hike, and when we sat down and took a drink of water, I bemoaned my plight. No creatures, no pictures, the imminent demise of my career when I show up in New York with blank rolls of film—all the usual freelancer's paranoid ramblings. Andreas listened patiently and then said quietly, "If you want to see something, look down at your boot, but don't move!" The quiet tone of Andreas's voice set off alarms in my head, and as I looked down I had to resist the urge to break the standing broad-jump record. Crawling from my hiking boot to my pants leg was a tarantula spider with a body as big as my fist! Andreas coaxed the creature onto a broken-off tree branch while I tried to regain my composure. I set up my flash and grabbed a few frames before the huge arachnid headed back into the undergrowth.

The tropics present special challenges for photographers. The heat, the humidity, and the very bright or very dark lighting conditions can all conspire against your photographic success. You could hardly come up with a less hospitable environment for making pictures. But so many travel destinations are located in tropical regions that you'll be called upon to work there time and again. And, as inhospitable as the conditions might be, the imagery of the tropics is worth the trouble. Take a few of the precautions discussed here, and you'll be ready to photograph anything from a Jamaican beach resort to a "Heart of Darkness" Amazon adventure.

The caves at Norman Island, British Virgin Islands, are popular snorkeling holes. The island is also said to have been the inspiration for Robert Louis Stevenson's Treasure Island. *I photographed the caves from a small Cessna plane on assignment for the British Virgin Islands Tourist Board.*

Nikon 8008s, Angenieux 28–70mm zoom lens, B+W circular
warming polarizer, Fujichrome Velvia pushed one stop to
ISO 80 and exposed for 1/250 sec. at *f*/4

Life Is a Beach and Then You Dive

Although ecotourism is on the rise, you are far more likely to be called upon to photograph a tropical beach than a rain forest. First, you need to protect yourself with a good sunscreen. Then you'll need to protect your gear from the elements present on the beach.

If you have a black or dark-colored camera bag, you'll find out quickly that it absorbs heat and becomes a portable oven. I've discovered that film, even professional film, is more heat-resistant than you think; I keep it cool, but I don't worry about refrigerating it when I am on the road. Nevertheless, a black camera bag in the sun will soon subject film to unhealthy temperatures. Try to stick to the shade whenever possible, or sling a white towel or pillowcase over your camera bag. Even though my bag is a much more practical light tan color, I carry a white towel or pillowcase

to cover it and keep it out of the direct sun during sightseeing drives through the countryside or long hikes along the beach. A white towel is especially helpful because you can soak it first, wring it out, and then let the evaporation further cool your bag of equipment, which is resting beneath the damp towel on the car or bus seat.

When shooting on the beach, you also have to remember that like snow, sand is brighter and more reflective than most landscape scenes. As a result, it might fool your camera's light meter, which is calibrated to read scenes of average reflectance. Even today's sophisticated multisegment metering systems can't help. So when I'm shooting a bright sand beach on a sunny day, I set my camera's exposure-compensation dial to +1 to +1.5 *f*stops.

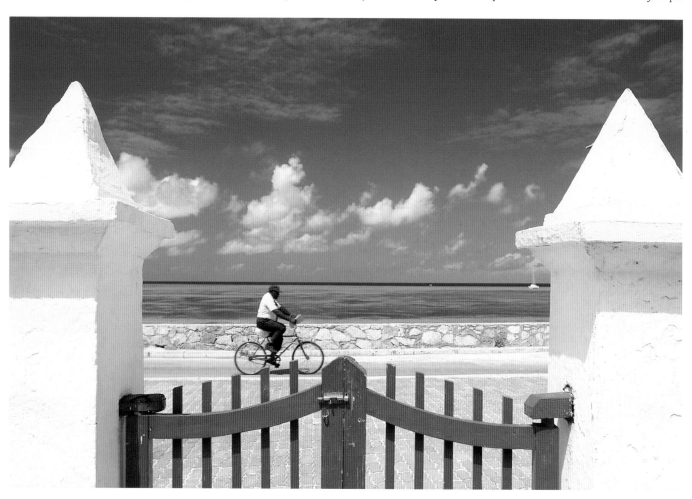

Life on Grand Turk Island is very quiet and proceeds at a slow pace. When I came upon this scene, the framing possibilities of the pillars and the red gate attracted me first. Then it was just a matter of waiting until someone interesting walked, or in this case, pedaled, through the frame. A vertical version of this shot became the cover for a story that appeared in Travel/Holiday *magazine.*

Nikon 8008s, Nikon 20–35mm AF zoom lens, B+W circular warming polarizer, Fujichrome Velvia exposed for 1/60 sec. at *f*/5.6

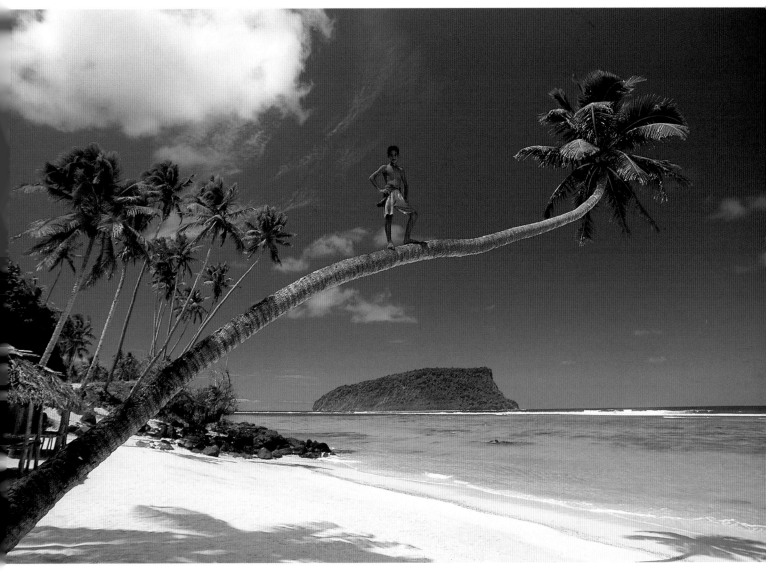

Parts of Samoa are so quiet and beautiful. When I came across this area, in Upolu, the young man was in the palm tree cutting away dead fronds. I asked him to stay up there for this quintessential South Pacific tableau. This was the lead shot from an Islands *magazine article about Samoa.*

Nikon 8008s, Nikon 20–35mm AF zoom lens, B+W circular warming polarizer, Fujichrome Velvia exposed for 1/125 sec. at f/4

I often double-check this reading with one that I make with a handheld *incident light meter*. This type of meter measures the light that is falling on the subject rather than reflecting off it, so highly reflective surroundings are less likely to fool the meter. Either technique will yield good beach exposures. Double-checking one reading against the other, and even then bracketing exposures, provides that extra measure of security that helps professional photographers sleep through the night!

The prime times for beach photography, like most other landscape work, are early morning and late afternoon. However, in the tropics, I'm not averse to shooting during the middle of a sunny day either, thanks to the magic of the polarizing filter. A tropical landscape and a wide-angle lens with a polarizer are made for each other. This filter's ability to eliminate reflections has a magical effect on the already incredible blues of the tropical waters and the greens of the foliage. A polarizer helps to tame the "killer contrast" that so often mars photographs taken at midday.

The fact that you can get good landscape photographs during the middle of the day makes the sightseeing helicopter flights offered on some islands a viable photo opportunity. These flights are usually offered during the business hours of 10 A.M. and 4 P.M., which isn't exactly the ideal time for most types of aerial photography. But the high sun offers the best penetration into the blue waters, and your polarizer will bring it all out.

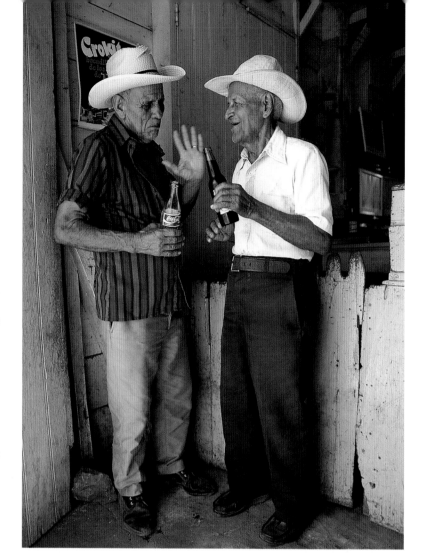

▶ *Sometimes it is best just to take a seat and let the action come to you. I was cooling off with a beer in a small rum shop in rural Costa Rica when these two farmers started chatting. The campesinos soon forgot all about my presence, and I was able to get a nice slice of everyday life.*

Nikon 8008s, Nikon 28mm AF lens,
Kodachrome 64 exposed for 1/30 sec. at f/2

▼ *Communal seine net pulls are still a fixture in the fishing villages around Grenada. I didn't walk up to these guys empty-handed; I stopped in a bar in Gouyave and bought a six-pack of beer to hand to the thirsty net pullers—and I was welcomed to photograph!*

Nikon 8008s, Nikon 20–35mm AF zoom lens, Nikon
SB24 flash set to -1 in matrix-balanced, fill-flash mode,
Fujichrome Velvia exposed for 1/250 sec. at f/5.6

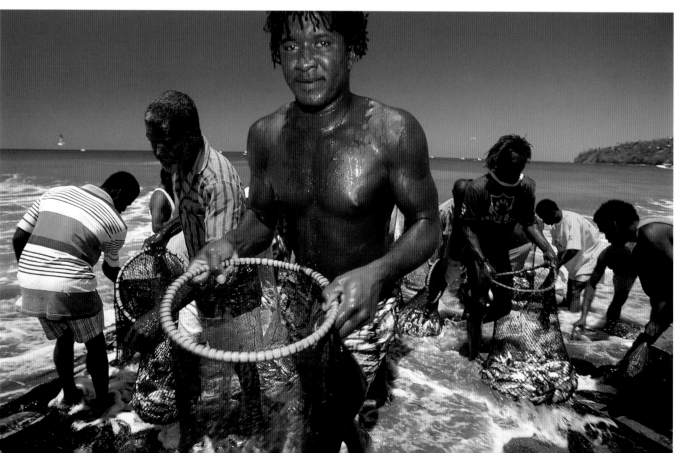

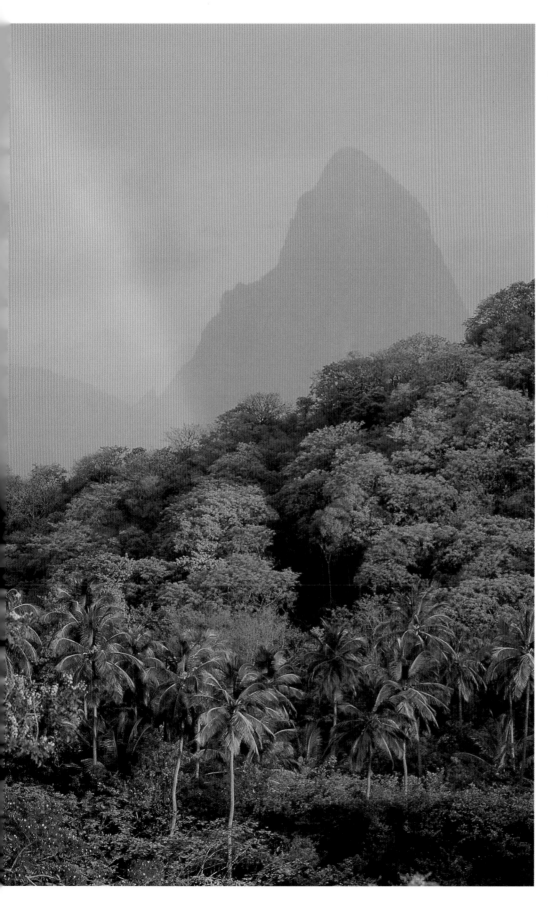

It rained for nine straight days when I covered St. Lucia for Islands magazine. It was an incredibly frustrating experience. Despite the torrential downpours, I always slung a camera over my shoulder even to go down to breakfast. Sure enough, one morning after a cup of coffee, the skies cleared, and I was able to make this shot of a rainbow over Piton in Soufrière between courses at breakfast!

Nikon 8008s, Angenieux 28–70mm AF zoom lens, Fujichrome Velvia exposed for 1/60 sec. at f/4

In and Around the Water

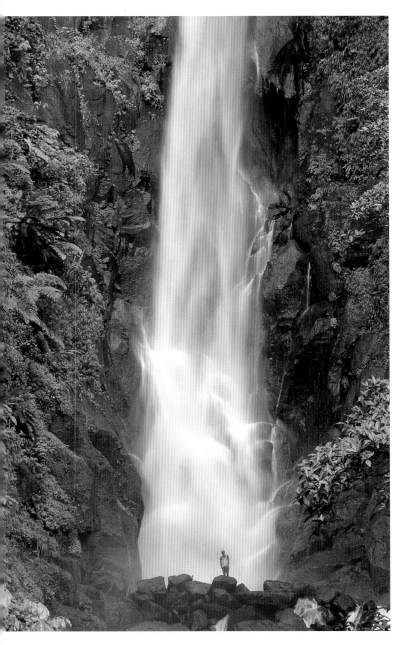

Nikon 8008s mounted on tripod, Nikon 80–200mm AF zoom lens, Fujichrome Velvia exposed for 1/4 sec. at f/11

The towering Trafalgar Falls is one of the prime sights on the lush island of Dominica in the West Indies. To give a sense of movement to the water, I used a slow shutter speed. The man standing at the base of the falls was an unexpected but welcome scale element.

"Cameras are like cats," photographer Richard Brown once observed. "They can take a lot of abuse, but they can't stand a dunking." In many tropical situations, so much photogenic activity—beachcombing, whitewater rafting, boating, snorkeling, sailing, and windsurfing—takes place in and around the water that you have no choice but to risk your hydrophobic equipment. When you take a camera around water, you can never be 100 percent certain that you can protect it. However, you can at least tilt the odds in your favor several ways.

For many activities, the only protection you might need is a zip-lock bag to protect your camera from spray and splashes. In calm, shallow water, you can wade out to photograph snorkelers or swimmers with this kind of setup and, unless you trip or stumble across a deep trough, come away unscathed. When the water gets a little rougher, you have a couple of options.

PROTECTING YOUR EQUIPMENT

The first option is one of the flexible, plastic-bag housings that Ewa Marine makes (see Resources on page 157). These have waterproof seals and optical glass ports, and are very lightweight and easy to pack. Some models have room for a strobe, and I highly recommend this feature because many water-based activities require fill flash in order for you to create publishable pictures.

Using this kind of housing is my first choice for photographing any activity around the water, as well as for taking shallow snorkeling shots. If the Ewa bags have a disadvantage, it is that the port, while allegedly facilitating the use of lenses with front filter mounts of up to 62mm, in reality doesn't allow for more than about a 55mm filter mount. This cuts down on your choice of lenses. I usually use my 24mm lens with this housing. I would love to use my 20mm lens, but it has a 62mm filter mount rather than a 52mm filter mount. This isn't too much of a hardship, but a larger port would make these housings even more of a "must-have" item.

Another possibility is a full-fledged, hard-sided underwater housing for your 35mm single-lens-reflex (SLR) camera. This is what the serious underwater photographers use for their work, and, basically, that is where this type of housing belongs. However, I've discovered that the Ikelite, one of the more inexpensive models in this category, comes in handy for making half-over/half-under water shots. These shots, called "over and unders," are very popular among photo buyers, but they are extremely difficult to do. An underwater photographer I know calls these shots "over and overs" because you have to do them over and over again to get them right! Nevertheless, these images can be very effective. In addition to the housing, you need a dome port, a full-frame fisheye or ultrawide-angle lens with split neutral-density (ND) filter, some calm water, and a lot of luck.

On assignment for Travel/Holiday magazine, I hooked up with a young couple going snorkeling in Providenciales, Turks, and Caicos. I found a quiet lagoon and did a series of "over" and "under" shots of the woman with the boat in the background.

Nikon 8008s in Ikelite underwater housing with dome port, Nikon 16mm AF lens, Fujichrome Provia exposed for 1/125 sec. at f/11

USING WATERPROOF AND WATER-RESISTANT CAMERAS

The venerable Nikonos is another option for working in or near water. You can shoot with this underwater rangefinder camera above water as well as long as you use a 35mm or 80mm Nikonos lens, or one of the older 28mm LW Nikkor lenses, which is only water-resistant. All the other wide-angle Nikonos lenses are corrected for underwater use only.

The Nikonos is definitely smaller than an SLR in an Ewa housing, and is a bit more convenient to load and reload. But with the Nikonos you have to *zone-focus*, which means using the depth-of-field scale on the lens to achieve focus. For example, with a 35mm lens set at $f/11$, you can zone-focus the lens so that everything from 5 feet to infinity is in focus. This range is called a lens' *hyperfocal distance*. Another disadvantage is that you have a very limited array of lenses for above-water shooting, and it is all but impossible to use fill flash unless you hook up one of the huge, dedicated underwater strobes for the Nikonos. Because of the

buoyancy underwater, designers really don't need to be concerned about size and weight when creating strobes for underwater photography. So unless you are Arnold Schwarzenegger, don't bother trying to use these flash units above water!

Nevertheless, my old Nikonos V comes along on every trip I take to the tropics, as well as when I go canoeing, rafting, kayaking, etc. The Nikonos is the grab-shot camera of choice around the water even though its design is quite old. We can only hope for an updated autofocus version with perhaps a wider lens that can be used above, as well as below, water. An autofocus Nikonos with a built-in flash and a 20mm lens usable above water is the dream of many outdoor photographers.

Several water-resistant point-and-shoot (P&S) cameras are tempting for working around the water. They have autofocus capability and built-in flash, but in most cases their 35mm lens isn't wide enough and their meter isn't quite accurate enough for color-slide film. But pop a roll of color-print film into one of these cameras, and you've got a very useful tool for recording water activities.

Fauna and Flora

Tropical islands offer quite a few opportunities for wildlife photography. You can photograph world-class pictures of birds on certain islands—for example, the large flamingo colonies on Bonaire and Great Inagua, a Bahamian island, and the scarlet ibis in Trinidad's Caroni Swamp—but you've got to track down your subjects. Flamingos and ibises are particularly shy, so if these birds are your quarry, you should be prepared with lenses in the 500mm to 800mm range and a portable *blind*. Shooting from a blind renders you pretty much invisible. Making a blind can be as simple as draping yourself with a 6 x 8-foot piece of netting, which is sold in hunting stores. Another option is to buy an elaborate camouflage-tent blind.

More common throughout equatorial regions, however, are opportunities to photograph small birds, such as parrots and hummingbirds. Finding hummingbirds in the wild can be difficult, but you can often photograph them with fewer problems around the feeders that are set up on hotel grounds. A close-focusing telephoto zoom lens and a flash are necessary to catch these fast-moving creatures. Some islands, like St. Lucia, have parrot conservation programs, and if you visit the sanctuary you can get fairly close to these colorful birds.

Lizards and iguanas are plentiful in the tropics, too. On Sandy Cay in the Turks and Caicos, the iguanas are protected and have no fear of people. In fact, iguanas will practically walk into the front element of your lens! But sharp-eyed travelers can spot iguanas in a variety of other places, from the beach to right outside their hotel door. I like to photograph these reptiles with an 80–200mm zoom lens and fill flash; this combination helps to reveal the detail in their scales.

Macro lenses are wonderful for closeups, but often their short focal lengths, commonly 50mm or 100mm, prevent you from getting close enough to small quarry to utilize them. For this reason, I rarely carry a macro lens. Instead, I carry one of two devices that can turn my 80–200mm zoom lens into a close-focusing lens. A small—12mm—automatic extension tube, fitted between the camera body and the lens, greatly extends the close-focusing capacity of the optic. The ability to use this device on an 80–200mm lens or even a 300mm lens turns these optics into the perfect tool for small, shy wildlife. You can be 5 to10 feet away from, for example, iguanas and little birds, and still have enough magnification to fill the frame with your subject. A 12mm extension tube is compact and light, and doesn't in any way affect the optical quality of your lens since no extra glass is present.

The other option for getting close to your subject with your telephoto lens is to use a screw-in *closeup filter*. These filters, which look thick, are actually magnifying elements designed for the front of your lens. Because they involve extra glass, you should get the very best one you can afford. Canon and Nikon

I came across this golden iguana basking in the shade in Chankanab Lagoon National Park in Cozumel, Mexico. Unfortunately, the boat and the rest of the scene were in bright sunlight. So I used fill flash to boost the light level on the iguana while maintaining a natural feel.

Nikon 8008s, Nikon 20–35mm AF zoom lens, Nikon SB24 flash with SC17 cord set to -1 in matrix-balanced, fill-flash mode, Fujichrome Velvia exposed for 1/250 sec. at f/4

Stingray City and the nearby sandbar is a popular spot for snorkelers and divers visiting Grand Cayman Island. I wanted to show the action going on above and below the surface simultaneously.

Nikon 8008s in Ikelite underwater housing with dome port, Nikon 16mm AF fisheye lens, Fujichrome Provia exposed for 1/125 sec. at *f*/11

make the better closeup filters, which feature at least two elements (see Resources on page 157). Multi-element closeup filters are expensive, but they produce superb results.

I also use the extension-tube setup for pictures of the orchids, hibiscus, and bougainvillea that are found in the tropics. Busy backgrounds mar many flower pictures, so I look for a blossom that I can isolate against a plain, dark-colored background. Soft shade and overcast light are ideal for revealing the detail in most flower closeups, but sometimes these conditions are in short supply in the tropics. In this case, I look for backlight in order to capture the detail and color of the blossom. If this isn't possible and I have to shoot in sunlight, I'll often use the -1 (stop) setting in the Matrix Balanced Fill mode on my Nikon SB-24 flash in order to open up the shadows and tame the contrast.

In order to capture some of the exotic insect life of the rainforest, you need to bring your own light. For this shot of an exotic moth in the Monteverde Cloud Forest in Costa Rica, I diffused the flash through a small umbrella and held it off to one side. A biologist friend held a small, 20-inch Flexfill reflector on the other side of the moth to create this portrait.

Nikon 8008s, Nikon 85mm AF lens, Nikon SB24 flash with SC17 extension cord, Kodachrome 64 exposed for 1/60 sec. at f/8

Festivals and Carnivals

The best and easiest places to get great people pictures in the tropics are the numerous festivals and carnivals held throughout the islands. Although many of these occur during the traditional pre-Lenten period—usually the week or two preceding Ash Wednesday—a lot of islands have rescheduled their celebrations to different times of the year so people can travel from island to island to enjoy the festivities. The biggest Carnevale celebration takes place in Trinidad at the traditional time of year, as do the celebrations in Martinique and Aruba. Other islands, such as the U.S. Virgin Islands of St. John, St. Thomas, and St. Croix, celebrate Carnevale during the summer months. In the Bahamas, the "jump up" occurs around Christmas and the New Year.

The colorful costumes and joyful atmosphere of these events are infectious. I've gotten my best Carnevale pictures by moving in close on the dancers and marchers with my wide-angle zoom lenses and using fill flash on almost every shot, whether the procession happens in bright sunlight or at night. Used up close this way, a wide-angle lens conveys a sense of immediacy and involvement in your pictures. I prefer the look to the more "removed" telephoto-lens perspectives. During night parades, I use a long shutter speed of 1/8 sec. or 1/4 sec. to record some of the ambient light in the background; the flash illuminates the subject. The blur patterns that result when you use a flash and a slow shutter speed really help to capture the sense of motion.

If you enjoy good music, tasty local-food specialties, and great people pictures, you might want to consider scheduling your entire trip around one of these celebrations. Contact the tourist board of the island you're planning to visit to find out when Carnevale or other festivals take place.

◀ When it comes to special events, I leave no stone unturned in my research. When I read in the local newspaper about a first communion at the cathedral in Soufrière, St. Lucia, one Sunday, I made sure I was there early, and I got this shot of some girls waiting on line outside the church.

Nikon 8008s, Nikon 80–200mm AF zoom lens, Fujichrome Velvia exposed for 1/125 sec. at f/2.8

▼ The weekly "fiafia" at Aggie Grey's Hotel in Apia, Samoa, features some amazing fire dancers. I keyed in on this young man and used a slow shutter speed to get a drag effect on the flames. I think the flash helped to open up detail on the dancer's face, but I am not sure! I know it didn't hurt!

Nikon 8008s mounted on monopod, Nikon 80–200mm AF zoom lens, Nikon SB24 flash set to -1 in matrix-balanced, fill-flash mode, Kodachrome 200 exposed for 1/15 sec. at f/2.8

The Virgin Islands

As I mentioned in the introduction to this book, I am reluctant to cite superlatives and favorites when it comes to the places I've traveled. I find something to like almost everywhere I go. So I won't come out and say that the Virgin Islands, especially the British Virgin Islands, are the most beautiful islands I've ever visited with probably the best beaches in the world. But if you ask me where I go with my family for rest and relaxation time and time again, I'll have no problem telling you: the Virgin Islands.

The quiet beauty of the British Virgin Islands is especially addicting. Cooled by the trade winds, blessed with a prosperous economy, and graced by a touch of gentle British civility, these islands are a siren song for anyone who has been fortunate to spend some time there. I've photographed them extensively, both for editorial and advertising clients, and yet, even when I go there to relax, I find myself grabbing a camera and getting up at sunrise to shoot yet another angle on a favorite beach or viewpoint.

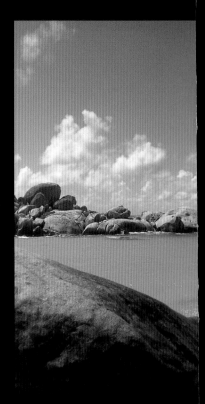

▼ *I took this picture looking down island over St. John in the U.S. Virgin Islands on an incredibly clear day with little or no aerial haze. I was shooting aerials of the British Virgin Islands from a small Cessna plane, but I was struck by this long view of St. John as it banked to make a pass.*

Nikon 8008s, Nikon 80–200mm AF zoom lens, B+W circular warming polarizer, Fujichrome Velvia pushed one stop to ISO 80 and exposed for 1/250 sec. at ƒ/4

▶ *Devil's Bay is another spectacular beach in Virgin Gorda, British Virgin Islands, that is worthy of the panoramic treatment. The beach is a favorite with yachters in the area because it is easier to reach from the water than it is from the island itself.*

Horizon panoramic camera mounted on tripod*, Fujichrome Velvia exposed for 1/250 sec. at ƒ/5.6

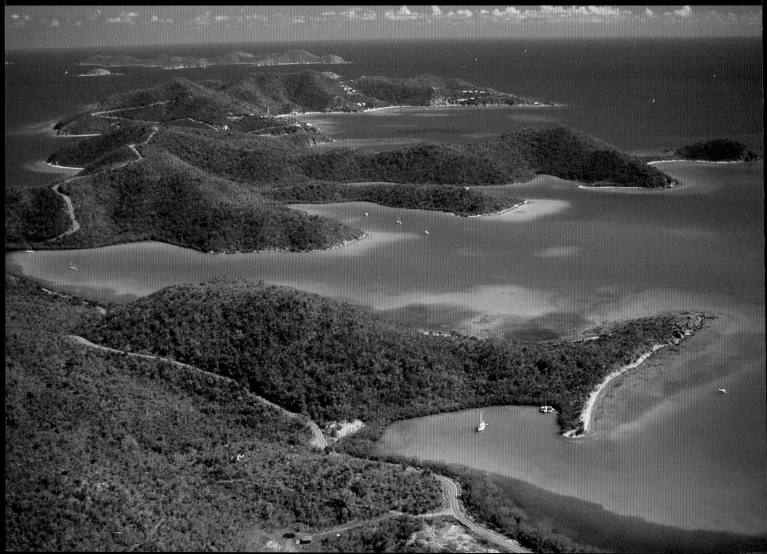

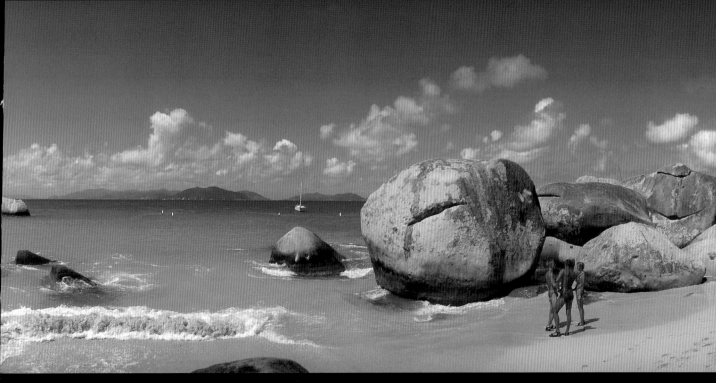

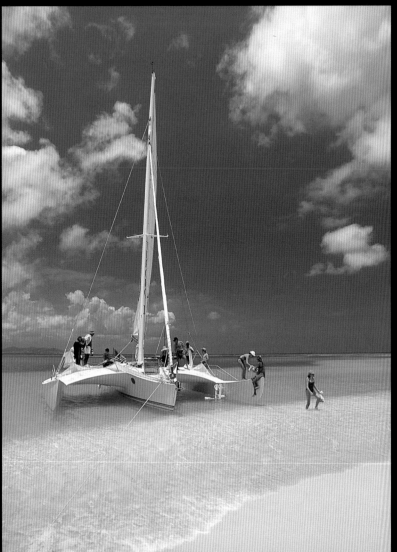

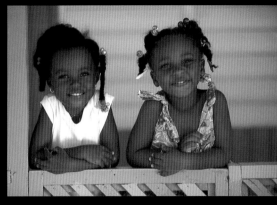

▲ These two young girls are the grand-daughters of a bone-fishing guide and taxi driver on the remote island of Anegada in the British Virgin Islands. I'd spent the morning photographing the guide out on his boat, and when we returned these two charmers were waiting for their grandfather. I got him to hold a reflector to open up the light on the girls waiting on the porch.

Nikon 8008s, Nikon 80–200mm AF zoom lens, Fujichrome Provia exposed for 1/125 sec. at f/4

◀ The beach at Buck Island, which is part of Virgin Islands National Park in St. Croix, U.S. Virgin Islands, is pristine and beautiful. I jumped off this day sail a bit early in order to get this shot of visitors hitting the beach.

Nikon 8008s, Nikon 20–35mm AF zoom lens, B+W circular warming polarizer, Fujichrome Velvia exposed for 1/125 sec. at f/4

121

▶ *I was working on some architectural shots of the fort in Christianstadt, St. Croix, U.S. Virgin Islands, when this gentleman approached me and asked me to take his picture. Of course, I couldn't refuse. I spent about half an hour shooting around the walls of the fort while he talked nearly nonstop!*

Nikon 8008s, Nikon 20–35mm AF
zoom lens, Fujichrome 100 exposed
for 1/125 sec. at f/5.6

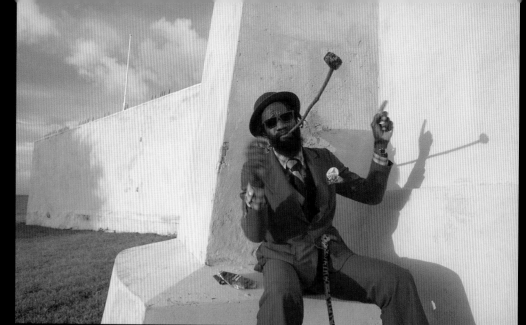

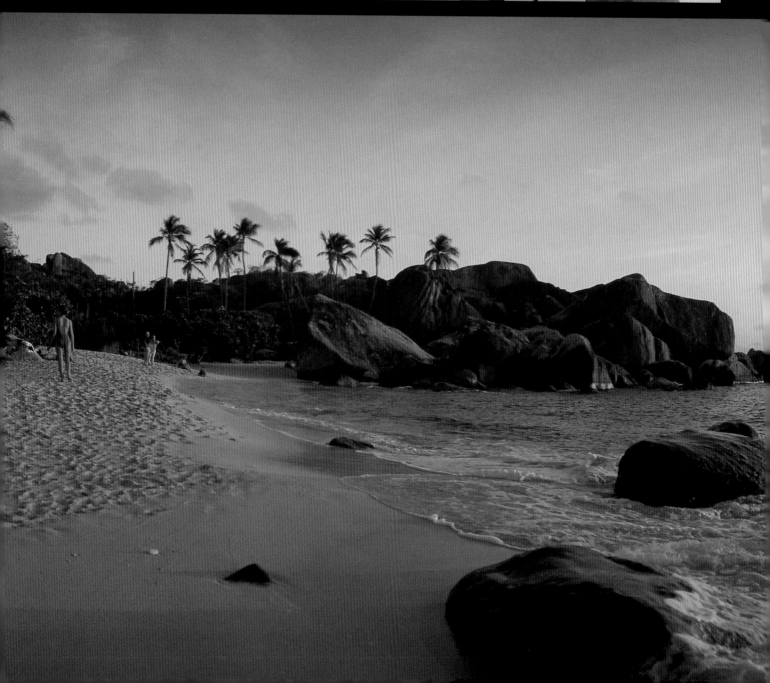

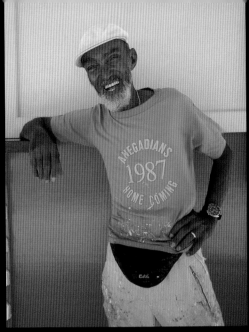

◀ I was shooting a brochure for the British Virgin Islands Tourist Board when I met a mellow islander who had spent a good deal of his life in New York City and retired back to Anegada to run a campground. I made this colorful portrait in some open shade near one of his concession stands.

Nikon 8008s, Nikon 20–35mm AF zoom lens, Fujichrome Velvia exposed for 1/125 sec. at ƒ/4

▼ The Baths are one of the most distinctive beaches in the world, thanks to the huge boulders that line both sides of the beach in Virgin Gorda, British Virgin Islands. I chose the wide view of a panoramic camera to include the entire scene and waited for the sweet light of sunset.

Horizon panoramic camera mounted on tripod, Fujichrome Velvia exposed for 1/4 sec. at ƒ/5.6

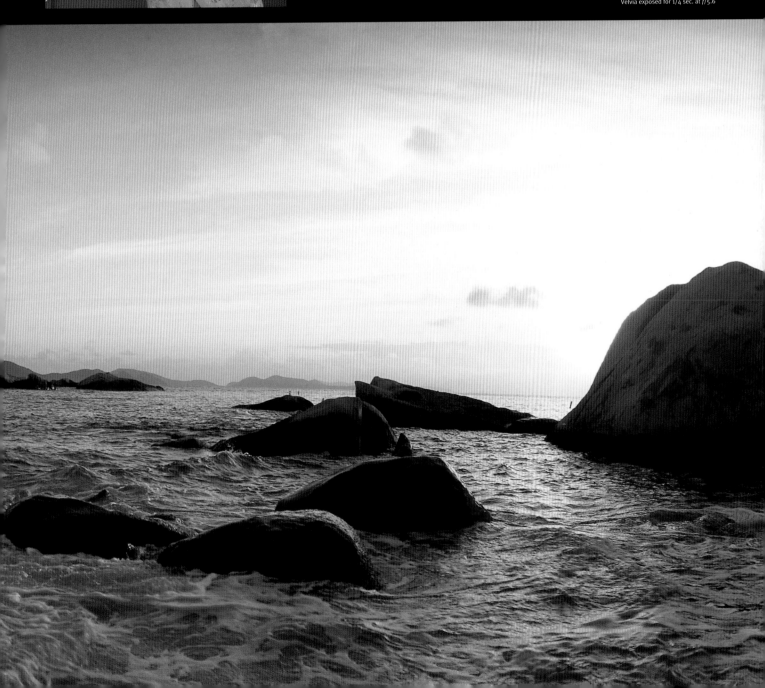

Special Places, Special Cases

"Photographers are just expected to be in the right place at the right time. We're paid to be lucky."

Mike Yamashita, *National Geographic* photographer

SOMETIMES IT ISN'T POSSIBLE to do justice to a location without making a special effort to photograph it. This can mean taking your cameras up in the air, in or around the water, or in some otherwise unfamiliar and sometimes hostile environment. It can also mean using a specific photographic technique or format to put a different spin on a place. While no one expects you to be an expert in aerial, underwater, sports, or wildlife photography, or alternative processes, it is a good idea to have more than a passing familiarity with the techniques associated with these specialties.

Sometimes you wonder if a picture is worth the trouble it takes to shoot it. A case in point: I was once up to my chin in the warm, clear water of the Caribbean off Grand Cayman Island, my camera safely ensconced in an elaborate underwater housing with a huge dome port. I'd mounted an ultrawide-angle lens inside it in an effort to simultaneously capture the scene above and below the water. With each wave, I swallowed another bit of the ocean as I attempted to frame the incredible scene before me: scores of stingrays swirling beneath the water while a few boats filled with observers watched safely from the surface. I waited for the calm between the waves, trying not to literally jump out of my skin when the grotesque winged creatures brushed against my legs as they swam past. The stingrays weren't aggressive, just curious. But that didn't make the experience any less weird!

While shooting a story on Palm Springs, California, for Private Clubs *magazine, I was having trouble showing the lush golf courses until the art director and I hired a helicopter for some graphic overhead views.*

Nikon F4, Angenieux 28–70mm AF zoom lens,
Fujichrome Velvia pushed one stop to ISO 80
and exposed for 1/250 sec. at f/4

Aerials

There is no better way to provide a visual sense of place than to show an area from the air. A landscape or city skyline that might look chaotic and jumbled from ground level suddenly takes on a geometry and beauty that are sometimes astonishing when seen from a 500- or 1,000-foot-high vantage point. So it is no wonder that nearly every story in a publication like *National Geographic* contains at least one aerial view of the region being covered.

The extreme mobility and freedom afforded by a moving aerial platform, while providing a nearly limitless array of possibilities, can also pose serious problems, especially for the novice photographer. Now you can move side to side and back and forth to change your viewpoint, as well as up and down. You travel hundreds of feet in an instant, and you can't, in most cases, just say, "Stop. This is where I want to shoot." You need quick reflexes and a complete command of your equipment; otherwise, the lim-itless choices for framing a picture can be overwhelming. Sometimes too much choice can be as stifling as no choice at all.

Nevertheless, you can employ certain techniques to help you make the right choices and make the most of your time aloft. Whether you'll be flying in a helicopter or a fixed-wing plane, you should keep in mind the following tips before going on an aerial shoot.

Dress Properly

More than likely, you'll be working with the door off the helicopter or airplane, or with an open window at least. You'll be at altitude and you'll be moving quickly, so the windchill will figure into your calculations. In general I find that it is wise to dress a season warmer than you would dress for on the ground. In the summer, dress for the fall or spring, and in the fall or spring, dress for winter. In the winter, bundle up and hope for the best.

While working on a story about South Carolina's Low Country for Islands *magazine, I hired a Cessna plane to get above the island areas around Beaufort. Because the islands are so flat, you need to get in the air to show the lay of the land and the water. The sailboat provided an important element of scale.*

Nikon 8008s, Nikon 85mm AF lens, Fujichrome Velvia pushed one stop to ISO 80 and exposed for 1/500 sec. at f/2

Make Yourself Secure

Since the *slipstream*, which is the gush of air just outside the airplane or helicopter, can be brutal, secure your eyeglasses with a safety strap, make sure your camera strap is around your neck, and batten down anything that is loose and might fly out of the door. In Iceland, the wind ripped my earphones from my head. They nearly fouled the rear rotor of the helicopter, which would have meant a certain crash. If the door is off, make sure you're securely strapped in with a harness. If you're using just a seatbelt, close the buckle with gaffer tape so that you can't inadvertently brush it open with your sleeve or camera strap.

Establish Communications

Besides chilling the air, the wind in an open cockpit makes it nearly impossible to speak or to be heard. Make sure that you have a working set of earphones and mike so you can communicate freely with the pilot.

Go Low and Slow

Most pilots are trained to get from point A to point B in the quickest, most direct way. You, however, are more interested in the scenic route. Some pilots have more experience working with photographers than others, so it pays to remind your pilot that you want to fly as low as possible—most Federal Aviation Agency-mandated minimum altitudes range from 300 to 1,000 feet, depending on the terrain—and as slow as safely possible.

▲ *To catch the dreaming spires of Oxford, England, while on assignment for* Travel & Leisure, *I hired a helicopter to get an overhead view. But the pilot wouldn't fly below the minimum ceiling of 1,000 feet or hover for fear of breaking strict noise-abatement rules, so we made several passes over the town much as we would have from a small plane. If I'd known this beforehand, I would have hired one—and saved a lot of money!*

Nikon 8008s, Nikon 85mm AF lens, Fujichrome Provia pushed one stop to ISO 200 and exposed for 1/500 sec. at f/4

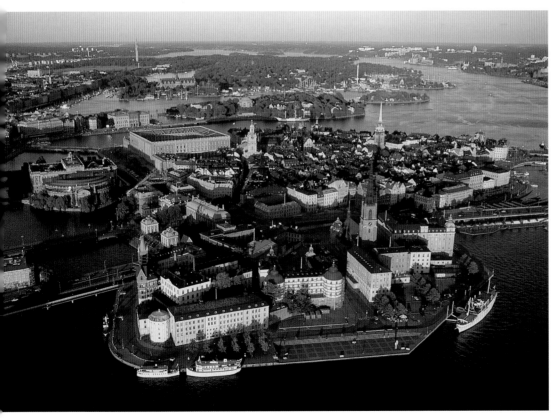

◄ *Stockholm, Sweden, is a city built on islands, and one of the only ways to show its topography is from the air. I made this photograph from a helicopter while on assignment for* National Geographic Traveler *magazine.*

Nikon F4, Angenieux 28–70mm AF zoom lens, Ken Lab KS6 gyrostabilizer, Fujichrome Velvia pushed one stop to ISO 80, exposed for 1/125 sec. at f/4

Avoid Vibrations

Be careful not to lean against the door or window when shooting. The airframe will be vibrating like crazy and will ruin your pictures. Use the highest possible shutter speed. *Gyrostabilizers* are battery-operated, self-contained gyroscopes that you attach your camera to. Gyrostabilizers resist movement and vibration, so they are extremely useful and result in sharper pictures than those shot handheld in the air. Because gyrostabilizers are expensive and heavy, they are rental items for most photographers.

Nikon F4, Angenieux 28–70mm AF zoom lens, Ken Lab KS6 gyrostabilizer, Fujichrome Velvia pushed one stop to ISO 80 and exposed for 1/250 sec. at f/4

The marsh grasses made for some great patterns, and the small crab boat gave an element of scale to this shot, which I made from a Cessna plane on assignment for Islands *magazine in New Jersey. The warm, late-afternoon light on Barnegat Bay did the rest.*

Shoot in the Right Light

In almost all cases, you need the long shadows of a low-hanging sun in order to add a sense of dimension to your photographs. This means shooting in the early morning or late afternoon. The only exception to this is when you're shooting around water, specifically in the tropics. As mentioned earlier, in those locations, it is better to shoot during midday when the high sun best penetrates and illuminates the water. For aerials over land, I often use a warming filter, like an 81C, to further warm the scene. For aerials shot over water, I like a polarizer to help emphasize the blues of the water.

Shoot in the Right Weather

Often the hardest aspect of shooting aerials is finding a plane available when the right weather finally sets in. Murphy's Law dictates that all kinds of aircraft will be around during bad weather, and that they all seem to disappear when the sun shines! Local weather forecasts are sketchy in their usefulness for predicting the kind of weather you need for aerials; they just don't tell you enough. Contact the local airport's meteorological office for a thorough, up-to-date weather prediction. When you tell the staff what you're doing, they'll be able to advise you as to upcoming conditions. If you travel with a laptop computer and have access to the Internet, you'll be able to look up the weather at CNN.com and check the radar pictures for cloud cover and movement.

Lenses

Many photographers find that a zoom lens in the 28–70mm range is a good all-around aerial lens. The altitude often makes lenses wider than 28mm unnecessary; focal lengths longer than 85mm are too prone to vibration and camera movement. If you want to shoot with a longer lens, say an 80–200mm, a gyrostabilizer is the only way to go. Always use the fastest possible lens to allow for the highest possible shutter speed. Some photographers prefer to use prime lenses. These single-focal-length lenses give you fewer framing possibilities, but they are often faster and exhibit better contrast, which can help in backlit and lowlight situations.

Exposure

In the best of conditions, exposure isn't an exact science. In a fast-moving plane or helicopter, it is a real problem. Because you're pointing down at your subject, chances are that your photographs will contain very little, if any, sky. Since most in-camera meters are weighted to include the bright sky, they tend to overexpose. I've found that, for aerials, a reading about one stop below the meter reading usually yields good results. But the great variation in landscapes always makes bracketing a good idea. I use the automatic-bracketing function on my camera, and I'll often set the sequence to give me a three-shot bracket: one at the meter reading, one at half a stop below that reading, and one at a full stop below it.

Shooting in Winter or Cold Climates

"Photography isn't a three-season sport," my former city editor used to snarl when we griped about working the streets during a brutal Northeastern winter. "You play year-round or you don't play at all. Now go out there and get me some cold-weather art, and make it good!" Not everyone has the luxury of a cigar-chomping editor with a two-day growth of beard to chase you outside when the weather turns cold anymore, but since every destination isn't necessarily balmy and sun-drenched, it pays to pretend you do!

It is essential that you dress properly so that you can enjoy cold-weather photography. As a young newspaper photographer, I stomped and shivered my way through three years of shooting frigid football games and ice-caked fire scenes before I learned this lesson. Of course, that was back in the mid 1970s when any talk of "layers" usually referred to a cake. Today, the concept of layering clothing to beat the cold is widely known.

A first layer of undergarments made from polypropylene or some other wicking material prevents perspiration from evaporating on your skin and robbing your body of its natural heat. Cotton underwear is a definite no-no since it absorbs, rather than transfers, moisture. ("Cotton Kills" were the the words used by a guide who led me through a winter-camping photo assignment in northern Maine years ago.) Polypropylene garments are comfortable, and are available in different weights and thicknesses. You'll want to select a heavy-weight polypropylene if your cold-weather activity will be passive, and a lighter-weight polypropylene if it will be active.

The second layer of clothing consists of the insulation, which is usually some type of synthetic fleece material or down. Finally, a third layer of breathable, wind- and water-resistant material, such as GoreTex, is required. For additional advice, consult the customer-service departments of outdoor outfitters, such as L.L. Bean or Cabellas.

Keeping your hands warm is especially important to photographers because you need to maintain dexterity in order to focus and change lenses and film. For moderately cold conditions, I like to wear Lowe Photo Gloves. These synthetic polypropylene gloves are covered with tiny rubber studs and enable you to retain enough dexterity to even change film. I don't recommend ragwool gloves because they tend to shed threads that inevitably wind up stuck in your shutter or some other inconvenient place.

For some reason, my hands are particularly susceptible to getting cold and going numb. So for more extreme conditions, I layer a pair of large ski gloves over my Lowe Photo Gloves. My ski gloves have a special gel in the palm and fingers. I insert a chemical heat pack in a pocket in each glove, and the gel warms up and keeps all my fingers warm and functioning.

Layering is a good idea for your feet as well. Wear a moisture-wicking sock liner, then an insulating sock of fleece or wool.

Finally, topping them off with a pair of insulated pack boots should do the trick. Get the lowest-rated pack boots you can, offering protection to -50°F or -100°F, because the comfort range ratings are highly optimistic.

I was shooting a story on Salzburg, Austria, during the pre-Christmas Advent season for Travel/Holiday *magazine when a snowstorm hit. I took a tour of a nearby museum and found a window overlooking the Christmas Market to shoot this snowy street scene.*

Nikon 8008s, Nikon 80–200mm AF zoom lens, Kodachrome 200 exposed for 1/125 sec. at f/2.8

Camera Equipment Use in the Cold

Today's autofocus, auto-everything cameras are completely battery dependent. Cold weather is extremely hard on batteries, causing them to function less efficiently—or not at all—and run out more quickly than they do at moderate temperatures. You can take several preventive steps to keep your battery from dying in the cold.

Keep the Camera Warm

Wear an oversized parka, and keep the camera in it until you are ready to shoot. Put the camera back inside your jacket when you're finished.

Carry Spare Batteries

Always carry an extra battery, preferably in close to your body where it will stay warm. Changing batteries in the cold is painstaking business, so if a battery holder is available for your camera, you should seriously consider buying one. Then keep it loaded and inside your parka. With my Nikons I find it a lot easier to load one cartridge than four separate AA batteries.

Use a Cold-Weather Battery Pack

Many cameras have an accessory cold-weather battery pack. This usually consists of a battery compartment with a long cord and an insert that goes into the camera's battery compartment. With this very convenient setup, you keep the battery pack inside your jacket, and run the cord and the insert out to your battery.

Use Lithium or Nicad Batteries

Alkaline batteries are the most sensitive to cold-weather problems, so you might want to think about replacing them with lithium or nicad batteries. Not all cameras can accept lithium or nicad batteries, so be sure to check your instruction manual before substituting batteries.

Weatherproof Your Tripod

In cold weather, handling a metal tripod can be a painful experience. Many cold-weather photographers tape foam pipe insulation around the upper section of their tripod legs to make handling the tripod more comfortable. These insulating tripod leg sleeves are also available from wildlife-photography-specialty catalogs.

Nikon 8008s, Nikon 80–200mm AF zoom lens, Fujichrome 100 exposed for 1/250 sec. at f/2.8

Shooting some winter-travel pictures in Germany for Lufthansa Airlines, I was in the ski resort of Garmisch-Partenkirken when a full-scale snowstorm hit. I managed to make my way through the storm to this park area, where some people were enjoying a horsedrawn-carriage ride through the driving snow.

Picture Points

Once you've devised a plan to protect yourself and your equipment from the cold, you should consider some of the technical aspects of winter-weather photography. Snowy landscapes are highly reflective and can wreak havoc with a camera's light meter, which is calibrated for scenes of average reflectance. Consequently, many pictures of white, snowy landscapes come out looking dull and gray because the camera has underexposed the scene. To correct this, you have to overexpose from the meter reading whenever you're faced with a scene that is mostly white snow. You can do this a couple of ways.

Use the Exposure-Compensation Dial

Today, even P&S cameras have an exposure-compensation dial. If you're shooting color-slide film, try programming in a +1 or +1.5 *f*stop compensation. With color-print film, try +2 stops. This tells the camera to overexpose the scene by whatever value you've programmed.

Change the Film-Speed Rating

If your camera doesn't offer exposure compensation but allows you to change the film speed from the DX rating, you can fool the camera into exposing properly for snow by lowering the film-speed rating. Halving the film speed results in a one-stop overexposure. For example, if you're shooting ISO 400 film, set the camera for ISO 200 for a 1-stop overexposure, or ISO 125 for a 1.7-stop overexposure.

Reset the Camera

It is too easy to forget to reset the camera when you're finished, and subsequent pictures shot under normal conditions will be overexposed. *Always, always* check to make sure you've undone the changes you've made.

Like most landscape scenes, snowscapes benefit from the long shadows that the early-morning or late-afternoon sun casts. At midday, the high sun can create glare and very flat, featureless lighting. To make the most of falling snow—or rain for that matter—use a telephoto lens to compose your images. The compressed perspective this optic offers emphasizes snowflakes and can make a moderate snowfall look like a veritable blizzard.

Of course, falling snow presents another problem: keeping the camera dry. The easiest and most versatile camera "raincoat" I've discovered is the simple hiking gaiter. Designed to keep snow out of the top of your hiking boots, these gaiters are usually made of a water-resistant nylon, have a Velcro-closing strip along their length, and work extremely well with long lenses. A pair of gaiters is less expensive than most commercially made camera raincoats, which have basically the same design.

Finally, after you've spent the day outside and you're returning to a warm room, remember to put your camera back into a camera bag or a resealable plastic bag. Like a pair of eyeglasses, your camera will become covered with condensation if it is uncovered when you bring it into a warm room after spending several hours in a cold climate. Putting the camera in the bag will cause the condensation to form on the bag instead of on the camera. Let the equipment warm up in the bag before taking it out.

It rained 8 inches in just eight hours on the second day of a hike across the famous Milford Track on South Island, New Zealand, that I was covering for Islands *magazine. The rain was falling so hard that it was impossible for me to shoot with one of my regular cameras without ruining it. So I spent the day shooting with my waterproof Nikonos, even when the rainfall was relatively light, as in this shot of some hikers.*

Nikonos V camera, Nikon 35mm underwater lens, Fujichrome Velvia pushed one stop to ISO 80 and exposed for 1/30 sec. at *f*/4

Photographing Wildlife

Luck is a major factor in wildlife photography. With ecotourism growing in popularity, many travel photographers find themselves called upon to shoot publishable wildlife images. If you believe the copy in some of the safari and ecotourism tour brochures, you'll think that getting great wildlife pictures on these trips is as easy as shooting fish in a barrel. However, when you're dealing with animals, nothing is easy.

LOCAL HELP

Presumably, if you're being called upon to photograph wildlife, it is because you're visiting a wildlife "hot spot." This might be a safari in Africa, a wildlife-refuge nesting area, or a rainforest. So you know the quarry is out there. But this doesn't necessarily

Nikon 8008s, Nikon 500mm F4 P lens braced on beanbag in car window, Fujichrome Provia exposed for 1/125 sec. at f/4

While covering a scenic-drive story for National Geographic Traveler *in Alaska, I came across this elk buck in a wildlife refuge near Seward. I shot from the car window so I wouldn't spook the animal.*

mean you can find it! Rainforests, for instance, are touted as having more species per square yard than any other environment, yet it is quite possible to walk through a rainforest and not see anything. Much of the activity goes on high above you in the tree-tops, something ecotourism outfitters often fail to mention!

So the first step is to *find a good local guide*. I can't overstate how important this is. Usually there is a ranger, an employee of the local forestry department, a resident biologist, or a wildlife expert around wildlife hot spots. Seek out these individuals to help you with your assignment.

THE RIGHT TIME

In most cases, your quarry won't be keeping banker's hours. Many creatures prefer the crepuscular light of dawn and dusk for their activities. This means that you'll be hunched over a tripod when you should be drinking coffee or enjoying an aperitif. There is simply no escaping this, unless you visit a wildlife area during breeding or nesting season when the animals can be active throughout the day.

Be aware, though, that ordinarily you'll experience long periods of idleness between your early starts and late finishes. On a tiger-spotting safari in Ranthanbore National Park in India, I started at 5:30 A.M., finished the morning session by 8:30 A.M., and went out again between 5 and 7 P.M. This kind of schedule isn't unusual, and it reinforces what a colleague once observed, namely, that a good book is an indispensable piece of equipment for wildlife work.

THE RIGHT STUFF

Unfortunately, a thick paperback isn't all you'll need when you want to photograph wildlife. In no other branch of photography, with the possible exception of sports, is the right equipment so crucial for success. If you have the right gear, you stand a fighting chance of coming back with good pictures. If you don't, it's hello fuzzy dots and furry spots.

Long lenses are the core of any wildlife outfit. While a 200mm lens might get you close enough to many creatures on an African safari, a 300mm or 400mm lens should be considered the minimum focal length required for general wildlife photography.

Since most of your quarry is active in the dim light of dawn and dusk, and not during midday, you have the added problem of light gathering. Most professional photographers who work with slow-speed, fine-grain film counter this problem by using high-speed, wide-aperture telephoto lenses: a 300mm F2.8 lens, a 400mm F2.8 lens, a 500mm F4 lens, and a 600mm F4 lens. You've seen these optics on the sidelines of football games; they are as big as bazookas, with dinner-plate-size front elements and price tags in the mid-four figures. Before you remortgage your

A good guide is key to successful wildlife photography, and I had one of the best during a recent trip to the Mala Mala private game reserve in South Africa. He was able to track this group of elephants through some thick undergrowth and finally found them bathing in golden late-afternoon light.

Nikon 8oo8s, Nikon 3oomm AF lens braced on beanbag support, Fujichrome 100 exposed for 1/125 sec. at f/5.6

house to buy these one of telephoto lenses, however, be aware that there are alternatives.

Since you need pictures that are publishable but aren't necessarily in the same league as those of the top wildlife photographers, you can make up for the low light by using a fast—and somewhat grainy—film. For color slides, try the new "pushable" films like Ektachrome 200 or Fuji MS 100/1000, both of which can be pushed two to three stops quite nicely. Then you can use a long lens with a much smaller maximum aperture, say F5.6, and a much more reasonable price.

Besides the lens, you'll need a good tripod for shooting from the ground and a beanbag for shooting from vehicle sunroofs and windows. You can buy one of the commercially available beanbags like the Steadybag (see Resources on page 157). If, however, you want to save weight, you can buy a waterproof sleeping-bag stuff sack, which you carry empty to your location. Once you arrive, buy 5 pounds of rice or beans and fill the bag. Then, before you go home, empty the bag.

You also need to keep in mind that the sight of a human form stalking them upsets most animals. In many cases, you can approach your quarry much closer when you work from a car or boat. When many serious wildlife photographers have to go on foot, they utilize *blinds*, which are small camouflage tents that blend in with the surroundings, and let the quarry come to them.

The most compact blind I've ever used is the Camoflex, made by Visual Departures (see Resources on page 157). It is, essentially, a camouflage baseball hat sewn into a rim that suspends floor-length camouflage netting material. Like the well-known Flex-fill reflectors, the Camoflex's rim folds into itself, and the whole unit packs up into a circular package 15 inches in diameter and about 3 inches thick. So it is small enough to stick in the corner of a suitcase or duffel bag.

To other humans, you'll look ridiculous standing with your tripod inside the Camoflex because it is like wearing a floor-length, camouflage lampshade on your head. But to the animal kingdom, you'll be almost invisible. I've used this rig successfully to photograph flamingos in the Bahamas and scarlet ibises in Trinidad, where to this day my guides are probably still laughing. Sometimes, your dignity is one of the things you must sacrifice for your photography.

▶ *The cliffs that line Alaska's Pribilof Islands are teeming with bird life, and the cliff tops are inhabited largely by wildlife photographers during the summer months. I was covering the area for a story in* Islands *magazine when I made this portrait of a tufted puffin on St. Paul's Island.*

Nikon FE2 mounted on tripod, Nikon 500mm F4
P lens, Kodachrome 64 exposed for 1/125 sec. at *f*/4

▼ *For a story in* International Wildlife *magazine, I was photographing the Western Hemisphere's largest colony of flamingos in the interior of Great Inagua island in the Bahamas. Every morning my guide and I slogged miles through the salt marshes and set up a small blind in the mangroves. Deep in the shade, a single shaft of sunlight hit this bird as it relaxed.*

Nikon 8008s mounted on tripod, Nikon 500mm F4
P lens, Fujichrome 100 exposed for 1/250 sec. at *f*/5.6

Photographing Sports and Action

It is surprising how often travel-photography situations involve photographing some kind of fast-moving action, such as wind-surfers, bullfighters, joggers, Frisbee players, and horseback riders. The key to any kind of action photography is to *anticipate* the peak moment of action. If you wait until you see that moment in your viewfinder, chances are you'll have actually missed the peak itself. This anticipation, of course, takes practice and a familiarity with the game or the action that you're photographing. You can shoot action two basic ways: either by freezing it with a fast shutter speed or by emphasizing the movement with a slow shutter speed.

If you don't get much of a chance to photograph action, you should practice before heading off to shoot, say, a bullfight festival in Spain or a lifeguard tournament in Sydney, Australia. Try photographing a local Little League baseball or Pee Wee football game, or the members of a local running club working out or racing. Any subject that gets you into the habit of watching and anticipating action through your viewfinder will help.

FREEZING THE ACTION

Freezing peak moments is the more common approach. In general, you need a shutter speed of 1/500 sec. or faster. The narrow depth of field of a telephoto lens, 200mm or longer, helps to soften distracting backgrounds and make your subject *pop*. *Sports Illustrated* magazine is filled with graphic, exciting photographs made this way and is a good place to look for inspiration. Keep in mind, however, that the professionals who made these shots use *extremely* long, wide-aperture lenses in order to get those super-soft backgrounds. An action shot taken with a 300mm telephoto lens isn't going to have quite the same feel as one taken with a 600mm lens.

As you practice, you'll find that it is easier to freeze motion coming directly toward the camera than it is to capture action moving across your field of vision. Of course, action coming directly toward the camera is very hard to keep in focus—the Predictive Autofocus mode of modern cameras is absolutely great for these situations— but you can often freeze this motion with shutter speeds as low as 1/125 sec.

PANNING

The second, less popular approach to action is to *pan* your subject, which means emphasizing it through the use of a slow shutter speed. The resulting blur effect can be quite artistic, but it is far less predictable than freezing the motion. In addition, panning is an even more difficult technique to master. When it works, however, the results are impressionistic and exciting.

When you pan the action with your camera at a slow shutter speed, the subject is rendered somewhat sharply, while the background registers as a blur. This approach is a very effective way to give a feeling of motion and speed to a still frame. Panning takes practice, so you should familiarize yourself with the following tips before you try it.

A lot of Portuguese bullfighting is done on horseback. The goal of the horsemen, or cavalheiros, is to keep their mounts away from the horns of the charging bull, while getting close enough to plant barbs in the shoulder area of the beast. I made this shot of a matador on horseback in Alentejo, Portugal.

Nikon 8008s, Nikon 300mm AF lens, Fujichrome Provia exposed for 1/30 sec. at f/8

Select the Proper Shutter Speed

Pick a shutter speed that is too slow, and nothing will be in focus in your final image. Too fast, and you'll lose the sense of motion. I've found that for most moderately fast subjects, including runners, horseback riders, and bicyclists, a shutter speed of about 1/30 sec. with a 200mm telephoto lens works well. With a 300mm lens, a shutter speed of 1/60 sec. is good. Shorter lenses can accommodate lower speeds, but when you get much below 1/8 sec. or 1/4 sec. with, for example, a 24mm wide-angle lens, rendering any subject sharply is very difficult.

Center the Subject

When you pan, stand with your feet firmly but comfortably planted. Follow the action by twisting your upper body only. Keep the subject in the center of the viewfinder. Then try to match the speed of the subject movement. You can tell if you're doing this successfully

I used a slow shutter speed and panned my camera to create this impressionistic rendition of a matador during a bullfight on Portugal's Azores Islands.

Nikon 8008s, Nikon 300mm AF lens, Fujichrome Provia exposed for 1/30 sec. at f/8

For a story about a young pilot for Boys' Life *magazine, I clamped a camera onto the wing of his yellow Piper Cub and used a radio control to trip the shutter. I gave the pilot the transmitter and asked him to make exposures when he was doing dramatic banking maneuvers above Allentown, Pennsylvania.*

Nikon 8008s, Nikon 16mm AF lens clamped on wing with Bogen Super Clamp and triggered with Venca Radio Slave, Kodachrome 64, aperture-priority automatic exposure unrecorded

when the subject is in the same position in the viewfinder *after* you make your exposure as it was before. Once you make an exposure, don't stop panning; follow through the way baseball players do with their swing after they hit the ball. To practice this technique, you can simply track cars driving by on a busy road. You don't need to shoot film; just try to follow the cars with your camera.

Assume a Straight-On Position

Panning with action moving either toward or away from you is quite difficult, even at an angle. To pan successfully, you need to position yourself so that the action moves straight across your field of vision. Then once you lock on your subject, you don't have to refocus while panning.

Practice, Practice, Practice

You can become proficient at this technique only one way, and that is to practice. At first you can practice panning without actually tripping the shutter and using film, but eventually you need to put some film through the camera to evaluate your mastery of the technique.

Point of View

Another excellent technique for photographing action is to shoot it from the participant's point of view. This technique is especially popular with filmmakers since the depiction of motion in film and video is easy to accomplish. Still photographers can obtain the same results with a little fiddling here and there.

For effective point-of-view action shots, you need to show part of the participant or the participant's mode of transportation, like a bicycle, raft, car, balloon, or gondola, in the picture. Typically this means working with an ultrawide-angle lens or even a *fisheye* lens, which can record an angle of view up to 180 degrees. If possible, you should use a slow shutter speed in order to impart a sense of action as well. Depending on the activity you're photographing, you can either handhold the camera as you participate in the action, or clamp the camera to a crossbar, helmet, or some other part of the gear or conveyance.

Point-of-view shots are currently very popular. Look through any travel magazine these days, and you'll find at least one picture taken through the windshield of a car, a train, or some other conveyance. These type of shots go a long way toward providing that "you are there" feeling.

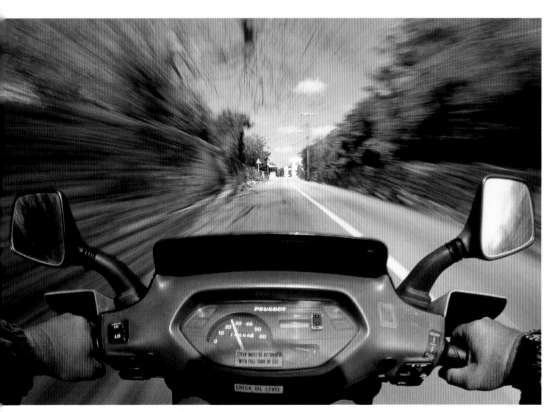

In order to capture the feeling of zooming around Bermuda on a scooter, I strapped my camera to my chest and checked composition through a right-angle finder. I threaded the long cable release down my sleeve and tripped the shutter whenever I went through an area that looked nice. The extreme angle of view of the fisheye lens took in both the scooter console and the roadside scenery.

Nikon 8008s with right-angle finder held to my chest with homemade harness and tripped with long shutter-release cord running down sleeve of my windbreaker, Nikon 16mm AF fisheye lens, Fujichrome Velvia exposed for 1/15 sec. at f/16

Alternative Processes

At one time everyone wanted to see destinations shot in full living color. Today, more and more magazine and brochure designers are open to seeing destinations portrayed in other ways, including black and white, handcolored black and white, infrared, Polaroid transfer, plastic toy cameras, and panoramics. This opens up a whole new palette for travel photographers and gives you an opportunity to stretch your vision.

A few years ago, I began to experiment with a film and filter combination that I might be able to use in bad weather. I was looking for a romantic, antique look for some of my European destinations. After much experimentation, I settled on a warm, grainy, diffused look.

I achieved this look by pushing Agfachrome 1000 film two stops. This strategy intensified the grain. Then I tried warming and diffusion filters to further accentuate the effect. Finally, after a lot of experimentation, I arrived at a workable combination of warming filters and fog diffusers for various focal lengths and weather conditions.

In the beginning, I couldn't convince any of the editors I worked with to try an assignment shot this way. Eventually, *Islands* magazine agreed to let me shoot Venice using this technique. The magazine's editors wanted to put a different spin on an often-photographed place. Since the appearance of this story, I've shot several assignments this way, many of which I would never have gotten at all without my having this technique in my bag of tricks.

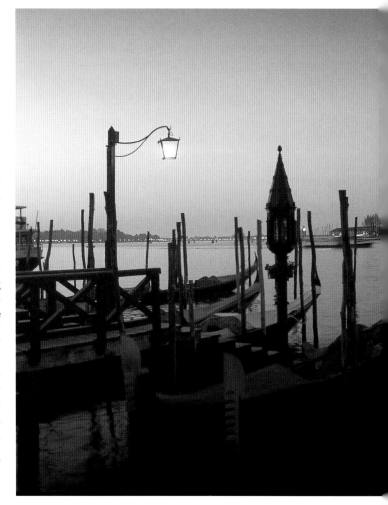

▶ *This is another classic view of Venice, Italy. I shot this from the Rialto Bridge over the Grand Canal. The panoramic format enhances the image.*

Horizon panoramic camera mounted on tripod, Fujichrome Provia exposed for 1/2 sec. at f/2.8

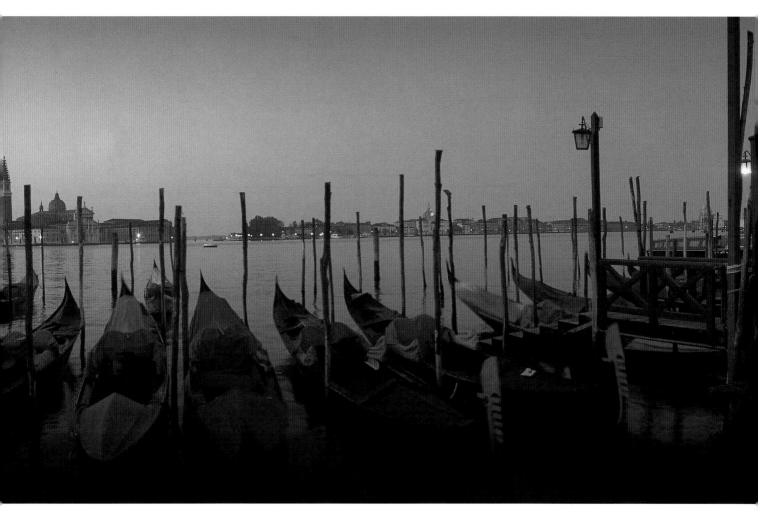

▲ *Everyone photographs this scene in Venice, Italy. I thought the panoramic format not only fit the composition beautifully, but also gave the familiar view of gondolas a slightly different twist.*

Horizon panoramic camera mounted on tripod, Fujichrome Provia exposed for 1/2 sec. at f/2.8

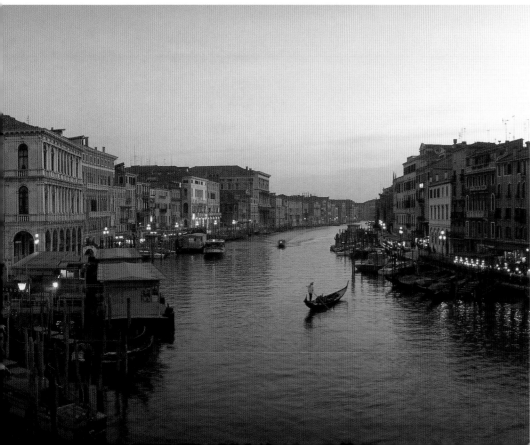

Sublime Venice

Venice presents a real challenge to photographers: how to do justice to the unbelievable beauty of this former city-state without repeating the work of the thousands of photographers and painters who have gone before. Lord Byron called Venice "a boast, a marvel and a show," and there is certainly that aspect to the city. When you try to walk through St. Mark's Square at noon, you're forced to cut a swath through a dense swirl of humanity from all over the globe. All of these people are gathered at once to observe, and in doing so despoil, the sublime beauty of the "show."

But Venice absorbs, ignores, and ultimately triumphs over the hordes of visitors it entertains. Wander that same St. Mark's Square at sunrise, and you find yourself sharing the exquisite beauty with a few locals on their way to work, street sweepers, and the spirits of the city that seem to emanate from building facades and canal sides. Venice is a city custom-made for the attentions of a visual artist because, as Jan Morris wrote, "If, as Scott Fitzgerald once observed, France is a nation, England a people, and America an idea, then Venice has always been above all an image. . . ."

I captured this overall view of the Grand Canal and St. Maria Della Salute Church from the Campanile tower in St. Mark's Square. I always look for church towers and other high places in order to get establishing shots.

Nikon 8008s, Nikon 24-120mm AF zoom lens, 85B and Tiffen Fog 3 P-sized filters in Hi-Tech holder, Agfachrome 1000 pushed two stops, exposure bracketed but unrecorded

▲ *This is the classic view of gondolas lined up with San Giorgio Maggiore Island in the background.*

Nikon 8008s, Nikon 24-120mm AF zoom lens, 85B, two-stop graduated neutral-density, and Tiffen Fog 3 P-sized filters in Hi-Tech holder, Agfachrome 1000 pushed two stops, exposure bracketed but unrecorded

◀ *Only a few gondola makers, called squeros, continue to practice their craft. Here at Squero Manin, a craftsman shapes the wood by hand.*

Nikon 8008s, Nikon 24-120mm AF zoom lens, 85B and Tiffen Fog 3 P-sized filters in Hi-Tech holder, Agfachrome 1000 pushed two stops, exposures bracketed but unrecorded

This vertical view shows a typical small canal in the back "streets" of this romantic city.

Nikon 8008s, Nikon 24-120mm AF zoom lens, 85B, two-stop graduated neutral-density, and Tiffen Fog 3 P-sized filters in Hi-Tech holder, Agfachrome 1000 pushed two stops, exposure bracketed but unrecorded

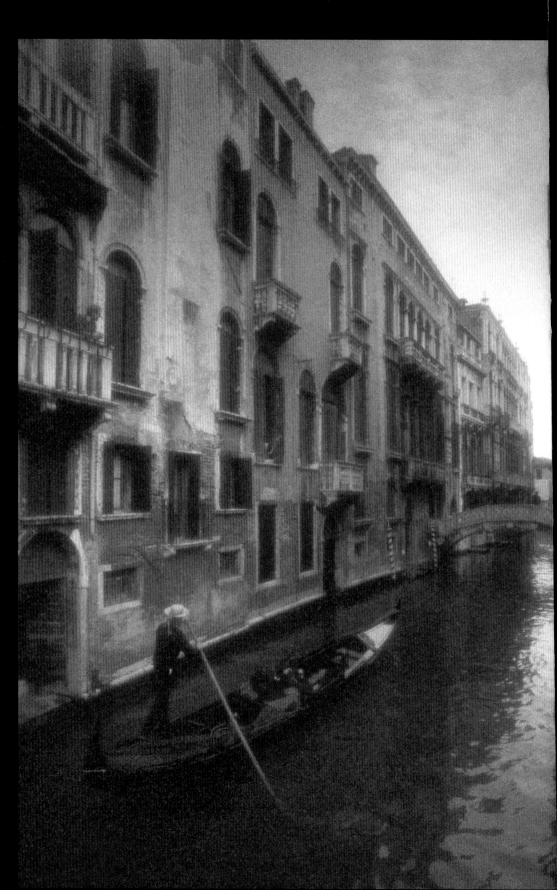

Nikon 8008s, Nikon 24-120mm AF zoom
lens, 85B and Tiffen Fog 3 P-sized filters
in Hi-Tech holder, Agfachrome 1000
pushed two stops, exposures bracketed
but unrecorded

◀ *I made this detail shot of a
Carnevale mask on display outside
a maskmaker's shop.*

▼ *A bride pauses outside the
Church of San Moise after her
Saturday-afternoon wedding while a
young ringbearer tends to her train.*

Nikon 8008s, Nikon 24-120mm AF zoom
lens, with 85B and Tiffen Fog 3 P-sized
filters in Hi-Tech holder, Agfachrome 1000
pushed two stops, exposure bracketed
but unrecorded

Equipment

"If you aspire to do anything as well as it is possible to achieve, the tool, instrument or, in our case, the camera, must contribute to, or at least not interfere with, the final product."

Magnum photographer DAVID HURN, *On Being a Photographer*

FOR TRAVEL PHOTOGRAPHY, a 35mm autofocus single-lens-reflex (SLR) camera with a couple of zoom lenses is an excellent choice. In fact, I do about 85 percent of my work with two Nikon camera bodies and two zoom lenses, a 20–35mm F2.8 and an 80–200mm F2.8. These two optics enable me to cover nearly the entire wide-angle and telephoto range without having to change lenses.

A lot of cameras are on the market, and a common question is, "Which one is best?" The famous photojournalist Alfred Eisenstadt told a story about a man and a boy who approached him at a gallery opening of his work. "What kind of camera do you use?" the man asked. "A Leica, usually," Eisie replied. "The man turned to his son and said, 'Son, I'm going to buy you a Leica so you can take pictures just like Mr. Eisenstadt!'"

People want to invest their machines with special powers, and photographers are especially prone to this brand mystique. But the truth is that almost any of the cameras from the top manufacturers will do the job admirably. When you shop for a camera, the question you should ask isn't "Which one is best?" but "Which one is best for me?" The camera model you choose should have the features and handling characteristics that appeal to *you* and not to the last expert who gave you advice because in the end your decision is a matter of personal preference.

For instance, I use a camera body that is one or two models below the top of the line in my brand, Nikon. This isn't a matter of economics. I simply prefer a smaller, lighter camera; it feels better in my hands than the big professional model and is easier to fit in my camera bag. Remember that a camera is merely a box—it is still the photographer who makes the picture.

Lens choice is also a matter of personal preference. A few years ago, most professional photographers shunned zoom lenses because they just weren't sharp or fast enough. Computer-aided lens design has enabled optical engineers to create zoom lenses with sharpness that is, in many cases, almost indistinguishable from a *prime*, or single-focal-length, lens.

Since I often use slow-speed slide film, I prefer zoom lenses with a fixed aperture of F2.8 or faster. These lenses—20–35mm, 28–70mm, 80–200mm, etc.—tend to be big, heavy, and expensive. But if you regularly shoot film in the ISO100 to ISO 400 range, you can probably live with zoom lenses with smaller, variable maximum apertures. An 80–200mm F3.4–4.5 zoom lens, for example, is routinely half the size and price of a straight F2.8 version—and you can use those savings for film and travel expenses!

A good basic equipment setup for travel includes a zoom lens in the wide-angle range (20–35mm) or in the wide-angle to standard range (24–50mm, 28–70mm), and a zoom lens in the 80–200mm range. One camera body is good, but two are better. You can dedicate one lens to each camera body, then if something should go wrong with one of your cameras during the trip, you'll always have a second one as a backup. A shoe-mount flash rounds out the kit. Look for one with a swivel head so that you can bounce the flash. Choosing a shoe-mount flash that your camera's manufacturer makes is preferable because it will enable you to take advantage of all the dedicated features.

Carryalls

People who are serious about their photography have a tendency to overload themselves with equipment when they head off to shoot. In the workshops I teach, I've seen students go on field trips lugging huge tripods and one or two big camera bags filled with every piece of equipment they own. Then when we actually get into a shooting situation, they spend more time looking for a place to put down their stuff than they do actually shooting pictures. Travel photography is a very fluid thing: you have to be able to react quickly, and you should expect to put in long days away from your hotel, bus, or car.

I worry less about keeping my actual suitcases light than I do about my camera bag. When it comes to gear, I subscribe to the "belt-and-braces" philosophy, or "belt-and-suspenders" philosophy in American English: I don't want to be caught with my photographic pants down during an assignment. Consequently, back in my hotel room, I have spares of everything vital to an assignment: lenses, cameras, flash units, film, and even eyeglasses.

Why all this redundancy? Well, you just never know what will happen. A friend of mine, shooting aerials in a remote island off Sumatra, had his eyeglasses ripped from his head by the slipstream outside the airplane window. He had to shoot for the next four days through borrowed spectacles! Needless to say, a spare pair of glasses has been standard equipment for him ever since this near-disaster.

What if you drop one of your zoom lenses on a shoot? It isn't like the old days, when all professional photographers carried four prime telephoto lenses in their bags. If you dropped your 135mm lens, you simply made do with your 105mm and 180mm lenses. But if you drop your 80–200mm zoom lens today, which has happened to me several times, you'll lose the entire zoom range in one fell swoop—not a good way to complete an assignment.

So I carry backup smaller, slower, lighter, and cheaper versions of my primary zooms. Then if one of my faster lenses should take a tumble, these slower zooms are more than serviceable.

Choosing a Camera Bag

Shopping for a camera bag can be frustrating. While photographers are using fewer lenses now than they did a few years ago, the zoom lenses they're opting for are generally larger. Unfortunately, most camera-bag designs are circa 1970, when professional photographers carried between 7 and 10 small prime lenses. Consequently, you'll find that most bags are designed with too many small, shallow compartments. Nevertheless, with a little luck you'll find a compact bag that enables you to store two camera bodies with the zooms attached, as well as your additional gear.

WHAT YOU'LL FIND IN MY CAMERA BAG

I have a simple rule: If I can't comfortably carry my bag of equipment all day long, I lighten it up until I think I'll be able to. Besides two cameras and two or three lenses, my bag contains a flash, several filters, a handheld light meter, a small table-top tripod, and a few other odds and ends. Despite this modest arsenal, my camera bag tips the scales at more than 20 pounds. Even for big, former high-school power forwards, this can be a burden after a couple of hours! The other items in my camera bag are:

- A Leatherman tool—This is a handy item, especially the pliers portion, which I use to help loosen over-tightened filters, tripod handles, etc.

- A hands-free flashlight—This is a small but very bright flashlight that has a head strap and a clip, which leave my hands free when I'm shooting at night.

- Gaffer's tape—I keep a very small roll of gaffer's tape attached to the shoulder strap of my camera bag. This tape comes in handy for a myriad of uses, from emergency repairs, to removing lint from a wool blazer!

- AA batteries

- A model-release pad

- Film labels—These are pressure-sensitive labels with processing instructions that I attach to film. The labels read, for example, "Unmounted" for film shot in my panoramic cameras, "Push +1 Stop," and "Push +2 Stops."

- A right-angle finder—This item is useful for high- and low-angle point of view shots.

- A cable release

- A lens-cleaning cloth

- A camera level—This handy accessory slips into the camera's hotshoe and indicates when the horizon is straight.

- A Sekonic Digilite F L328—This tiny handheld meter measures both ambient light and flash, is extremely accurate and simple to use, and runs off one AA battery.

Explore both waist packs and shoulder bags because the weight of your gear is often easier to bear when strapped to your waist instead of hanging from your shoulder. No matter how proud you are of your equipment, you should avoid bags with camera and film logos: these are just advertisements for thieves. Although bag manufacturers continue to put them out by the score, black or dark-colored camera bags are very hard to see into when you're working, and they absorb film-damaging heat like crazy.

If you work primarily with large zoom lenses, look for a deep bag. The J-1 bag from Domke has such a design, as do the MetroPaks from Tenba, and some of the swanky Billingham bags from England. I found a shop in New York City that custom-makes backpacks and other articles, and I finally designed my own bag out of frustration with commercially available bags. My camera bag is very deep but very narrow, so it kind of hugs my body and creates a low profile. This bag fits in any carry-on template I've ever encountered, yet I can store two camera bodies with 80–200mm F2.8 and 20–35mm F2.8 lenses mounted and ready to go.

Selecting a Photo Vest

Photo vests are useful, but, once again, the large majority of them are poorly designed. Fly fishermen might need a short little vest with a ton of tiny pockets, but photographers don't. Unfortunately, most so-called photo vests are based on fishing vests, and are all but useless.

Look for a vest that has only a few large pockets, is lightweight, and utilizes a mesh construction; a large number of the better photo vests on the market today still have so many layers of material that they are far too insulated for use in warm climates. Many of these vests are also made exclusively of cotton instead of the new breathable, quick-drying synthetics. Cotton is heavy, absorbs perspiration, and takes forever to dry. Unfortunately, vest manufacturers tend to be way behind the curve when it comes to utilizing the latest in textile technology.

Tripods

A tripod is one accessory that everyone loves to hate. Bulky, awkward, and decidedly low-tech, even the best tripods are annoying to use. Still, a tripod will open up the whole world of low-light and night photography to you. As you might have noticed, I often shoot in the off-light of dusk and dawn, and I do most of this work with a tripod.

I actually carry two tripods on most assignments. One is very small, a Leitz table-top tripod that fits in my camera bag. A good, sturdy table-top tripod will get you through a lot of situations; you can brace it on or against railings, lampposts, mailboxes, windowsills, and, in a pinch, even a vertical wall. Putting your camera on a table-top tripod and bracing it against your chest lowers your handholding-shutter-speed threshold by two *f*stops. To determine this shutter speed, photographers usually put a "1"

over the focal length of the lens. This calculation tells them the slowest shutter speed at which they can handhold their camera without causing shake. For example, with a 50mm lens the slowest "handholdable" shutter speed is 1/60 sec.—the closest shutter speed that most cameras have to 1/50.

However, a full-sized tripod is also a necessity for serious work. "Full-sized," however, doesn't necessarily mean huge. Some good sturdy tripods collapse down to a quite compact size. In general, a tripod is steadier when its center column isn't raised, so look for a tripod that you can bring to your eye level by means of its leg sections rather than by raising the center column. I use a ballhead tripod rather than a traditional, multihandled pan-head tripod. Ballheads are basically a ball-and-socket joint onto which you attach your camera. You loosen the ball, position your camera, and tighten the head. This is much quicker than the multiple adjustments required for a traditional tripod head.

One of the hardest parts about using a tripod is finding a convenient way to lug it around. I solved this problem years ago by taping a Fastex D ring on the top and bottom of the thickest section of one of the legs and clipping a camera strap to the rings. This setup enables me to hang the folded tripod on the opposite shoulder from my camera bag and leaves my hands free for photography.

Although you can't do much about the basic design of a tripod, recent innovations have included the use of lightweight, ultra-strong carbon fiber—which is used in fighter jets and other high-tech applications—instead of metal or aluminum. This reduces the weight of the tripod by one third to one half without sacrificing strength and stability. These tripods are rather expensive, but for photographers who do a lot of tripod work and need to conserve every ounce of excess weight, they are worth the investment.

I was hesitant at first to plunk down the $500 required to purchase a Gitzo Mountaineer carbon-fiber tripod (see Resources on page 157). But this tripod is so light and so strong that it literally changed the way I work. When something is light and easy to carry, you find that you have it with you more often for those times when you need it. This tripod is one of the best investments in photographic equipment I've ever made.

Additional Gear

Besides the cameras, the flash, and a tripod, you don't really need much else in the way of gear to do travel photography. Occasionally, though, more specialized equipment is required. The following is a rundown of some of the more specialized gear that I use when necessary.

SPECIALTY CAMERAS
When I'm doing a lot of city coverage, I might supplement my Nikon SLR system with a smaller, lighter rangefinder camera and a few lenses. I find that the Contax G2 camera with 21mm,

28mm, 45mm, and 90mm lenses makes an extremely lightweight package, and covers the range I use most for city and street photography. Besides the obvious weight advantage, which is important when you're carrying your gear all day long and not working out of a car, the camera's small size makes it look like a point-and-shoot (P&S) camera to the untrained eye, and I can photograph freely around people who might otherwise object to professional pictures being taken. The lenses are superb, and the autofocus and auto-advance features make this a rapid-handling camera.

I wish I could carry my Contax on every assignment, but sometimes I just don't have the extra room even for that relatively small setup. However, no matter what the assignment, the other camera that I can always find room for in my suitcase is the Ricoh GR1 (see Resources on page 157). This is a tiny, 6½-ounce, shirt-pocket P&S camera with an extremely sharp 28mm F2.8 lens with exposure override, spot metering, and some other very sophisticated controls usually associated with more expensive full-featured cameras. I carry this camera on my way to dinner, and into places where I don't expect to take pictures or might not be allowed to. The Ricoh GR1 is a great little backup camera.

Because of the huge amount of excellent travel stock photography available, and the subsequent increased competition for picture buyers' attention, a little novelty can go a long way. Several years ago, I began to experiment with a panoramic camera. These cameras are available in medium format, but I chose a 35mm version for two reasons: this kind of panoramic camera is smaller than the others, and I didn't want to carry a different size film.

Two types of 35mm panoramic cameras are available, both of which produce a transparency, or *chrome*, that is 24 x 56mm or 24 x 65mm long, as opposed to the standard 24 x 36mm transparency. The *rotating-lens* type, such as the Widelux, Noblex, and Horizon, features a lens that scans across the film, covering a huge area of view, 140 or more degrees. The *interchangeable-lens, standard-shutter* type, like the Hasselblad XPan and the 35mm panoramic insert on the Mamiya 7, features a standard shutter that covers a longer strip of film. These panoramic cameras don't have the angle of coverage of the scanning panoramic cameras, but they offer a wider array of shutter speeds, permit the use of flash, and are easier to use with filters.

Panoramic cameras are ideal for photographing skylines, street scenes, and landscapes. They provide just enough of a different view to catch a photo editor's attention. Both types of panoramic cameras mentioned are rangefinder designs, so they are fairly compact and easy to carry.

Specialty Lenses

As I mentioned, I probably shoot about 85 percent of my work with two Nikon zoom lenses, a 20–35mm F2.8 and an 80–200mm F2.8. Besides the specialty cameras mentioned above, I might also employ some specialty optics in order to get the picture.

16mm F2.8 Fisheye Lens

This full-frame, wide-angle fisheye lens, with its nearly 180 degrees of coverage, is perfect for working in tight spaces and aboard ship, as well as for doing remote photography. It is my lens of choice for shooting half-over/half-under water pictures when the camera is in a housing. I also use my 16mm F2.8 fisheye lens for point-of-view remotes by strapping a camera mounted with this lens to the handlebars of a bicycle or the wings of a biplane.

14mm F2.8 Rectilinear Lens

Even though this lens is technically shorter than the 16mm optic, its rectilinear design means that it covers less of an angle, about 109 degrees. However, this lens doesn't produce any fisheye distortion. In fact, if you hold the camera straight, very little distortion results. The wide view of the 14mm F2.8 rectilinear lens comes in handy when you shoot some city scenes and architectural interiors. The Sigma and Tamron versions focus extremely close, to 7 inches, which enables you to make interesting closeups of items while still showing a lot of the environment behind them.

28mm F1.4 Fast Prime Lens

This is a great lens for photographing nightclubs, restaurants, nighttime street scenes, and aerials. It is very sharp when it is wide open, which makes it extremely useful when you want to shoot aerials because you need to use the highest shutter speed possible.

85mm F1.4 Lens

A companion lens to the 28mm F1.4 fast prime lens, this optic covers the telephoto end during available-light situations. The 85mm F1.4 lens is a bit big and bulky, but it is quite sharp when wide open.

300mm F4 lens

When the 200mm setting of my zoom lens isn't quite enough, this is the long lens I reach for. It is great for landscapes, action, sports, etc. The 300mm F4 lens isn't too terribly big or bulky, and I can carry it in one channel of my custom-made camera bag. This particular lens provides a good compromise between speed and portability.

500mm F4 Lens

This is the last non-autofocus lens I own, and I'll never part with it! This long lens is extremely sharp and easy to focus, and most important, it is half the weight, size, and price of autofocus (AF) versions. Even though my 500mm F4 lens is smaller than AF versions, it is still a major commitment to carry and use. I combine this lens with Nikon 1.4X and 2X teleconverters for wildlife, sports, and certain scenic and landscape shots.

Filters

Purists argue against working with filters, but I find them useful for tweaking the light into the contrast-recognition range of film and for giving me a few more minutes of sweet light. I try not to overdo using filters, but they are a very important part of my kit. Some of my filters, the ones I use more often, are 77mm screw-in types. The rest are "P"-sized filters from either Tiffen or Hi-Tech. I use a Hi-Tech "P"-sized filter holder for these. The following is a list of the filters I carry and what each does.

Tiffen 812

I have a Tiffen 812 filter on each of my lenses as protection, using these filters the way other photographers use a skylight or UV filter. The Tiffen 812 filter is like a cross between a skylight and an 81A warming filter, and the result is a very slight but natural warming effect for skin tones that I find hard to resist. Because of the dirty, sandy, moist, and other rough conditions I often work in, these filters get scratched easily, so I replace them about once a year; this is much cheaper than replacing the front elements of my lenses.

B+W Circular Polarizing Filter

Polarizers are extremely useful for working in the tropics, around water and foliage, and when you have to shoot in midday conditions. When held at a 90-degree angle to the sun, polarizers cut reflections from all but metallic surfaces. This gives greenery a lush look and intensifies the blues of water and sky. No obvious physical difference between a circular polarizer and a linear polarizer exists; they simply achieve polarization in different ways. The metering systems of most modern SLR cameras require a circular polarizer in order to work accurately, so be sure to check your camera's manual before investing in one of these filters. Because I find a straight circular polarizer to be a little cool or blue, I prefer this type, which has a slight KR3 warming filter built in. This feature makes the filter more expensive, but much more useful.

81B Warming Filter

This is a mild warming filter that is useful on overcast days.

85C Warming Filter

This is a strong warming filter that comes in handy for stretching out the warm light of early morning or late afternoon.

Graduated Neutral-Density Filters

I carry graduated neutral-density (ND) filters in both two-stop and three-stop strengths. These filters effectively render dramatic skies when the contrast range between the foreground and the sky is too great. Used mostly with wide-angle lenses, graduated ND filters take a bit of practice to master. You have to learn to see the way your film sees: with far less ability to see bright and dark tones together.

Graduated Blue Filter

This is a variation of the graduated ND filter. I use a graduated blue filter to hold detail in blue skies on clear days in wide-angle compositions.

CC40 Magenta Color-Correction Filter

I opt for this filter when I'm shooting daylight-balanced film under fluorescent lighting. A CC40 magenta filter is also helpful in terms of punching up colors during a lackluster sunset.

Choosing Film

Deciding which is the best film to put in your camera can be a daunting experience. You have a myriad of options to choose from: black-and-white or color film; color-negative or color-slide film; high-speed (fast), medium-speed, or low-speed (slow) film; daylight-balanced or tungsten-balanced film; and normal or saturated color rendition. But when you take the decision process one step at a time, you'll find that it becomes much easier.

WHICH FILTER SYSTEM IS RIGHT FOR YOU?

You have several filter systems to choose from. The most common system uses the round screw-in filters that come in individual sizes to fit each of your lenses. If all of your lenses have the same filter diameter, this is a very economical way to go. If, however, you have lenses with several different diameters, getting individual screw-in filters for each lens can get expensive, not to mention unwieldy.

You can handle this a couple of ways. One option is to buy a set of filters to fit your largest-diameter lens. Then, instead of buying individual filters for the rest of your lenses, you simply buy inexpensive, lightweight adapter rings that change the diameter of the filter from its large size to whatever size you need. For example, you can adapt a set of 72mm filters to a set of filters with diameters of 67mm, 62mm, 55mm, 52mm, etc.

The other way is to buy one of the filter systems that Cokin, HiTech, Lee, and others make. Essentially, these systems feature square or rectangular filters that fit in a filter holder. This holder attaches to your lens via a system of small, inexpensive adapter rings. The advantages of this type of arrangement are that you buy only one set of filters, and that you can slide graduated filters up and down in the holder to suit your composition (screw-in graduated filters don't allow you that flexibility). The disadvantages are mainly the polarizers, which are bulky and expensive in these systems, and the general bulk of the filter holder itself.

SLIDES OR PRINTS

According to Kodak, more than 95 percent of the film sold today is color-negative film for making color prints. This overwhelming popularity stems from several reasons. Color prints are easier to handle than slides; you can pass around 4 x 6-inch prints and share them with family and friends much more easily than you can set up a projector and show slides. Color-negative film has a much wider exposure latitude than slide film, which is also called *transparency film* or *reversal film*. This means that it is much more tolerant of exposure mistakes than color-slide film. You can get good prints from negatives that are either several stops overexposed or a stop or two underexposed. Because of its wide exposure latitude, color-negative film works in almost any camera, whether it is a P&S camera, a one-time-use camera, or a sophisticated SLR camera. Slide film requires a camera with a fairly advanced light-metering system. In addition, you can have color-negative film developed and printed in countless places. Today even the most far-flung outposts have some kind of a mini-lab that provides quick-turnaround service. (Not all of the staff members of these labs are as skilled as they should be, however, which leads to other problems—see below.) Slide-developing labs are harder to find.

But some very solid arguments for using slide film exist. Slide film is the preferred medium for most professional and advanced-amateur photographers for the following reasons. Because slides are viewed by transmitted rather than reflected light, they exhibit a depth of color saturation and sharpness that is difficult to achieve in a print. The per-picture price of slides is far less than prints. This makes editing images—i.e., throwing away the bad slides—much easier. Also, slides are smaller and easier to store. Slide film yields positive images, not negatives. There is no intermediate printing process, so any adjustments or special effects that the photographer does in-camera result directly in corresponding changes in the appearance of the final photograph. So the inexperience or incompetence of the photofinisher, which leads to the many poor results obtained with color-negative film, is much less of a potential problem with slides. Because slide-film development is an absolute process, there is less chance of lab staff members making interpretive or technical mistakes.

Although color-negative film is gaining favor with more and more photographers, especially in the art and photojournalism fields, the industry standard for most magazine work is still slide film. I have to admit a strong prejudice for slide film. It is the type of film I work with almost exclusively and the type of film I know best. So much of what follows deals with slide film.

If you are an avid color-negative-film user and need advice on choosing emulsions, check out the Kodak and Fuji Web sites for the latest information. Because of the popularity of color prints, a new generation of color-negative films seems to be coming out every two weeks or so—far too often for a casual observer to keep track of!

FILM SPEED

The light sensitivity of a film is referred to as its *speed*. The higher a film's speed, the more light-sensitive, or faster, it is; this means that it needs less light to record an image. The lower a film's speed, the less light-sensitive, or slower, it is.

Film speeds are measured in ISO (which stands for International Standards Organization) numbers. Like *f*stop numbers and shutter speeds, these designations move up and down in an arithmetical progression. A doubling or halving of the number results in a one-*f*stop difference in light sensitivity. So, ISO 100 film is twice as sensitive to light as ISO 50 film, and half as sensitive as ISO 200 film.

If all else were equal, using the fastest film possible would make sense. However, along with its increased sensitivity to light, fast film also exhibits larger grain and generally less rich, saturated colors than slow film. As a result, most photographers use the slowest possible film the lighting conditions allow in order to ensure the best possible results.

In the last several years, advances in film technology have significantly improved the film-speed/image-quality ratio. Until fairly recently, you had to use a slow ISO 25 film to achieve great color and superior sharpness. Today several ISO 50 and ISO 100 films rival and even surpass the performance of that older, slower film. ISO 400 film used to be considered a high-speed film and had all the corresponding characteristics of that designation, such as large grain and muted colors. Now ISO 400 might be considered a medium-speed film with excellent sharpness and color. ISO 800, ISO 1600, and even ISO 3200 are the upper-speed levels.

WHAT DOES PUSHING A FILM MEAN?

When you *push* a film, you're instructing the lab to extend the developing time to squeeze some extra speed out of the emulsion. Most films can be pushed up to one or two *f*-stops without too much harm. The usual signs that a film has been pushed are a buildup of grain and contrast and a falloff in color saturation. Photographers are sometimes willing to put up with these effects in order to gain the increase in the film speed. Both Kodak and Fuji have slide films that are designed to be pushed up to three stops while showing little or none of the ill effects of pushing film.

How can you tell whether you have transparency film for slides or color-negative film for prints? It's simple. Any film name that ends in the word "color" is color-negative film for prints. A film name that ends with the word "chrome" is a transparency film for slides. So, for example, Kodacolor is a print film, and Kodachrome is a slide film.

POPULAR SLIDE FILMS

Film	Speed	Characteristics
Agfachrome Scala	ISO 200	Wonderfully sharp, snappy black-and-white slide film, with a version designed to be pushed up to two *f*-stops.
Fujichrome Astia	ISO 100	Extremely fine grain. Has lower contrast and less color saturation than Fujichrome Provia. Excellent skin tones.
Fujichrome MS 100/1000	ISO 100	Very fine grain and good color. Designed to be used at ISO 100 but can be pushed one, two, or three *f*-stops with little or no buildup of grain or contrast.
Fujichrome Provia	ISO 100	Extremely fine grain with good color saturation. Has a more neutral color palette and slightly lower contrast than Fujichrome Velvia.
Fujichrome Sensia II	ISO 100	Amateur version of Fujichrome Astia.
Fujichrome 64T	ISO 64	Very fine grain with saturated colors. Designed to be shot under tungsten and incandescent lights.
Fujichrome Velvia	ISO 50	Extremely fine grain with supersaturated colors. A warm-toned film that many landscape photographers favor. Skin tones are very reddish, making it less useful for portraits.
Kodak Ektachrome E100S	ISO 100	Extremely fine grain with saturated, neutral-toned colors. Pushes well to ISO 200.
Kodak Ektachrome E100SW	ISO 100	Extremely fine grain with warm, saturated colors. Pushes well to ISO 200.
Kodak Ektachrome E200	ISO 200	Very fine grain with good color. Designed at ISO 200 but can be pushed one, two, or three *f*-stops with little or no buildup of grain or contrast.
Kodak Ektachrome 320T	ISO 320	Fine grain and good color. Balanced for tungsten or incandescent light. Pushes one *f*-stop to ISO 640 with good results. Excellent for shooting stage shows.
Kodak Elitechrome 100	ISO 100	Amateur version of the Ektachrome 100 films. Has color characteristics that fall between Kodak Ektachrome E100S and Kodak Ektachrome E100SW.
Kodak Elitechrome 200	ISO 200	Amateur version of Ektachrome E200.
Kodak Kodachrome 25	ISO 25	Extremely fine grain with neutral color rendition and moderate saturation. Requires K14 processing, which isn't widely available.
Kodak Kodachrome 64	ISO 64	Very fine grain with neutral color rendition and moderate saturation. Requires K14 processing, which isn't widely available.
Kodak Kodachrome 200	ISO 200	Moderate grain with warm color rendition and moderate saturation. Requires K14 processing, which isn't widely available.

Professional Versus Amateur Film

Many films come in two versions: professional and amateur. What is the difference? Kodak says that the products themselves don't differ, just the way they're stored and marketed. Amateur films are designed to age on the store shelves and are shipped before they reach maturation in terms of their color. Professional films are shipped only when they have been tested and have reached peak color rendition. Once you purchase professional film, you should refrigerate it to prevent further aging and have it processed promptly after you expose it.

Fuji states that its professional and amateur versions of the same film differ physically. The company's professional films are specifically designed for reproduction and have an extra layer of emulsion to accommodate this. Fuji's amateur films, on the other hand, are specifically designed for projection and don't have an extra layer of emulsion.

In either case, other than looking at the receipt for the film itself—professional film is more expensive—I defy anyone to tell the difference between a picture shot on amateur film and a picture shot on the professional version of the same film. So because the resulting images are indistinguishable, because the quality control of the major film manufacturers tends to be excellent, and because of the substantial cost savings, I shoot the amateur version of a film if it is available.

The following is a rundown of some of the most popular slide films for travel photography.

My Favorite Emulsions

For a large portion of my career, I didn't shoot any film other than Kodachrome 64 and Kodachrome 25. You simply couldn't beat them for sharpness and color saturation. The machinery for processing Kodachrome, however, is unique and expensive. Not many labs offered Kodachrome processing, but professionals didn't seem to mind the inconvenience because the results were so good.

The introduction of highly saturated, ultra-sharp Fujichrome Velvia changed all that. For the first time, 35mm photographers had a film that rivaled Kodachrome for sharpness and absolutely put it to shame in the saturation department. In addition, Fuji Velvia was compatible with E6 processing, the universal slide chemistry available in processing labs worldwide.

Although a large number of emulsions are available on the market, I prefer to stick to just a few films and learn their characteristics and how they handle different situations. I've gotten it down to about three or four emulsions that I now use regularly. These are:

Fujichrome Sensia II
This is a good all-around emulsion for portraits and natural-looking color and skin tones.

Fujichrome Velvia
I love this film for shooting landscapes. Its warm, rich colors are hard to beat. Fuji Velvia is excellent for the greens and blues of tropical landscapes, but it is also good for just about any other color spectrum as well. But this film is too red for most skin tones.

Kodak Elitechrome 100XC
This is another good all-around emulsion with punch and color similar to those of Fujichrome Velvia but with better skin tones.

Kodak Elitechrome 200
This is a wonderful, tight-grained, sharp ISO 200 film. You can push this film one ƒstop to ISO 320 and two ƒstops to ISO 640 with little buildup in grain or contrast. Kodak Elitechrome 200 is a superb high-speed emulsion.

EQUIPMENT CHECKLIST

Standard Equipment

☐ F100 camera bodies

☐ Filters and cables

☐ 20–35mm F2.8 lens

☐ 80–200mm F2.8 AF lens

☐ 70–210mm F4 AF lens

☐ 24–50mm F3.5–4.5 lens

☐ 20mm F2.8 AF lens

☐ TC14E teleconverter

☐ Sekonic meter

☐ 2 Nikon SB24 flash units

Additional Cameras

☐ 8008s

☐ Ricoh GR1

☐ Nikonos V with 28mm and 35mm lenses

☐ Contax G2 with 21mm, 28mm, 45mm, and 90mm lenses

☐ Hasselblad XPan with 45mm and 90mm lenses

Survival Techniques for Road Warriors

"Experience is the residue of our mistakes."

UNKNOWN

W E ARE ON THE CUSP of the twenty-first century, and in many ways travel has become much easier than it ever was. But it is not entirely problem-free, nor will it ever be. Consider the following scenario that happened to me recently.

Heading off for a domestic assignment in northern New England, I parked in the remote lot of Newark Airport (as per my client's expense policy) and, using the collapsible luggage cart I always travel with, wheeled my two cases and two carry-ons to the monorail station. I boarded the train, and it left the station—and stalled about 60 feet out of the station. I sat, along with several other fidgeting passengers, for the next 45 minutes, trapped above the tarmac.

Finally, the train returned to the station, but the monorail was out of commission. My flight, at the most distant terminal, was taking off on time, and I was still a mile away, with no visible means of support. The airport didn't arrange for any buses or provide any other alternate means of transportation to the terminals. It was case of "every man for himself."

So I loaded my bags on my luggage cart—there wasn't a SmartCarte in sight—and headed off for the terminals on foot. Cutting through parking lots and around construction sites, I finally arrived at the closest terminal, which was about half a mile away. With my departure time barreling down on me, I ran to the lower-level taxi queue and offered $10 to the nearest cabby to take me from Terminal A to Terminal C. I jumped into the cab, and we headed off down the airport road toward Terminal C. I breathed a sigh of relief—until we confronted a huge backup of cars jamming the ramp that leads to this, the busiest terminal at the airport. Everything was at a standstill. I paid the cab driver, hopped out of the taxi, got my bags, rolled them down to the Departure level, and entered the terminal through there. I looked back to see that the cab was still in traffic several hundred yards back down the ramp.

Next, I checked my bags with a skycap, offering a generous tip of $15, and headed for the gate. Pulling out the clear plastic bag that contained my film, which I'd taken out of the boxes and placed in clear, translucent film cans, I passed through security with minimal delay. I arrived at the gate in time to get my reserved-seat assignment—an aisle seat at the back of the plane, so I get on during the first boarding call and have a chance of getting some overhead space—and made the initial boarding call for my flight. Total elapsed time from parking the car to arriving at the gate: 1 hour, 40 minutes.

There are a number of reasons why I was able to successfully complete this assignment and didn't have to call the client and say, "Sorry, I missed the the only flight out that day and delayed the shoot, but it wasn't my fault, etc., etc." They involve simple steps that experienced road warriors take without thinking, but that less experienced travelers might overlook.

First of all, I always arrive at the airport early—really early. My family makes fun of my penchant for leaving for the airport so much ahead of time, calling me, among other things, "paranoid." But as former Secretary of State Henry Kissinger was once said to have observed, "Even paranoids have enemies!" With the congestion on the roads leading to most metropolitan airports, especially the New York and Philadelphia airports (the ones I use most often), you never really know how long the journey will take. It could be an hour, it could be two, depending on the traffic. And who knows what's going to happen once you actually get to the airport!

Second, I always carry my own collapsible luggage cart. Yes, you can find trolleys almost everywhere at most airports, but you just never know. In the case of the monorail station mentioned above, not a single one was in sight. Toting my gear from the station to the terminal without wheels would have been impossible.

Third, I was prepared to improvise and was willing to reward the people who helped me do that. Sure, the cabby might have

taken me to the terminal for $2, and the skycap might have accepted $3 instead of $15. But my tips gave these guys an incentive to help me, and, I hope, left a residue of goodwill to help the next poor traveler caught in a similar situation.

Fourth, I made it easy for the security inspectors to check my film. If they had to open up boxes or bags, the process would have been slowed down. And, finally, I reserved an aisle seat at the back of the plane in order to get on during the first boarding call. Doing this ensures that I'll have the space to stow my two relatively small but extremely vital carry-ons: my camera bag and my film bag.

Now, you might be asking yourself, "Showing up two hours early for a flight might have saved you this time, but what about when everything goes smoothly? Isn't it a waste of time to sit at an airport?" Not at all. I use that time to catch up on my reading and writing. In fact, I wrote large portions of this book in airports and on airplanes! The airport is one of the last places where you are safe from the distractions of phones, faxes, and e-mail.

If you travel enough, your experience bank will be filled with such incidents. From backwater outposts in developing nations, to the most modern transportation mecca, no place is immune to travel snafus. The experienced road warrior hopes for the best but prepares for the worst.

Safety, Security, and Self-Sufficiency

Travelers have always been exposed to dangers on the road, from the highwaymen and swindlers of yesterday, to the thieves of today, whose only purpose is to separate you from your valuables. This situation hasn't changed much, although in most—but not all—places petty theft, not violent crime, is a visitor's main concern. Consider a few of the following tips regarding safety and security on the road.

Copy Your Documents
Make copies of the identification page of your passport, as well as your airline tickets. Stow one set in your carry-on or in another bag that doesn't already contain the originals. Leave another set at home with someone who can fax them to you if the originals are lost or stolen. It is infinitely easier to replace lost tickets and passports if you have these copies with you. It can actually save you days.

Identify Your Bags
Make sure that you have at least two name-and-address tags on the outside of each piece of luggage in case one gets torn off in transit. It also doesn't hurt to put another tag somewhere on the *inside* of each bag. On this tag, I write the words "Reward If Found" to encourage anyone who has found (or taken) my bag to contact me (before trying to sell my stuff elsewhere).

Use Luggage Locks
Buy luggage locks with user-set combinations rather than keys, which are too easy to lose. Set all of your locks to the same combination, one that you can remember easily. Most luggage locks are too flimsy to stop a determined thief, but they discourage the casual pilfering that luggage handlers at some airports are prone to. If you have spiffy new luggage, silver camera cases, or any other luggage that looks like it contains valuables, you should consider putting them in old duffel bags and locking them up. Why tempt luggage handlers?

Soft-sided luggage and the Lightware-type cordura-and-plastic-shell cases have always been vulnerable to unscrupulous handlers with razors or box cutters. You can slice into these bags even when the zippers are locked. An Australian company named PacSafe has developed a series of flexible steel-mesh covers for backpacks, duffels, and some Lowe camera bags (see Resources on page 157). These covers not only prevent "slashers" from slicing open your gear in transit, but also feature a metal locking cord that enables you to padlock your steel-mesh enclosed bag to a radiator or some other immovable object in your room. This is about as secure as you can get without going to extraordinary measures.

Foil Pickpockets
Countless aids to help you combat pickpockets are available. Put your wallet, passport, and tickets in a pouch that hooks around your belt and rides *inside* your trousers or skirt. Use a moneybelt to hold extra cash. Avoid waistpacks because they advertise where all your valuables are. In addition, they are so uncomfortable that most people take them off when sitting down at, for instance, restaurants, and often leave them behind. Many travel-gear catalogs, like Magellan's and TravelSmith, offer shirts, blouses, jackets, and pants with zipper pockets for your valuables (see Resources on page 157). These garments are extremely useful.

Be Discreet
In many places you visit, your gear will represent months' or possibly even years' worth of salary for an average member of the local population. If you leave any equipment in your hotel room, put it back in your suitcase, and make sure that the bag is closed and locked. You can't really do much to thwart a determined thief from stealing your equipment from your hotel room. However, you can avoid tempting otherwise honest hotel staff members simply by not leaving lots of easily "fence-able" gear strewn around the room. Your equipment is often most vulnerable when the maid is cleaning your room; bold thieves, nicknamed "dippers," often just walk in the open door and help themselves. Walking out with a locked, fully loaded suitcase is much harder than walking out with a camera or a lens.

Take Several Equipment-List Copies
Unless you're carrying cases of professional-looking equipment, chances are that you won't have any problem entering a country

with your gear. But in some places, including developing nations and even such popular tourist destinations as Bermuda and Jamaica, customs officials are wary of people bringing in even a modest amount of equipment. The officials are concerned that you'll sell it. If a customs official stops you when you are about to enter a country, you can often defuse the tension by presenting a copy of your equipment list, complete with serial numbers, and offering to have your gear inspected against this list when you leave. If you're working on a professional assignment, the staff members at the local tourist board can assist you if you fax the list to them before your arrival.

To be completely safe, you should register your gear with U.S. Customs *before* you go. This way, you won't have any trouble *getting back into* this country. Ask for Form 4457. (Frankly, I don't do this anymore since I almost always customize my list of equipment to each assignment, and I don't want to take the time to register a new list every time I leave the country. I've never been hassled about bringing my stuff back into the States.)

X-Ray Damage

A subject of never-ending debate, the question of whether or not X-rays damage film recently became much more complicated with the introduction of the CTX 5000. This two-phase, checked-baggage scanner is in use in a growing number of airports around the world. The effects of the older machines that are currently used to screen carry-on luggage have been, despite the controversy, negligible. This new machine, however, whose second phase of scanning is similar to that of a CAT scan, will undoubtedly ruin film. The damage, as described by Kodak, is "catastrophic."

So if a definite statement can be made about X-rays and film, it is this: Don't put your exposed or unexposed film in checked baggage. Not every piece of luggage in an airport goes through the second phase of a CTX 5000 scan, but if yours does, your imagery will be destroyed.

The safest strategy is to carry your film on board with you. In the United States, Federal Aviation Agency (FAA) regulations provide for hand inspection for anyone who requests it. Despite this guarantee, it is wise to make the inspection process as easy and expeditious as possible for both you and the security personnel. Take your rolls of film out of their boxes, and put them in clear or translucent canisters. (Kodak has finally joined Fuji in putting at least some types of its film in translucent rather than opaque black canisters.) Then put these canisters in clear zip-lock plastic bags; the gallon size holds almost 50 rolls of film. When you come to the X-ray inspection point, pull out the film and politely request a hand inspection.

In most European countries and other places in the world, you won't be afforded the courtesy of a hand inspection—no matter how much you protest, no matter what letters you produce, no matter what. My advice in this situation is to simply relax and let your stuff go through the X-ray. I always ask for a hand inspection—you never know, and once in a while your request is honored—but if I can't get one, I just whisper a little prayer and put my bags through. Luckily, I've never seen any evidence of X-ray damage.

Keep in mind that the effects of X-rays are cumulative, so you'll be more likely to encounter film damage if you're making an extended trip with many passes through airports. But even in the face of such trips, I haven't seen any damage. This isn't to say that it couldn't or hasn't happened, but I think many photographers obsess unnecessarily on this topic.

Carry-On Woes

A far more ominous development to obsess about is the airlines' inexorable progress toward a strict one-carry-on rule. Because of the CTX 5000 checked-baggage scanner, this rule poses a serious threat to traveling photographers. The reason? Most of the photographers I know carry on two bags, one filled with camera equipment and one with film. This way, if their luggage is misdirected or even lost, they can complete their assignment. It is always cheaper and easier to replace shirts, socks, and underwear than it is to replace film and equipment.

No one feels the overwhelming crunch of excess carry-ons more than a travel photographer. Since the advent of roll-aboard carry-ons, the situation has become untenable. People are wheeling all kinds of stuff onto the plane and then searching not only for someplace to stow them, but often even someone to help them lift their burdens. You can't really blame the airlines for cracking down.

If the airlines enforce the one-carry-on rule, you'll be forced to chose between a bag of film or a bag of cameras. Of course, neither option is really viable. If you check your film bag, it might get lost or the CTX 5000 might zap it. If you check your camera bag, it, too, might get lost or it might be destroyed by rough treatment by baggage handlers. This is a no-win situation.

What can traveling photographers do? Some photographers' organizations are trying to petition the airlines to be exempted from any one-carry-on rule. This is a naive approach, though, because every professional organization would be able to make a similarly compelling case as to why their members should be exempted. For example, "As a lawyer, I need both my laptop and my Armani suit to successfully conduct business."

A far more effective approach would be to strictly enforce the one-carry-on rule, but to give passengers the option of carrying on a second piece *for a premium price*. If the airlines charged $35 for a second carry-on and, say, $50 for a third piece, the overhead bins of most planes would empty out. The college students, vacation travelers, and others who jam the overhead compartments with

dirty laundry and stuffed animals just because they don't want to wait at the luggage carousel would promptly check all of these items. The only people who would carry on more than one piece would be the people who really need to and are willing to pay for it. It might hurt to pay another $35 for every plane trip you take, but it is a far better alternative than a strict one-carry-on rule.

Wash, Wear, and Go

A few years ago, I had back-to-back assignments in Paris and Germany. Two days before leaving the City of Light for my next stop, I brought a stack of dirty laundry to the hotel's front desk for 24-hour service. *Four days later*, I got my laundry back. I not only had to reschedule my entire assignment—you try finding shirts with 18-inch necks in Paris—I had to pay full price for the laundry as well! This was the last straw in my struggle against the tyranny of hotel laundries. Years of missed service deadlines and paying nearly as much to wash a shirt as to buy it had primed me for action.

Fortunately, the boom in travel has been accompanied by a similar boom in conveniences for travelers. New, breathable, fast-drying, high-tech fibers make much more sense for travel than cotton or even wool. Even though I always saw myself as a natural-fibers type of guy, I broke down and bought some Intera polyester boxer shorts, Coolmax polyester undershirts and socks, and an assortment of Supplex nylon and Intera polyester shirts and pants. I tossed out my heavy wools and replaced them with Microfleece layers and even a polyester microfiber blazer. I also bought a little laundry kit that includes a laundry line, soap, hangers, and the ever-important sink stopper.

Now, instead of traveling with seven or eight sets of clothes, I go off with just two. I rinse my clothes out in the hotel sink every other evening, and hours later they are dry. I can go weeks, even months, without needing a washer or dryer, and I laugh at the hotel-laundry price lists. In the field, I am cooler in hot weather and warmer in cold weather, thanks to the moisture-wicking properties of these new materials. And I have tons more room in my suitcase for important stuff—like heavy cameras and lenses!

Afterword

A FEW YEARS AGO, following the publication of *National Geographic: The Photographs*, which was one of the occasional coffee-table books the National Geographic Society puts out and which contained some of the finest pictures that have run in the magazine, a prominent art-photography critic reviewed the book in an upscale photography magazine. The critic dismissed the book as nothing more than a collection of visual epiphanies. It wasn't a genuine portrayal of the locations in the photographs, she maintained, because she herself had been to many of those places, and they never looked that way when she was there! This was her ringing indictment of the book: those places never looked like that when she saw them; therefore, these weren't honest pictures. Somehow, the photographers were duping the viewers by presenting these locations in some beautiful light or an unusual weather condition.

Of course, it never occurred to the critic that this might be the reason she writes about photography instead of actually practicing the craft. Making beautiful, story-telling pictures requires a certain amount of talent and craft—the qualifications to critique them are less clear. The critic preferred the work of certain art photographers who, for lack of a kinder way to put it, celebrate the banal because that's the way she sees the world.

But the critic's taste is timely if nothing else because that post-modern snapshot aesthetic is all the rage at the moment. Well-crafted pictures are disdained as being slick and somehow dishonest. Using this criterion, an honest picture is one that looks like it was shot without a care or concern for lighting and composition. And so you see all types of awful pictures published in the name of truth in photography!

Talking about the truth and honesty of photographs in the Photoshop era when newsmagazines routinely retouch the features of newsmakers on the cover to make them appear more friendly or ominous—think of the dental work done on the crooked teeth of the mother of septuplets, and the darkening of O. J. Simpson's skin—is a bit of an oxymoron. It is unfortunate, but the genie of photographic credibility has been sprung from the bottle, and I don't think we'll ever get him back inside.

However, even before the era of easy post-production manipulations, photographs always revealed the prejudice of the photographer. If I so choose, I can trash any destination I photograph with pictures that make the most idyllic paradise look like a living hell. It is not difficult to dwell on the negative aspects of a location, such as garbage, poverty, and overdevelopment. In my early years as a newspaper photographer, I shot many picture stories covering those aspects of the paper's circulation area. Indeed, over the last century, by highlighting these types of problems, the work of photojournalists has brought many of these issues to the attention of the public. But this approach didn't come readily to me. I am, by nature, a positive person. I see half-full glasses in most places I look. Some crusading photographers are emotionally much better equipped to expose the injustices of the world.

But I did start my professional life as a photojournalist, and I still consider myself one—to a certain degree. I like to think that a travel photographer is, in a way, a photojournalist who accentuates the positive. The lure of travel, faraway places, interesting people, and different cultures is a strong one for me, and I try to capture those aspects of a location that best illustrate this appeal. Is this romanticizing a destination? Yes, maybe. Is it a dishonest portrayal of a place? I don't think so.

By encouraging viewers to visit faraway places, travel photography can be a tool in the resistance against the homogenization of world culture. There is no denying that the globalization of culture is occurring, and that the primary force behind that juggernaut is our own American culture. Hollywood movies and the American consumer culture have proven to be frighteningly effective propaganda machines, and Americans are often excoriated for exporting this powerful mix as if we were wielding it like a weapon. Of course, this presupposes that Americans are doing this deliberately in some kind of imperialist plot. In truth, most Americans barely acknowledge the existence of the rest of the world, let alone dream of taking it over!

American culture has an insular quality: we like everything neat and tidy, and as a nation, we tend to have a timid approach to travel. Look at the popularity of cruise travel, all-inclusive resorts, and Disney World visits; you go places without leaving the familiar comforts of home. This is the very antithesis of what traveling is really about. If a travel photograph can lure someone out of the tourism cocoon and into a genuine encounter with a different culture, then it has indeed served an honest purpose.

Resources

BOOKS

Haas, Ken. *The Location Photographer's Handbook.* New York: Van Nostrand Reinhold, 1989. This book is out of print and tough to find, but it is the equivalent of about 15 years experience in the business. Worth finding, highly recommended.

Hudson, Andrew. *PhotoSecrets: Travel Guides for Travel Photography.* San Diego, CA: PhotoSecrets Publishing. This very useful series currently comprises three books: *San Diego* (1998), *San Francisco and Northern California* (1997), and *Yosemite National Park* (1997). Hudson scouts and photographs the areas and tells you where all the best angles are. Good general travel-photography tips as well.

Jay, Bill. *On Being a Photographer.* Portland, OR: Lenswork Publishing, 1997. A book-length interview with Magnum photographer David Hurn. An incredibly insightful, helpful discussion of the practice of photojournalism by two highly articulate photographers and friends. This book is a gem.

Krist, Bob. *Secrets of Lighting on Location.* New York: Amphoto Books, 1996. How to use lighting, from basic on-camera strobes, to large, multiple AC light setups. Heavy emphasis on simple solutions to lighting problems that travel photographers encounter.

Lloyd, Harvey. *Aerial Photography.* New York: Amphoto, 1990. Everything you need to know about shooting aerials.

McCartney, Susan. *Travel Photography: A Complete Guide to How to Shoot and Sell,* 2nd edition. New York: Allworth Press, 1999. This is a very detailed, extremely useful guide to all aspects of travel photography from a seasoned pro. Highly recommended.

Purcell, Ann, and Purcell, Carl. *Guide to Travel Writing and Photography.* Cincinnati, OH: Writer's Digest Books, 1991. Extremely useful information from two of the most successful people in the business.

TRAVEL GEAR AND CLOTHING

L.L. Bean Traveler Catalog. Freeport, ME 04033. 800-221-4221. A specialty catalog of items of interest to travelers. Great stuff, good prices. The regular catalog is useful, too.

Magellan's. Box 5485, Santa Barbara, CA 93150. 800-962-4943. Voltage transformers, plug adapters, fax and phone adapters, other neat travel gear.

TravelSmith. 60 Leveroni Court, Novato, CA 94949. 800-950-1600. A good array of travel clothing and accessories, although you must be prepared for long waits and back orders.

PHOTOGRAPHIC EQUIPMENT

Agfa Corporation. 800-879-2432. www.agfachrome.com. Film and paper. Scala, the black-and-white slide film, is especially interesting.

Bogen Photo Corporation. 201-818-9500. www.bogenphoto.com. Gitzo tripods, Elinchrom flash equipment, lightstands, etc.

Canon U.S.A. Inc. 800-652-2666. www.usa.canon.com. Cameras and flashes.

Chimera. 800-424-4075. E-mail: chimera@usa.net. Softboxes galore.

Contax Cameras. 800-526-0266. www.contaxcameras.com. The incredible G2 autofocus rangefinder system.

Domke Bags. 716-328-7800. www.saundersphoto.com.

Dyna-Lite Inc. www.dynalite.com. Compact, rugged pack and head systems, Uni-400 monolight, Jackrabbit batteries.

Eastman Kodak Co. 800-242-2424. www.kodak.com. The film people. Especially good are the 100VS and E200 films.

F.J. Westcott Co. 419-243-7311. www.fjwestcott.com. Umbrellas, diffusers.

Four Designs Inc. 9400 Wystone Avenue, Northridge, CA 91324. 818-882-2878. Converts Polaroid cameras for use as testers, 35mm backs, AC power supplies.

Fuji Photo Film, U.S.A. 800-800-3854. www.fujifilm.com. The other film people. Makers of the superb Velvia and Provia F films.

Lightware. 1541 Platte Street, Denver, CO 80202. 303-455-6944. Strong, lightweight cases for transporting cameras and lights.

Minolta Corporation. 201-825-4000. www.minoltausa.com. Minolta cameras, great flash and color meters.

Nikon Inc. 800-645-6687. www.nikonusa.com. The great F100 and F5 cameras, and the even greater SB28 flash system.

NPC Photo Division. 1238 Chestnut Street, Newton Upper Falls, MA 02164. Polaroid backs for 35mm and larger-format cameras.

Photoflex Products, Inc. 408-476 7575. www.photoflex.com. Softboxes, Lite Disc reflectors, etc.

Rosco Laboratories. 914-937-1300. www.rosco.com. Gel and diffusion materials.

R.T.S. Sekonic. 914-347-3300. www.sekonic.com. Flash and ambient light meters.

Sto-Fen Products. 800-538-0730. Omni bounce diffusers, sensor shields for Vivitar.

Tamrac. 800-662-0717. www.tamrac.com. Camera and lighting bags.

Tamron Industries, Inc. 800-827-8880. www.tamron.com. Interesting, often unique lenses, such as the F2.8 28-105mm AF.

Tenba, Inc. 718-222-9870. www. tenba.com. Camera and lighting cases.

Tiffen Manufacturing Corporation. 716-328-7800. www.tiffen.com. Filters; corporate owners of Saunders Group, of Domke Bag, et. al., fame.

Tocad Marketing Co. 973-428-9800. www.tocad.com. Sunpak strobes and video lights, SLIK tripods.

Tokina Lenses. THK Co. 800-421-1141. www.thkphoto.com.

Visual Departures. 800-628-2003. www.visualdepartures.com. Flexfill reflectors, Hi-Tech filter system, Steadybags, suction-cup mounts, other assorted useful gadgets.

Wein Products Inc. C/O Saunders Group. 716-328-7800. www.saundersphoto.com. Slaves, infrared triggers, sound triggers, etc.

Index